THE HIGH MUSEUM OF ART
Recipe Collection

ATLANTA, GEORGIA

Copyright 1981 by The High Museum of Art

ISBN number 0-939802-14-7

Published by The High Museum of Art
1280 Peachtree Street NE
Atlanta, Georgia

Designed by Vicky Stovall Spieler, Atlanta
Typography by The Abraham Company, Inc.
Printed by Williams Printing Company, Atlanta

First Printing October, 1981 15,000 copies
Second Printing October, 1982 20,000 copies
Third Printing February, 1987 15,000 copies

To order additional copies of
The High Museum of Art Recipe Collection
use the order blank provided in the
back of the book or send
$12.95 + $2.00 shipping charge to:
 Cookbook: High Museum of Art
 1280 Peachtree Street, NE
 Atlanta, Georgia 30309

Cover Illustration:
WILLIAM J. GLACKENS (American, 1870-1938)
Still Life with Roses and Fruit, c. 1924, oil on canvas, 19¾ x 24 inches.
Museum purchase with Henry B. Scott Funds, 1957.

Color reproduction in The High Museum of Art Recipe Collection
sponsored by The Cross Roads Restaurant, Atlanta.

THE MEMBERS GUILD OF THE HIGH MUSEUM OF ART

The members guild is the volunteer organization
of The High Museum of Art.
All proceeds from this cookbook and other
projects of the guild go toward
acquisitions, exhibitions and educational programs
at The High Museum of Art.

Table of Contents

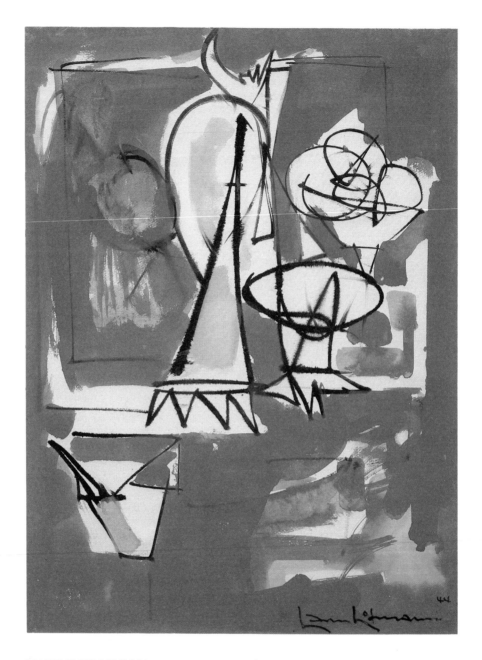

HANS HOFMANN (American, 1880-1966)
Still Life, 1944, water color on paper, 24 x 17½ inches. Museum purchase with funds from the Members Guild of The High Museum of Art, 1972. *Color reproduction in The High Museum of Art Recipe Collection sponsored by Stanley and Schenck, Inc., Dealers in Fine Contemporary Art and ROLIN ENTERPRISES, INC.*

Introduction

This book is a celebration of the relationship between food and art, between what supports life and what sustains it. The collectors who assembled this book are among the prime movers behind the resolute drive to build a new High Museum of Art in Atlanta. To purchase this book is to invest in the future of art in our part of the world.

Something bright and irresistible is happening in our green city. While the planet Earth grows smaller and more accessible, the city of Atlanta enlarges its angle of vision, alters the structure and conformation of its skyline each day, and begins to show signs of that spiritual, interior hunger for culture which is the indelible mark of a young city on the move. It is now possible to eat an early dinner at one of Atlanta's fine restaurants, cross the Atlantic by moonlight, have breakfast at The Savoy in London, and dine on pressed duck at the Tour D'Argent while watching, by moonlight again, the river barges working the currents of the Seine. In Atlanta we are nine hours from the works of van Gogh, from the Flemish villager, from German Lager, and from the new Beaujolais as it arrives in Paris from the vineyards. Because we love Atlanta, we love the search for a life of quality wherever it is found. This book, then, is an introduction to the Atlanta way of life.

The art of cooking is private and strange and beautiful. It is one of those solitary arts, like reading or composing letters, that is good for the soul by its very nature. It is no surprise to the cook that most religions of the world have included offerings of grain and fruit and sacrificial beasts to the gods of both harvest and storm. Food lovers are the happiest, the most inspired universalists. They take their pleasures where they find them and offer their praises and benedictions to any culture which honors the preparation of food. They are also the most cunning and least repentant of thieves. They will steal from the French, the Chinese, or the Scandinavians to improve the quality of the cuisine they set before their families and friends.

A good cook is the most valuable artist. Each day, each sunrise we are confronted with our own human dependency on food. We eat quickly to survive; we eat slowly to remember and to become more deeply human and alive. Food is intimately connected to memory and the fine meal reposes in deepest honor in the lightest cells of our brain. When an exquisite meal is set before us and we are among friends who are splendid conversationalists and whom we will love the rest of our lives, when the wine is breathing, when the aromas of the kitchen bind us

together, when there is laughter and hunger and remembrance, it is a time of astonishment and the possibility of magic is all about us.

Time in the kitchen is no longer considered peonage but a call to artistry. It is a time for the Atlanta cook to summon the bright spirits of creative hubris to arms—a time to preen, to strut, to display subtly the gentlest and most imaginative mysteries of cuisine. By owning this book, you will be the commandant of a hundred elegant meals. You will learn well the merits of garlic, the amazing properties of eggs, the binding powers of butter, the infinite and variable secrets of herbs, and the enormous role of yeast in the history of civilization. You will understand that the history of cooking is a history of genius, that it was a singularly uncommon human being who first matched the lemon with the fish, who took the creative leap to combine the yellow coinage of orchards with the fruit of the sea. You will discover that eating is often the surprise of the unimagined, the mystery of confronting the unknown. You will never repeat yourself because each meal is different and no recipe can ever be duplicated exactly. With this book, you will let the historians of the future know what the people who loved and supported the arts in the 1980's put on their tables. They will know you ate very well.

<div align="right">Pat Conroy</div>

GALLERY I
Hospitality!

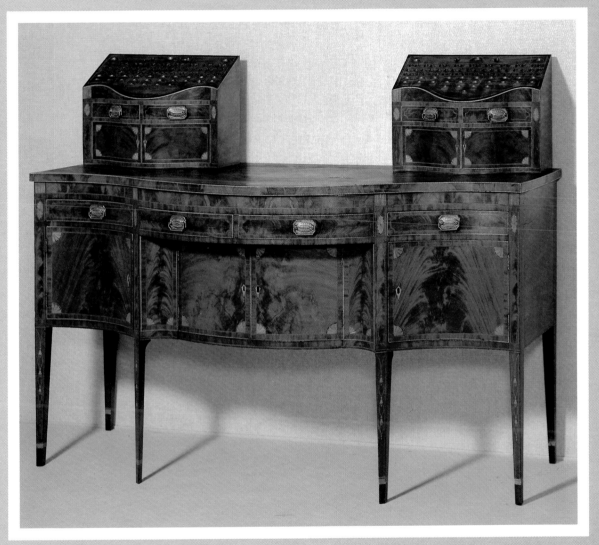

Sideboard with Matching Knife Boxes, c. 1794-1799, mahogany veneer over poplar, 40⅜ x 72 inches, labelled by William Whitehead, New York City. Museum purchase with funds from a Supporter of the Museum, 1976. *Color reproduction in The High Museum of Art Recipe Collection sponsored by Deanne Levison American Antiques and Folk Art.*

Gallery I

Iced Spiced Coffee

Serves: 4-6
(easy to multiply)

Takes the place of coffee and liqueur for summer dinners.

4 cups strong hot coffee
¼ cup sugar (or less)
10 whole allspice berries
10 whole cloves
4 small cinnamon sticks
½ cup Tia Maria
whipping cream
shaved chocolate (optional)

Combine coffee, sugar and spices in a mixing bowl. Stir mixture and cover with plastic wrap and let it stand for 1 hour. Strain coffee into a 1-quart pitcher. Add ½ dozen ice cubes and liqueur. To do a day ahead, strain coffee mixture and add liqueur only. Store in the refrigerator. Just before serving, add ice and stir. Serve in a wine glass over ice cubes. Top with whipped cream and add a few shavings of chocolate if desired.

Mrs. William Bowen Astrop

Mock Champagne Punch

Serves: 30

Refreshing, not too sweet, non-alcoholic but tastes like it might be. Men like it!

2 qts. ginger ale
1 qt. apple juice

Chill ingredients in refrigerator the day before opening. Mold ice ring with slices of lemon, limes, mint. Combine ginger ale and apple juice and center mold in punch bowl. For 300 people use 20/10 ratio.

Mrs. Robert Wells

Mushroom Bleu Cheese Appetizer

Serves: 8-12

Also good hot.

4 tablespoons butter (½ stick)
1 lb. mushrooms
pinch nutmeg, garlic powder, pepper
1 or 2 tablespoons Dijon mustard
white wine or vermouth to taste
8-oz. package cream cheese
3-oz. package cream cheese with chives
wedge of bleu cheese (to taste)
chopped parsley (as topping)

Cut and sauté mushrooms in butter until tender. Add the spices, mustard and wine to taste. Keeping on low heat, add the cream cheese and blend until soft. Crumble in the bleu cheese, a little at a time, and taste as you stir. Add more seasonings or wine to adjust to personal taste. Pour mixture into serving bowl, top with parsley, chill. Remove from refrigerator about 1 hour before serving. Serve with crackers or sliced French bread.

Dr. Eric Zafran

Caviar and Avocado Mold

Serves: 12-16

Handsome and good. There has never been any left over!

1 envelope unflavored gelatin
¼ cup cold water

4 hard-boiled eggs, chopped
½ cup mayonnaise
¼ cup parsley, chopped
1 large green onion, minced
salt and pepper to taste
Tabasco sauce to taste

1 avocado, chopped
1 tablespoon fresh lemon juice
1 avocado, puréed
2 tablespoons mayonnaise
1 tablespoon lemon juice
salt, pepper, Tabasco to taste

1 cup sour cream
1 large green onion, minced
salt and pepper to taste

1 (3 or 4 oz.) jar caviar, red or black
lemon juice
additional sour cream, optional

Line straight-sided 1 quart dish with plastic wrap and oil lightly. Soften gelatin in cold water, then heat on stove (or 20 seconds on lowest microwave setting) to dissolve. Set aside to use in various layers to follow.

Mix chopped eggs, ½ cup mayonnaise, ¼ cup chopped parsley, 1 large green onion (minced), salt, pepper and Tabasco, and add 1 tablespoon of the liquified gelatin. Pour into lined pan and refrigerate to set.

Mix the chopped avocado with the 1 tablespoon lemon juice and set aside. To the puréed avocado add 2 tablespoons mayonnaise, 1 tablespoon lemon juice and salt, pepper and Tabasco. Add 1 tablespoon liquified gelatin and the chopped avocado. Pour over the egg layer (now set) and refrigerate.

Mix 1 cup sour cream with 1 large minced green onion, salt and pepper, add 1 tablespoon liquified gelatin, pour over the two set layers and return to refrigerator. Cover with tight plastic wrap and refrigerate several hours or overnight.

At serving time rinse caviar in fine sieve and then sprinkle with lemon juice. Unmold the egg-avocado mixture and remove wrap. Spread caviar over top (you may want to use more sour cream to make caviar adhere easily).

Serve with melba toast or any other mild, crisp cracker or toast.

Mrs. E.M. Ruder

Chicken Log

Makes: 1 9-inch log

Nice use for leftover chicken.

2 (8-oz.) packages cream cheese
1 tablespoon steak sauce
½ teaspoon curry powder
1½ cups minced, cooked chicken
⅓ cup finely chopped celery
2 tablespoons minced fresh parsley
½ cup chopped toasted almonds

Combine softened cream cheese, steak sauce and curry powder; beat with mixer until smooth. Stir in chicken, celery and parsley. Shape into 9-inch long log; wrap in waxed paper. Chill for 4-5 hours. Roll log in almonds. Serve with crackers.

Mrs. James H. Joyner

Crabmeat Dip

Serves: 75 *Recipe can be halved.*

6 (8-oz.) packages softened cream cheese
2 sticks softened butter
1 pint white crabmeat
2 cans minced clams plus juice
fresh lemon juice
minced onion (approx. 1 tablespoon)
1 teaspoon Worcestershire
Tabasco sauce

Over moderate heat in saucepan combine cream cheese and butter. Add crabmeat and minced clams. Season to taste with clam juice, lemon, minced onion, Worcestershire and Tabasco sauce. Serve in chafing dish with crackers.

Ms. Diana Graves

California Artichoke and Shrimp Dip

Serves: 20 (as appetizer) *I normally double this recipe even for a small group. Delicious!*

2 cans artichoke hearts, well-drained and chopped
½ lb. shrimp, cooked and cleaned
1 cup sour cream
1 cup mayonnaise
1 bunch chopped green onions
Nature's Seasons, Jane's Crazy Mixed Up Salt, or
 garlic salt to taste

Mix all ingredients and refrigerate overnight. Serve with crisp crackers.

Mrs. Curt B. Jamison

Hors d'Oeuvre Salmon Loaf

Serves: 12-16 *This is a big hit at cocktail parties and unusual!*

1 loaf French bread
2 small bunches watercress (chopped)
8 oz. whipped butter
grated onion (optional)
7½ oz. red salmon
8 oz. whipped cream cheese

Cut bread in half lengthwise. Scoop out bread to make 2 boats. Reserve bread crumbs. Remove stems from watercress and chop leaves. Mix watercress with butter and half of the scooped-out bread crumbs. A small amount of grated or finely chopped onion may be added to butter-watercress mixture. Mix salmon with whipped cream cheese and other half of scooped-out bread crumbs. Put one mixture in one half bread boat and the other mixture in the other half. Put the 2 boats back together. Wrap tightly with plastic wrap. Secure the loaf with rubber bands. Refrigerate overnight or 24 hours. Slice thinly with electric knife and arrange in rows on serving plate or tray. Decorate tray with watercress leaves, crisp carrot sticks or cherry tomatoes.

Mrs. Edward H. Baxter

Norwegian Meat Balls

Serves: a crowd *Add sherry if you like.*

2 lbs. round steak
½ lb. suet
⅛ teaspoon pepper
2 teaspoons salt
¼ teaspoon mace
2 tablespoons flour
2 eggs
1½ cups milk
1½ quarts beef stock
butter

Grind meat and suet together four times then stir in seasonings and flour. Beat in one egg at a time. Add milk gradually, beating until light and spongy. Shape into small balls using teaspoon dipped in cold water. Boil meatballs in beef stock about 5 minutes. Drain and then brown in butter. Serve with brown gravy made from beef stock. Three tablespoons sherry may be added to two cups of sauce.

Mrs. Edward Ramlow

Guacamole—Fort Sam Houston

Serves: 6-8 *I serve this with drinks at Chastain Park before dinner.*

3 ripe avocados
1 ripe tomato
1 large clove garlic, minced
1 medium onion, grated
1 lemon
2 tablespoons olive oil
2 dashes Tabasco
salt to taste

Peel avocados and tomato and mash, leaving small lumps. Add garlic, onion and juice of whole lemon, olive oil, Tabasco and mix well with hands. Add salt to taste and stir with spoon. Serve cold with taco Doritos.

Mrs. John C. Rieser

Egg Salad with Caviar

Serves 12-16 *Serve with crackers or homemade toast points.*

6 eggs, hard-boiled, chopped
⅓ cup butter, softened
⅓ cup real mayonnaise
2 teaspoons fresh lemon juice
⅓ cup green onions, chopped
sour cream
red or black caviar

Line a round, 8″ bowl with plastic wrap. Combine ingredients except sour cream and caviar and place in the prepared bowl. Chill. When ready to serve, unmold and ice with sour cream. Cover top with caviar.

Mrs. George B. Vanstrum

Cheese Date Treats

Makes: 2-3 dozen
Oven Setting: 325°

Delicious with coffee or as a sweet hors d'oeuvre.

Pastry:
2 cups sharp cheese
1 stick butter (¼ lb.)
1½ cups flour
1 teaspoon salt
dash of red pepper

Filling:
8-oz. package dates
½ cup brown sugar
¼ cup water
½ cup nuts, finely chopped

Pastry: Grate cheese and mix with other pastry ingredients with a pastry cutter until dough can be rolled. Roll out and cut with a medium-sized biscuit cutter.

Filling: Cut dates into pieces, mix with other filling ingredients except nuts and cook over medium heat until thick and fairly dry. Cool. Add nuts. Put small amount of filling on half of each cheese biscuit. Fold over other side and squeeze edges together. Prick each biscuit with a fork. Bake 15-20 minutes.

Ms. Elizabeth Schutze

Hot Crabmeat Dip

Serves: 20

I'm repeatedly asked for this recipe by guests. A caterer even requested it!

16 oz. cream cheese
6 tablespoons mayonnaise
4 tablespoons white wine (or vermouth)
1 tablespoon Dijon mustard
½ teaspoon sugar
pinch salt
16 oz. crabmeat (preferably fresh but you can use frozen or good quality canned)

Combine cream cheese, mayonnaise, wine, mustard, sugar and salt in the top of a double boiler over hot water. Cook over simmering water, stirring until well blended and heated through. Add crabmeat drained and flaked. Transfer to chafing dish and keep hot over low heat. Serve with bite-sized pastry shells, toast points or bland crackers.

Mrs. C.W. Morris

Shrimp Butter

Makes: 1 large ball

Delicious change for parties.

2 lbs. fresh shrimp
seafood seasonings
1 teaspoon mace
1 teaspoon onion, finely chopped
¼ cup fresh parsley, finely chopped
½-1 cup softened butter

Boil shrimp 3-4 minutes in water and seafood seasonings. Then clean, devein and chop coarsely. Blend with seasonings and softened butter to make a ball. Chill, but remove from refrigerator 1½ hours before serving to soften the butter. (Definitely tastier when chilled overnight.) Serve with small rounds of bread, melba toast and lemon wedges.

Ms. Vicki Williams

Hot Bacon and Cheese Hors d'Oeuvres

Oven Setting: 400° *Men love it!*
Serves: 8-10

½ lb. raw bacon
1 medium onion
½ lb. sharp cheese
Worcestershire sauce
party rye bread (1½ packages)

Put first three ingredients in food processor or through meat grinder. Add a few drops Worcestershire sauce, mix and spread on party rye bread. Bake about 10 minutes, until brown and bubbly. Store in freezer in small amounts and take out for each party.

Mrs. Elyea Carswell, Jr.

Stuffed Mushrooms

Makes: about 16 large *Easy and can do ahead*
mushrooms *of time.*
Oven Setting: 350° or broil

1 lb. mushrooms (largest you can find)
1 cup bread crumbs
2 tablespoons chopped onions
⅓ stick butter
2 tablespoons bleu cheese
Worcestershire sauce
salt
freshly ground pepper

Clean mushrooms. Break stems from caps. Chop the stems. Put chopped stems, onions and butter into a pan and sauté lightly. Add bread crumbs and bleu cheese and mix. Add Worcestershire sauce, salt, pepper to taste. Stuff mushroom caps. Put into oven or under broiler for 5 minutes.

Ms. Sussi Craig

Hot Asparagus Dip

Serves: 16-20 *Easy—always enjoyed!*
Oven Setting: 350°

2 (15-oz.) cans asparagus (cut spears)
1½ cups mayonnaise
1½ cups freshly grated Parmesan cheese
1 clove garlic (crushed)
salt and pepper

Drain and mash asparagus and mix with the remaining ingredients. Pour into round, deep baking dish and bake for 20-30 minutes or until slightly brown and bubbling. Serve hot with crackers or large corn chips.

Editor's note: The cheese can be grated in food processor, then add other ingredients and combine.

Ms. Betsy Bairstow

Hot Cheese Balls

Serves: a crowd *Keep a supply in the freezer.*
Deep fry at 330°

½ lb. cream cheese
½ lb. Parmesan cheese, freshly grated
2 eggs
½ teaspoon salt
dash cayenne
1 cup bread crumbs
oil

Combine cheeses, eggs, salt and cayenne. Beat until smooth. Roll into 1-inch balls. (To make this easier, put oil on hands.) Roll each ball in crumbs. Chill or freeze. Slowly heat oil in deep pot—about 2 inches of oil. Using cooking thermometer, heat oil. Fry, turning once, until well-browned. Drain on paper towel. Serve hot. To freeze, spread out on cookie sheet and freeze. Then put into heavy plastic bag. They then remove easily if only some of them are needed.

Ms. Elizabeth S. Ellett

Sausage-Cheese Stuffed Mushrooms

Makes: 16 caps *Very filling and rich.*
Oven Setting: 350°

16 large mushrooms
6 links sweet Italian sausage
3 tablespoons olive oil
2 tablespoons parsley
1 large clove garlic, minced
¼ cup grated Parmesan cheese
¼ cup water

Remove and mince mushroom stems. Remove gills from caps. Remove sausage skin from meat and crumble meat while sautéing in 1 tablespoon olive oil. Add minced mushroom stems, parsley, cheese, and garlic. Drain excess grease. Place caps upside down in shallow baking pan. Fill lightly with meat mixture. Pour water and 2 tablespoons oil into pan and bake for 20 minutes.

Ms. Linda Hall

Mushroom Croustades

Makes: 30 *Can be frozen before baking.*
Oven Setting: 350°

Cut 2½-inch rounds of fresh Pepperidge Farm bread from slices that you have rolled with a rolling pin to flatten. Gently press into miniature muffin tins. Bake at 350° until lightly toasted. Brush inside of croustades with melted butter and put into freezer until ready to use.

Mushroom Filling:
4 tablespoons butter
½ lb. mushrooms, finely chopped
3 tablespoons shallots, minced
2 tablespoons flour
½ cup heavy cream
salt and pepper to taste
2 tablespoons chopped parsley
1½ tablespoons chives, chopped
½ teaspoon lemon juice
2 tablespoons grated Parmesan cheese
bits of butter

Melt butter and sauté the mushrooms for 4-5 minutes, but do not brown. Add chopped shallots and stir for two minutes over moderate heat. Stir in the flour and cook slowly for 2 minutes more, stirring constantly. Off heat, blend in the cream and seasonings, parsley, chives and lemon juice. Cook down rapidly until thickened. Cool slightly before using in croustades. Fill bread cases, dot with butter and sprinkle with Parmesan cheese. Bake for 15 minutes.

Mrs. Rodman B. Teeple, Jr.

Turkey in Lettuce Leaves

Serves: 30-40 for cocktails *Festive and intriguing.*

6 tablespoons butter
2 cups onion, finely chopped
¾ cup green pepper, finely chopped
4-oz. can green chili peppers, drained and chopped
1-2 tablespoons fresh hot chili pepper, finely chopped
 or 1 teaspoon dried
4 cups cooked turkey, finely diced
1 tablespoon fresh basil or 1½ teaspooons dried basil,
 chopped
1 teaspoon salt
½ teaspoon freshly ground black pepper
⅓ cup good cognac
(chicken broth)
¼ cup parsley, chopped
¾ cup shaved toasted almonds
3 heads iceberg lettuce

Melt butter in large skillet and sauté the onion and green pepper until wilted. Add the green chili peppers, fresh hot chili pepper and turkey and toss well. Cover and simmer 5 minutes. Add the basil, salt, pepper and cognac. If the mixture seems too dry, add some chicken broth. Taste and adjust the seasonings.

Arrange in a large heated bowl or chafing dish and garnish with ¼ cup chopped parsley and ¾ cup shaved, toasted almonds. On separate tray or bowl arrange leaves of 3 heads of iceberg lettuce, well chilled. To eat, spoon turkey mixture on a lettuce leaf, roll as a taco and eat. The cold lettuce combined with a hot filling is interesting.

Editor's note: Guests seem to enjoy a "do it yourself" opportunity. To make this dish you can buy a frozen turkey breast and simmer with some onion, celery and parsley until tender. The broth can then be cooked down and frozen for future use. If you use a processor to chop the turkey be very careful not to chop it too finely. Can be made in advance and reheated.

Mrs. Rodman B. Teeple, Jr.

Egg Salad Mold

Good served with crackers at a cocktail party. Also good served on lettuce with ham as a luncheon salad.

1 envelope gelatin
¼ cup cold water
1 cup mayonnaise
5 hard-cooked eggs (sliced, diced or chopped)
½ cup celery, finely chopped
2 tablespoons green pepper, finely chopped
2 tablespoons pickle relish
1 tablespoon pimiento, chopped
1 tablespoon lemon juice
¾ teaspoon salt
dash cayenne pepper
½ teaspoon dry mustard

Soften gelatin in cold water; place over boiling water and stir until dissolved. Cool and beat into the mayonnaise. Add other ingredients and mix thoroughly. Turn into loaf pan that has been rinsed in cold water; chill.

Mrs. Clyde Higginbotham

Special Ham Biscuits

Makes: 9-10 dozen
Oven Setting: 350°

A southern specialty.

2½ sticks butter, softened
2 small onions, finely chopped
2 tablespoons poppy seeds
5 teaspoons Dijon mustard
1½ to 2 lbs. shaved ham
9 or 10 dozen biscuits

Blend together until smooth the butter, onions, poppy seeds and mustard. Refrigerate 24 hours. Return to room temperature to soften, spread each biscuit with butter mixture and add ham. Cover biscuits with foil and warm for about 10 minutes.

Mrs. Don T. Parke

Cream Biscuits

Makes: 35 2-inch biscuits
Oven Setting: 425°

Always useful.

2 cups all-purpose flour
1 teaspoon salt
1 tablespoon baking powder
2 teaspoons sugar
1 cup heavy cream
4 tablespoons butter, melted

Sift together flour, salt, baking powder and sugar. Fold in the cream, mixing well to make a soft dough. Knead on a floured board 1 to 2 minutes. Roll and cut out. Dip biscuits in melted butter and place on a buttered baking pan. Bake in pre-heated oven for 15 minutes. Serve very hot.

Mrs. John L. Watson, III

Almond Brandy Mold

Serves: 35

Unusual and wonderful for a cocktail buffet.

12 oz. cream cheese at room temperature
1 stick butter, softened
½ cup sour cream
½ cup sugar
1 envelope gelatin
¼ cup cold water
1 cup slivered almonds
grated rind of 2 lemons
1 cup white raisins
brandy

Place cream cheese, butter, sour cream, sugar in food processor. Blend. Dissolve gelatin in cold water over hot water. Combine with cream cheese mixture; add almonds and lemon rind and raisins which have been soaked in brandy overnight and drained. Put into greased 1-quart mold. Chill. Serve with saltine crackers for a cocktail buffet or with wheat meal biscuits and fresh fruit after dinner.

Mrs. Clyde Higginbotham

Gurkas Dilisas
(Norwegian Hors d'Oeuvres)

Makes: 2 dozen

Pretty on the buffet table. Different and good.

3 or 4 small, young cucumbers
1 tin (2 oz.) anchovy filets
2 packages (3 oz. each) cream cheese
1 teaspoon dill weed
1 teaspooon shredded green onion
1 tablespoon mayonnaise
cayenne to taste
dairy sour cream
chervil

Scrub cucumbers but do not peel; cut off ends. Cut into 1-inch lengths. Scoop out center seedy portion with sharp knife. Drain anchovy filets and chop. (Do not chop in food processor, they will become gummy.) Mix together with cream cheese, dill, green onions and mayonnaise. Season with cayenne; blend well. Stuff mixture into cucumber slices. Chill for several hours. Just before serving, top each piece with a small spoonful of sour cream and a sprinkle of chervil. Serve very cold. Can be made hours ahead. Will stay crisp and crunchy.

Mrs. Ardis Roderick

Delicious Pineapple Cheeseball

Makes: 1 large cheeseball

Cheeseball with a different twist.

8-oz. package cream cheese
¼ cup green pepper, chopped
⅛ cup onion, chopped
1 small can crushed pineapple (about 6 oz.), well drained
1½ cups chopped pecans

Combine cream cheese, green pepper, onion, crushed pineapple and 1 cup pecans. (Save ½ cup pecans to roll ball in.) Form into one large ball. Roll in ½ cup pecans. Cover and refrigerate. Serve with several types of crackers.

Ms. Ann Hall
Mrs. Douglas Torbush

Cheese Fingers

Oven Setting: 350°

This recipe was given to me by Miss Mary Simmons.

½ lb. butter
½ lb. shredded sharp cheese
2⅔ cups all purpose flour, to which a dash of red pepper has been added
slivered pecans

Cream first two ingredients. Add flour laced with red pepper. Chill overnight in refrigerator. Roll with sliver of pecan in center. Bake for 20 minutes. Accompaniment for any beverage.

Mrs. Homer Hansen

Cocktail (or Cream) Puffs

Makes: 1 dozen large
or 4 dozen small
Oven Setting: 400°

For cocktails fill with chicken, ham, crab salad or with bleu cheese mixture below.

½ cup butter (preferably unsalted)
½ teaspoon salt
1 cup boiling water
1 cup sifted all-purpose flour
4 large eggs

Heat butter and salt with boiling water in medium saucepan over high heat. Remove from heat after butter melts. Using a wooden spoon, stir in the flour all at once. Place over low heat and beat until mixture leaves sides of pan and makes a ball. Again remove from heat and using spoon or electric mixer add eggs, one at a time, beating after each until smooth. Beat until dough has satin-like sheen, is stiff and holds its shape.

Editor's note: This dough can be mixed easily in a food processor as follows: In a small, heavy saucepan bring the water, butter and salt to a boil over high heat. Meanwhile, place the flour in the work bowl of a food processor fitted with the metal blade. With the motor running, carefully pour the boiling mixture down the feed tube in a moderately slow stream. Let the motor run for 40 seconds after the mixture has been incorporated. Now add the eggs, one at a time. Snap the motor on, crack an egg, then let the egg slide down the feed tube into the spinning pastry. Run the motor nonstop for 10 seconds after each egg has been added, then uncover work bowl and scrape down the sides before proceeding.

Drop the pastry by rounded spoonful (teaspoons for tiny puffs, tablespoons for larger puffs) onto ungreased baking sheets, spacing them 2 inches apart for tiny, 3 inches apart for larger puffs. Bake in a hot oven for 20-25 minutes for the small, 40-45 minutes for the large puffs. They should be richly browned and should not collapse when you take them out of the oven. Transfer to wire racks, cool to room temperature, then slice about ¾ inch off the tops of the puffs and scoop out and discard any doughy bits inside.

Use for desserts, filled with custards or ice cream.

For example, fill puffs with peppermint or vanilla ice cream and top with hot fudge sauce, or fill with coffee or butter pecan ice cream and top with hot butterscotch sauce. For cocktails try the following filling.

Bleu Cheese Filling:
4 oz. cream cheese
3 tablespoons bleu cheese
½ cup pecans

Process cheeses until smooth and creamy. Stir in pecans. Use to fill cream puffs.

Mrs. L. Ralph Boynton

Cheese Straws

Freeze well.

1 stick butter
1½ cups of flour
1½ teaspoons baking powder
1 teaspoon salt
½ teaspoon cayenne
2 cups grated cheese (½ lb.)

Soften butter, do not melt. Mix with dry ingredients, then add cheese. It is easier to mix with your hands. Put through cookie press. Bake on ungreased cookie sheet for approximately 10-12 minutes or until golden-colored. Store in an airtight container.

Ms. Clarkson Terrill

Marinated Roast Tenderloin

Serves: 25 for cocktails *Handsome for a cocktail buffet.*
Oven Setting: 450°, 400°

**5-8 lb. tenderloin (or ribeye, but it will not be as
 good)**
coarsely ground pepper or lemon-pepper
2 cloves garlic, crushed
1½-2 cups soy sauce
½-¾ cup bourbon
bacon, 3 or 4 strips
1 medium onion, sliced

Place roast in large plastic bag. Sprinkle with
pepper or lemon-pepper. Mix garlic, soy sauce and
bourbon together and pour this mixture over roast in
bag. Marinate at room temperature for 2 hours or
overnight in refrigerator. Allow roast to come to
room temperature before roasting. Place strips of
bacon on top. Put meat on a rack. Pour marinade
over it and put slices of onion on top. Place in oven
which has been preheated to 450°; immediately
reduce to 400° and roast for 35-50 minutes. Internal
temperature of the meat should be 135° for a rare,
juicy roast.

Sesame Cocktail Biscuits

Makes: 80-100 tiny biscuits *Doubles easily.*
Oven Setting: 425°

½ cup butter or margarine, softened
1 3-oz. package cream cheese, softened
1 cup flour
1 egg beaten with 1 tablespoon water
Sesame seeds

Cream butter and cream cheese. Add flour and
blend well. Chill at least 1 hour. Roll on floured
board. Cut into tiny rounds. Brush with egg and
water mixture, then sprinkle with seeds. Bake for
12-15 minutes. This freezes beautifully.

Mushroom Puffs

Makes: 50 *These freeze beautifully*
(doubles easily) *before baking.*
Oven Setting: 450°

Pastry:
3 oz. cream cheese, softened
½ cup butter, softened
1½ cups flour

Filling:
1 onion, minced
3 tablespoons butter
½ lb. mushrooms, minced
¼ teaspoon thyme
½ teaspoon salt
pepper to taste
2 tablespoons flour
¼ cup sour cream

For pastry, mix cheese and butter. Stir in flour and
blend well. Chill. For filling, sauté onion in butter.
Add mushrooms and cook 3 minutes. Add
seasonings. Sprinkle flour over mixture. Add sour
cream. Cook until thickened. Do not boil.

Roll chilled dough until very thin on floured board.
Cut 3-inch rounds and place 1 teaspoon filling on
each. Fold edges over and press together with tines of
fork. Prick with fork. Bake on ungreased sheet for 15
minutes. If frozen, allow a little extra time for baking.

Smoked Oyster Roll

Serves: 18-20 *A special treat for oyster lovers.*

2 (8-oz.) packages cream cheese
2 tablespoons mayonnaise
2 teaspoons Worcestershire
dash Tabasco
1 tablespoon grated onion
½ teaspoon salt
garlic salt
2 (3¾ oz.) cans smoked oysters
fresh parsley

Mix cream cheese, mayonnaise and seasonings. Spread ½ inch thick on foil. Mash oysters with fork and spread on top of cheese. Chill, then roll "jelly-roll fashion." Refrigerate. Before serving roll outside in chopped parsley. Serve with crackers.

Mrs. Jerry Minge

Chicken Bolognese

Serves: 4 (multiplies easily) *An easy recipe that can be*
Oven Setting: 350° *done in advance except for*
 the final baking.

2 whole chicken breasts, skinned, boned, and cut in
 half lengthwise
salt, freshly-ground black pepper
¼ cup flour
5 tablespoons butter
2 tablespoons vegetable oil
¼ lb. prosciutto, cut in 8 paper-thin slices
½ lb. Fontina or Bel Paese cheese cut in 8 to 12 ⅛"
 slices
3 tablespoons grated Parmesan cheese
6 tablespoons chicken broth

Spread the chicken breasts, smooth sides up, on a board and slice horizontally. Place 4 slices of breast at a time on a piece of waxed paper; lay another sheet of paper over them and pound gently with the flat of a cleaver or small heavy saucepan to flatten them gently.

Spread 1 tablespoon softened butter over the bottom of a shallow baking dish just large enough to hold the breasts side by side in one layer. Sprinkle both sides of the breasts with salt and pepper then dip one at a time in flour, shaking gently to remove any excess.

Melt 3 tablespoons butter and the oil in a heavy skillet over moderately high heat. When fat begins to turn slightly brown, add the breasts (do not crowd, do two batches if necessary) and brown them lightly for about 2 minutes on each side. Use tongs to turn them. Be careful not to burn.

Arrange the breasts in the buttered baking pan and lay a slice of ham on each, trimming where necessary but completely covering the breast. Lay slices of cheese on top, covering the sides as well as the top. Sprinkle the Parmesan on top of each breast.

Slowly pour the chicken stock down into one side of the baking dish, tipping it to spread the stock evenly. Dot with the remaining butter, place in upper third of the oven and bake until cheese is melted and lightly browned—about 10 minutes. Just before serving you may place under the broiler for a few seconds.

If you prepare this dish ahead, be sure to have chicken at room temperature before baking. This recipe has been successfully multiplied to serve as many as 18. Ham or dried beef can be substituted for prosciutto but don't use a substitute for the imported Italian cheese.

Mrs. Rodman B. Teeple, Jr.

Chicken-Seafood-Artichoke Casserole

Serves: 20
Oven Setting: 375°

Exceptionally good.

4 (8½-oz.) cans artichokes (drained weight)
4 lbs. crabmeat or shrimp (cooked and cleaned)
8 whole chicken breasts (cooked and cut up)
3 lbs. fresh mushrooms (sliced)
3 tablespoons butter
6 cups thick white sauce
2 tablespoons Worcestershire
salt and pepper to taste
1 cup sherry
½ cup grated Parmesan cheese
paprika and chopped parsley

White Sauce:
1½ cups melted butter
1½ cups flour
6 cups milk

Arrange artichokes in bottom of buttered casserole. Add shrimp and chicken. In large skillet sauté mushrooms in butter. Drain and add to casserole. Combine ingredients for white sauce. Heat and stir until creamy. Add Worcestershire, salt, pepper and sherry to white sauce. Pour over casserole. Sprinkle top with cheese and dust with paprika and parsley. Bake uncovered for 40 minutes.

Mrs. C.E. Smith

Baked Chicken with Curry and Coconut

Serves: 12
Oven Setting: 450° then 350°

Good for buffet dinners—so tender it can be eaten with a fork.

2 cups uncooked rice
6 chicken breasts, halved, boned and skinned
2 tablespoons butter
1 cup flaked coconut
2⅓ cups curry sauce

Prepare rice according to instructions on package. Cover bottom of greased 9" x 13" glass pan with rice. Place 12 chicken breast halves on top of rice. Dot with butter. Bake for 15-20 minutes until brown. Remove from oven. Pour sauce over chicken. Sprinkle with coconut. Return to oven and bake at lower temperature for 15-20 minutes. Be careful that coconut doesn't brown.

Curry Sauce:
½ cup minced onions
1 clove garlic, crushed
1 tablespoon curry powder
1 tablespoon applesauce (or chopped apple)
½ lb. bacon, finely chopped
1 tablespoon tomato paste
¼ cup fresh lemon juice
1 tablespoon flour
1 cup chicken stock
1 tablespoon cream or milk

Combine all ingredients in saucepan and mix to a paste. Cook over medium heat 10-15 minutes.

Mrs. E. Lewis Hansen

Moussaka with Artichokes

Serves: 10-12
Oven Setting: 350°

A winning combination.

¼ cup butter
1 medium onion, finely chopped
2 lbs. lean veal, ground
2 lbs. lamb, ground
½ cup red wine
2 tomatoes, peeled, seeded and chopped
⅓ cup parsley, finely chopped
¼ teaspoon each cinnamon and nutmeg
salt and pepper to taste

Bechamel Sauce:
¼ cup butter
¼ cup flour
3 cups scalded milk
1 teaspoon salt
3 eggs, beaten
⅛ teaspoon nutmeg
butter, bread crumbs
24 marinated artichoke hearts, drained
4 tablespoons Parmesan cheese, grated

In a large skillet, heat butter and cook onion until lightly browned. Add veal and lamb and brown lightly. In saucepan, heat together the wine and tomatoes. Blend into meat mixture. Add parsley and seasonings. Simmer for 30 minutes or until most of liquid is absorbed. Make bechamel sauce: heat butter, add flour, stirring until smooth. Gradually add milk and salt; stir until thick and smooth.

Stir 3 tablespoons bechamel sauce into meat mixture. With whisk, combine remaining sauce with eggs and nutmeg. Butter a deep baking pan (11"x16") and sprinkle evenly with bread crumbs.

Arrange 12 artichoke hearts on bread crumbs. Cover with half the meat mixture. Sprinkle with 2 tablespoons Parmesan cheese. Repeat layers: 12 more artichoke hearts and remaining meat mixture. Over top, pour the remaining bechamel sauce and sprinkle with 2 tablespoons Parmesan. Bake 1 hour or until top is golden brown.

Mrs. Donald M. Stewart

Bolichi (Bo-lee-chee) (Stuffed Eye of Round)

Makes: 8+
Oven Setting: 475° then 325°

This is a wonderful old recipe of Spanish origin that I learned in Tampa.

1 eye of round roast beef (3-4 lb.)
½ Chorizo sausage (sweet Cuban sausage), chopped
1 onion, chopped
¼ green pepper, chopped
¼ cup black olives, halved
¼ teaspoon garlic salt
1 teaspoon Worcestershire
1 small can tomato sauce
flour
1 (10½ oz.) can beef consommé

With a long, very sharp knife, make a pocket from one end of the eye round roast almost to the other end. Mix all other ingredients except the consommé. Stuff roast with mixture, forcing it to end. Flour and roast at 475° for 20 minutes. Add consommé to pan. Roast, uncovered at 325° for 2 hours, basting frequently.

Slice roast and serve on a warm platter with a little juice. Serve with saffron rice and a mixed green salad stuffed in a heated envelope of pita bread with an herb/garlic dressing.

Mrs. Doug Thatcher

Blanquette de Veau

Serves: 6

A delicate and classic dish. Doubles easily.

3 lbs. boneless veal
6 cups chicken stock, fresh or canned
2 medium carrots, cut in 1" pieces
1 large onion
1 teaspoon thyme
2 cloves garlic, unpeeled
bouquet consisting of 4 sprigs parsley, 2 celery tops, 1 bay leaf
1 teaspoon salt
18 small white onions, peeled
2 tablespoons butter
⅔ cup chicken stock
1 teaspoon lemon juice
1 lb. button mushrooms
3 tablespoons butter
3 tablespoons flour
1 teaspoon Dijon mustard
2 egg yolks
1 cup heavy cream
1 teaspoon lemon juice
cayenne to taste
2 tablespoons fresh parsley, chopped

Blanch the veal by covering it with cold water in a pan. Bring to a boil, let simmer 1 minute then drain in a large sieve. Wash under cold running water.

Place the blanched veal in a heavy casserole with 6 cups chicken stock or enough to completely cover the meat. Add the carrots, onion, thyme, garlic cloves, bouquet and 1 teaspoon salt. Bring slowly to a boil, skim if necessary, then reduce heat to barest simmer. Cook partially covered for 1 to 1½ hours until tender.

Meanwhile, cook the onions. Melt 2 tablespoons butter in saucepan, add ⅔ cup chicken stock and when this comes to a boil, add the onions. Simmer covered until done, about 15 minutes. (Add more stock if necessary.) Remove with a slotted spoon to a bowl and set aside. Add 1 teaspoon lemon juice to remaining stock and add the mushrooms. Cook briskly for 5 minutes, remove with slotted spoon to bowl with onions.

When veal is tender remove with a slotted spoon to a bowl. Strain the stock and boil it rapidly until it is reduced to 2 cups.

Prepare a cream sauce with 3 tablespoons butter, 3 tablespoons flour, 1 teaspoon Dijon and 2 cups veal stock. Simmer for 15 minutes. Mix the egg yolks with the heavy cream, stir in ¼ cup of the hot cream sauce then pour this into the simmering sauce, stirring constantly. Cook over moderate heat until it almost reaches a boil. Remove from heat. Stir in 1 teaspoon lemon juice and cayenne to taste. Drain the veal, onions and mushrooms and place in a clean casserole. Cover with the cream sauce, gently mixing together. Reheat just before serving without letting it boil. Sprinkle with chopped parsley, serve with rice and crusty French bread.

Casserole can be prepared the day before serving and slowly reheated.

Party Pasta

Serves: 8-10
Oven Setting: 375°

Doubles and triples nicely.

2 cups tomatoes
5 tablespoons butter
4 tablespoons flour
2 cups chicken broth
1 cup heavy cream
salt and pepper to taste
⅛ teaspoon nutmeg
½ pound Italian sausage
1 cup green pepper, finely chopped (1 large)
1 cup celery, finely chopped
1 cup onion, finely chopped (1 large)
1 tablespoon garlic, finely chopped
½ pound ground sirloin
3 cups fresh mushrooms, thinly sliced
Tabasco and Worcestershire to taste
1 cup black olives, sliced
12 strips lasagne, cooked al dente (homemade or imported Italian)
2 cups cooked chicken, shredded
3 cups cheddar cheese, grated
½ cup Parmesan cheese, grated

1. Cook the tomatoes until they measure 1½ cups (about 30 minutes).
2. Make cream sauce with 3 tablespoons butter, flour and broth. Cook about 10 minutes, stirring occasionally. Add the cream, salt and pepper to taste and the nutmeg. Add the tomatoes. Set aside.
3. Remove casing from sausage and cook meat in frying pan until it loses its raw color. Drain and set aside.
4. Heat 2 tablespoons butter in large frying pan and sauté the green pepper, celery, onion and garlic just until crisp-tender. Add the beef, breaking up the lumps and cook until done. Add the sausage meat and fresh mushrooms. Cook briefly, stirring to combine. Add salt and pepper to taste.
5. Combine the cream sauce with the meat mixture. Season with Tabasco and Worcestershire. Add the olives and heat through.
6. Butter a lasagne dish, place 4 lasagne strips on bottom. Add ½ of the chicken, spoon ⅓ of the meat sauce over and cover with ⅓ of the cheddar cheese. Add 4 more lasagne strips, rest of chicken, ⅓ meat sauce, ⅓ cheddar cheese. Repeat layer of lasagne strips, rest of the meat sauce and final ⅓ cheddar cheese. Just before baking sprinkle with the Parmesan and bake for 30-40 minutes or until bubbling.

Can be prepared a day ahead, refrigerated and brought to room temperature before baking.

Best Ever Lasagna

Serves: 8-10
Oven Setting: 350°

Wonderful with a salad and garlic bread for parties.
Can be frozen for a future occasion, or can also be a gift.

Tomato and Beef Sauce:
1 medium onion, finely chopped
2 tablespoons oil
1½ lbs. lean ground beef
1 clove garlic, crushed or minced
2 6-oz. cans tomato paste
½ cup dry red wine
1 teaspoon salt
1 teaspoon oregano
1 tablespoon basil
½ tablespoon each pepper, sugar and MSG
1 1-lb. can tomatoes, crushed
1½ boxes (24 oz.) lasagna noodles

Ricotta and Spinach Filling:
1 lb. ricotta cheese (or small curd cottage cheese)
½ cup Parmesan cheese, grated
½ lb. cooked, drained and chopped spinach
3 eggs, beaten
2 or 3 tablespoons warm water
½ teaspoon each salt and pepper
dash nutmeg
¾ lb. Mozzarella cheese, shredded
½ cup Parmesan cheese, grated

In a large skillet or heavy pot, sauté onions in oil until soft. Add beef and garlic and cook, stirring constantly until the beef is lightly browned. Stir in tomato paste, wine, seasonings and tomatoes. Cover and simmer slowly for 30-40 minutes. Meanwhile cook noodles as directed on package, drain and rinse. Mix together the ricotta and spinach filling.

In a 3-quart casserole, criss-cross ⅓ of the noodles. Spread ⅓ of the tomato sauce over noodles and then ⅓ of the Ricotta filling and finally ⅓ of the Mozzarella. Repeat this layering 2 more times. Top with ½ cup Parmesan. Bake for 30-40 minutes or until bubbly.

Mrs. Jerry McManis

Party Chicken Salad

Serves: 10-12

Good for a luncheon buffet.

1 cup celery, diced
1 cup seedless white grapes, halved
¾ cup toasted slivered almonds
1 cup bell pepper, finely chopped (optional) or 1 cup pineaple chunks (either pepper or pineapple is delicious in recipe)
¼ cup light cream
⅔ cup fresh mayonnaise (homemade, if possible)
salt
2 tablespoons vinegar
4-5 cups cooked chicken, cut in small chunks

Mix ingredients and gently fold in chicken, making sure to coat chicken thoroughly.

Mrs. Osgood Willis

Delta Gumbo

Serves: 10-12 *From the delta areas of the Arkansas and Mississippi Rivers.*

4-5 cloves garlic (used to flavor oil)
2-3 tablespoons oil or bacon drippings
2-3 tablespoons flour
2 medium onions, chopped
2 large bell peppers, chopped
5 stalks celery, chopped
½ teaspoon saffron
8-10 ripe tomatoes, or 1 28-oz. can
1½ quart water, boiling
1 large slice ham, cut into pieces
1 teaspoon salt
1 teaspoon freshly-ground black pepper
2 teaspoons Tabasco
1 teaspoon thyme
1 or 2 bay leaves
1-1½ lbs. fresh okra (or 3 packages frozen okra)
2 lbs. fresh crab meat
1 pint oysters
3 lbs. fresh shrimp, cleaned
½ cup fresh parsley, chopped

If possible, use 2 black iron skillets. In one, sauté, garlic in 2 tablespoons oil until brown, then remove garlic and discard. Make a roux in oil with flour. In the other skillet, sauté chopped onion, bell peppers and celery in 1 tablespoon bacon grease until tender. Combine roux and sautéd vegetables and transfer all to a very large soup pot. Add saffron, tomatoes, water, ham and seasonings and simmer. Meanwhile, cook okra in a separate pot, drain and set aside. Add seafood and parsley to large pot and simmer gently for 20-30 minutes. Add okra 5-10 minutes before serving. Serve over rice (preferably brown rice from Arkansas).

Editor's note: The roux serves as thickening agent, although some use gumbo filé for thickening.

Mrs. Robert C. Garner

Broccoli Salad Mold

Serves: 12-14 *Good to take to a covered-dish party.*

2½ packages unflavored gelatin
13-oz. can clear Madrilene consommé
3 (10-oz.) packages frozen chopped broccoli, cooked, drained and mashed (or chopped in food processor)
4 hard-boiled eggs, chopped finely
1 teaspoon Tabasco
1 teaspoon black pepper
3 tablespoons Worcestershire sauce
1½ teaspoons salt
2 tablespoons lemon juice
1 cup mayonnaise

Dissolve gelatin in undiluted warm Madrilene consommé. Add finely chopped eggs to broccoli. Add remaining ingredients except mayonnaise to consommé;fold in broccoli and eggs and blend well. Fold in mayonnaise and blend well. Put in mold which has been rinsed in water, drained and placed in freezer. Always unmolds easily and slices well. Doubles. Attractive if molded in a bundt type tin and served on a silver tray.

Mrs. John W.H. Miller

Tomato Aspic with Artichoke Hearts

Serves: 8

Can be doubled, tripled or quadrupled easily.

2 tablespoons gelatin
4 tablespoons cold water
2 pints V-8 juice
juice of 1 lemon
1 teaspoon sugar
2 ribs celery
1 small onion, sliced
1 bay leaf
salt and red pepper to taste
dash Worcestershire sauce

Prepare separately:
8-oz. package cream cheese, softened
mayonnaise, seasonings (salt, white pepper, cayenne, lemon juice)
8½-oz. can artichoke hearts (8 or more hearts)

Soften gelatin in cold water. Combine other ingredients; cook over slow heat for 15-20 minutes. Pour over gelatin and stir until dissolved. Strain. Pour a small amount of aspic in bottom of each individual mold (or into bottom of large ring mold if recipe is increased); let congeal until almost set.

Season softened cream cheese with small amount of mayonnaise, salt, white pepper, dash of cayenne and few drops of lemon juice. Mix well. Open artichoke hearts carefully. Press seasoned cream cheese into each one. When aspic is almost set, put an artichoke heart, cheese side down, into each mold.

Pour more partially congealed aspic around artichoke hearts, completely filling mold with aspic. (Follow same procedure for ring mold. Large mold will hold 10-12 artichoke hearts.) Chill until firm. Unmold on bed of lettuce. Serve with seasoned mayonnaise. Recipe can be increased for large groups. For 10-cup ring mold, quadruple recipe. When doubling aspic recipe, add an additional envelope gelatin.

Mrs. Crawford F. Barnett, Jr.

Buffet Vegetable Salad

Serves: 8

Broccoli, brussel sprouts and artichoke hearts.

Salad:
1 large bunch broccoli
1 pint brussel sprouts
2 (9-oz.) packages frozen artichoke hearts
1 cup sliced celery
¼ cup sliced onion
¼ cup sliced green olives
½ cup chopped pecans

Dressing:
⅔ cup salad oil
⅓ cup wine vinegar
½ clove garlic
1 teaspoon sugar
1 teaspoon salt
¼ teaspooon dry mustard
¼ teaspoon cayenne

Cook **just until crisp-tender** and drain vegetables. Cut broccoli and sprouts into fairly small pieces. Combine all the dressing ingredients and blend well. Marinate all the vegetables and the olives in the dressing for 24 hours. Just before serving add chopped pecans.

Mrs. Joseph Wright Twinam

Party Salad

Serves: 10-12

This is a delicious luncheon or supper salad. Serve with French bread or rolls and dessert. It is a meal in itself.

10 oz. fresh spinach
salt and freshly ground pepper to taste
6 hard-boiled eggs, finely chopped
½ lb. boiled ham cut in strips
1 small head lettuce, shredded
10-oz. package frozen tiny peas, thawed and
 patted dry
1 red onion sliced and separated in rings
1 cup sour cream
1 pint mayonnaise
½ lb. Gruyere cheese, cut in strips
½ lb. bacon, crisply cooked and crumbled

Trim spinach, discard stems, rinse leaves, pat dry and break into bite-size pieces. Arrange spinach at bottom of large glass salad bowl. Sprinkle with salt and pepper. Add eggs, ham and lettuce in layers. Sprinkle with more salt and pepper and scatter peas all over. Then arrange onion rings on top. Combine sour cream and mayonnaise well and spread over top of the salad. Scatter cheese strips over salad, cover the bowl tightly with foil or plastic and refrigerate overnight. Just before serving, sprinkle with bacon. Do not toss.

Mrs. Robert W. Battle

Corn Pudding

Serves: 12
Oven Setting: 325°

Rich but always appreciated and easy to do.

3 10-oz.) packages frozen corn
3 half pints whipping cream
8 eggs, slightly beaten
¼ cup sugar
1 tablespoon salt
dash red pepper

Blend defrosted corn in blender or food processor until chopped; add other ingredients—stir, don't blend in machine. Put in large casserole and dot with butter. Bake 1 hour and 15 minutes. Test for doneness with knife inserted in center. If knife does not comes out clean, bake a few minutes longer. Casserole may be refrigerated or frozen before baking.

Mrs. Charles Williams

Broccoli-Rice Casserole

Serves: 8-10
Oven Setting: 350°

Good with a boned chicken breast and simple green salad.

1¼ cups long grain rice
6 cups rich chicken stock (homemade preferred)
2 (10-oz.) packages frozen broccoli or fresh, if you
 prefer
½ cup (1 stick) butter
¾ cup finely chopped onion
¾ cup fresh, chopped mushrooms
½ cup flour
1 cup heavy cream or evaporated milk
salt and pepper
2 tablespoons butter
½ cup bread crumbs

Cook rice according to package directions, using 3 cups broth in place of water. Fluff with fork and set aside. Parboil broccoli; drain thoroughly. In 12-inch skillet melt 1/2 cup butter. Sauté onion and mushrooms until soft. Blend in flour and cook 2 to 3 minutes, stirring constantly. Add remaining 3 cups broth and cream, still stirring constantly. Cook until mixture just comes to a boil; add salt and pepper to taste. Preheat oven. Place cooked rice in a buttered 2½-to 3-quart casserole. Spread drained broccoli on top of rice and cover with sauce. In small skillet, melt 2 tablespoons butter. Add bread crumbs and cook, stirring until lightly browned. Sprinkle over casserole. Bake uncovered until sauce bubbles, about 30 minutes.

Mrs. Robert Peterson

Embassy Cauliflower Salad

Serves: 8-10

Served at embassy parties in Near East—Bahrain, Beirut and Kuwaite.

2 large heads cauliflower
1 bunch spring onions, sliced
salt and pepper to taste
½ cup of bleu cheese, crumbled
bibb or boston lettuce

Dressing:
1 cup sour cream
1 cup mayonnaise
1 package cheese garlic salad dressing mix

Slice the cauliflower flowerettes vertically. Add sliced spring onions, salt and pepper and small pieces of bleu cheese. Combine the dressing ingredients and mix with the cauliflower. Place in center of bed of lettuce. The vegetable and the dressing may be prepared in advance and combined just before serving. This recipe expands easily.

Mrs. Joseph Wright Twinam

Macedonian Salad

Makes: 12 cups

Garnish with plain yogurt.

2 medium (1 lb.) eggplants
2 cups diced tomato
2 cups diced unpeeled cucumber
1 cup diced green pepper
1 cup diced red pepper
½ cup sliced green onion
½ cup chopped fresh parley
½ cup safflower oil
¼ cup olive oil
½ cup wine vinegar
¼ cup dry red wine
2 tablespoons lemon juice
2 cloves garlic, minced
½ teaspoon leaf oregano, crumbled
½ teaspoon leaf basil, crumbled
½ teaspoon leaf thyme, crumbled
½ teaspoon salt
¼ teaspoon freshly ground black pepper
salad greens

Peel eggplant, cut into ¾-inch-thick slices, salt lightly. Broil until light brown on both sides (4-5 minutes per side). Cool. Cut into bite-size pieces. Combine eggplant, tomato, cucumber, red and green pepper, green onion and parsley in large bowl. Combine remaining ingredients (except salad greens) in large jar with screw top. Shake thoroughly. Pour over vegetables. Toss gently. Cover and refrigerate for several hours for flavors to blend. Serve on salad greens.

Ms. Cynthia A. Joiner

Spinach Rice Balls

Makes: 12
Oven Setting: 350°

Delicious with roast lamb or pork.

3 cups cooked rice
½ cup butter or margarine, softened
2 (10-oz.) packages frozen, chopped spinach, thawed
1 cup grated Parmesan cheese
6 eggs, beaten
2 teaspoons salt
½ teaspoon pepper
1 onion, finely chopped
⅛ teaspoon nutmeg
½ teaspoon curry (optional)

Mustard Sauce:
½ cup mayonnaise
2 tablespoons prepared mustard

Combine rice and butter in large bowl. Squeeze all liquid from spinach. Add spinach and all remaining ingredients (except mustard sauce) to rice mixture. Mix thoroughly and form into 12 balls (each about ⅓ cup in size). Place on greased baking pan and refrigerate at least one hour. Bake 25-30 minutes and serve with mustard sauce if desired.

Mrs. E. Lewis Hansen

Cheesecake Squares

Makes: About 16
2" squares
Oven Setting: 350°

Judging from the number of times I've given out this recipe, it's a big hit with nearly everyone.

Crust and Topping:
⅓ cup butter (or margarine)
⅓ cup brown sugar, firmly packed
1 cup flour
½ cup finely chopped walnuts or pecans

Filling:
¼ cup sugar
1 8-oz. package and 1 3-oz. package cream cheese
1 egg
2 tablespoons milk
1 teaspoon lemon juice
½ teaspoon vanilla
powdered sugar
1 cup sour cream (optional)
¼ cup sugar

Cream butter with brown sugar in small mixing bowl. Add flour and nuts to make a crumb mixture. Reserve 1 cup crumb mixture for topping. Press remainder into bottom of 9" x 9" pan and bake for 10-12 minutes. For filling, blend sugar with cream cheese until smooth. Add egg, milk, lemon juice and vanilla. Beat well and spread over baked crust. Sprinkle top with reserved crumb mixture. Bake for 25 minutes. When cooked, sprinkle top with powdered sugar, cool and cut into squares. Optional: rather than powdered sugar, beat together sour cream and sugar. Drizzle over top of cheesecake squares after baking and return to oven for 5 minutes. When cool, cut into squares. This recipe is especially easy with a food processor, but it was created long before the processor.

Mrs. John Donnell, Jr.

Deep Dark Secret

Serves: 12-16
Oven Setting: 350°

Cut at the table and end dinner with a flourish! Rich looking, but on the light side.

Cake:
4 large eggs, beaten
1 cup sugar
½ cup sifted flour
1 teaspoon baking powder
¼ teaspoon salt
1 lb. pitted dates, chopped
1 cup nuts, chopped
2 teaspoons vanilla

Fruit Filling:
2-3 bananas, sliced
2 large navel oranges, sectioned and cut into bite-sized pieces
15-or 22-oz. can crushed pineapple
1 small jar maraschino cherries
1 pint heavy cream, whipped

Mix eggs and sugar until well blended. Add sifted flour, baking powder and salt. Mix in dates, nuts and vanilla. Spread mixture (about ½" thick) in lightly greased and floured 12" x 15" cake pan. Bake 30 minutes. This can be done one or two days ahead. Two or three hours before serving, break up one half of the cake into small (2") pieces.

Arrange these pieces in the center of a platter. Over this place bananas, oranges, drained pineapple, some of the cherries and some juice, if desired. Tear up remaining cake. Cover fruit with cake pieces and mold with hands to a dome shape. Cover with whipped cream. Be sure all bananas are covered or they will darken if exposed.

Mrs. George B. Vanstrum

Miniature Cheesecakes

Makes: 3 dozen
Oven Setting: 300°

Dainties for tea.

12 oz. cream cheese
½ cup sugar
2 eggs
¾ teaspoon vanilla

Topping:
1 cup sour cream
¼ cup sugar
½ teaspoon vanilla
¼ teaspoon jam (each cake)

Cream cheese and sugar, add eggs one at a time and vanilla; heat until smooth. Fill small teflon muffin tins ⅔ full with mixture. Bake 20 minutes, cool 10 minutes. Mix topping ingredients. Put about 1 tablespoon on top of each cake; top with jam (your favorite), return to oven and bake 10 more minutes. Do not use paper muffin cups.

Mrs. John M. Hoerner

Coconut Macaroon Cupcakes

Makes: 32 small
Oven Setting: 350°

Great as a sweet hors d'oeuvre . . . looks beautiful on a serving tray!

4 egg whites
pinch of salt
½ cup sugar
1½ cups shredded coconut
 (sweetened)
¼ cup sugar
¼ cup ground blanched almonds
2 tablespoons flour
½ teaspoon grated lemon rind
32 cherry slivers

In a large bowl beat 4 egg whites with a pinch of salt until they hold soft peaks. Beat in gradually ½ cup sugar and continue to beat the meringue until it holds stiff peaks and is smooth and shiny. In another bowl toss together 1½ cups coconut, ¼ cup sugar, almonds, flour and lemon rind. Fold the mixture into the meringue. Spoon the mixture into well greased tea-sized muffin tins, filling them ¾ full. Bake in a preheated oven for 20 minutes or until tops are golden. Top each muffin with a cherry sliver to add color.

Ms. Linda Cosby

Lemon Pecan Squares

Makes: 3 dozen
Oven Setting: 350°

Excellent for cocktail parties or teas.

Dough:
½ cup butter
¼ cup sugar
1 egg
1¼ cup sifted all-purpose flour
⅛ teaspoon salt
½ teaspoon vanilla

Filling:
2 beaten eggs
1½ cups brown sugar
1½ cups chopped pecans
2 tablespoons flour
½ teaspoon baking powder
½ teaspoon salt
1 teaspoon vanilla

Icing:
1½ cups powdered sugar thinned with lemon juice

Cream well ½ cup butter and ¼ cup sugar until blended. Beat in 1 egg. Combine and add to mixture 1¼ cups flour and ⅛ teaspoon salt; blend well and work in ½ teaspoon vanilla. Pat dough evenly into a 9″ x 13″ pan. Bake 15 minutes. Mix filling ingredients and spread on top. Bake additional 15 minutes. When cool, ice with powdered sugar and lemon juice.

Mrs. F.C. Steinmann, Jr.

Grand Marnier Pie

Serves: 6-8
(can be doubled or
quadrupled)

*Can be made weeks in advance—
perfect for unexpected guests.*

2 tablespoons freeze-dried coffee
2 tablespoons Grand Marnier liqueur
1 quart "good" (Breyer's or Greenwood)
 vanilla ice cream, softened
1 teaspoon freeze-dried coffee
9" or 10" graham cracker pie shell
½ quart heavy cream, whipped
semi-sweet chocolate, shaved

Dissolve 2 tablespoons coffee in Grand Marnier. Add to softened ice cream. Add the additional teaspoon coffee to above. Spread in pie shell and place in freezer. Make border of whipped cream and sprinkle shaved semi-sweet chocolate over top.

Mrs. Paul L. Dorn

Chocolate Fantasy

Serves: 10-12

Easy, pretty and good!

12 oz. semisweet chocolate bits
6 tablespoons water
6 eggs, separated
4 tablespoons sugar
2 teaspoons vanilla
2 dozen ladyfingers

Melt chocolate with water in top of double boiler. Add egg yolks that have been beaten with sugar. When mixture thickens (it thickens very rapidly) remove from heat. Fold in stiffly beaten egg whites and add vanilla. Line a glass bowl with ladyfingers, cover with chocolate mixture, repeat layers. Refrigerate for at least 3 hours. Serve at table with sweetened or unsweetened whipped cream

Mrs. Crawford F. Barnett, Jr.

Charlotte Russe

Serves: 12

Light and elegant.

1½ envelopes gelatin
2 cups cold milk
3 egg yolks
1½ cups sugar
2 tablespoons dry sherry
1 quart whipping cream
4 egg whites
½ lb. ladyfingers

Soak gelatin in ½ cup cold milk. Put remainder of milk in double boiler to scald. Pour hot milk over egg yolks that have been well beaten with sugar. Add gelatin and milk mixture. Return to stove and cook for about 15 minutes. Cool completely and add sherry. Whip cream stiff. Beat egg whites. When custard begins to set and drops thick from spoon, fold in egg whites and cream. Pour into a soufflé dish lined with ladyfinger halves. Save a few lady fingers for decoration on the top. Refrigerate for at least several hours—preferably overnight. Looks pretty served in a glass soufflé dish.

Ms. Sussi Craig

Coffee Tortoni

Serves: 10 *Dainty and good.*

1 stiffly beaten egg white
1 tablespoon instant coffee
6 tablespoons sugar
½ pint heavy cream
2 tablespoons sherry, rum or anisette
4 tablespoons finely chopped toasted almonds

Combine stiffly beaten egg white and coffee in a bowl. Continue to beat, adding the sugar a little at a time. Whip cream and fold into egg white mixture. Add the 2 tablespoons of flavoring and pour into individual paper or foil baking cups. Place on a tray and sprinkle each with almonds. Chill the tortoni at least 4 hours or overnight, or you may freeze them.

Mrs. Richard L. Evans

Orange-Banana Sherbet

Serves: 10-12 *Great after any Italian or pork dish.*

1½ lemons, juice
1 orange, both pulp and juice
1 sliced banana
1 cup sugar
1 cup water
2 eggs
1 teaspoon sugar
maraschino cherries, optional garnish

Combine the following ingredients: juice of 1½ lemons; 1 orange, both the cut-up pulp and juice; 1 sliced banana; 1 cup sugar; and 1 cup water. Separate the egg yolks from two eggs, beat thoroughly and add to the above mixture. Place mixture in freezer trays until mushy. Then beat the two egg whites with beater and add 1 teaspoon sugar. Fold the above into tray while the mixture is still mushy. Freeze.

Serve sherbet in your favorite glass dessert dishes, but be sure to take the sherbet out of the freezer a few minutes before actual serving so that removal from the tray will be easier.

Ms. Marilyn S. Kaston

Cheesecake Eagle's Nest

Serves: 12 *Cheesecake with apricot sauce.*
Oven Setting: 350°

butter, softened
½ cup graham cracker crumbs
2 lbs. cream cheese, softened
4 eggs
1¾ cup sugar
1 large lemon, juice and grated rind
1 teaspoon vanilla extract

Apricot sauce:
10-oz. jar apricot jam
¼ cup sugar
¼ cup water
1 tablespoon rum or cognac

Butter a large soufflé dish (8" x 3"). Sprinkle with crumbs and shake out excess. Beat together at low speed the cream cheese, eggs, sugar, lemon juice and rind, and vanilla. Increase speed to high and beat until mixture is smooth and creamy. Pour into prepared dish and level by shaking. Set inside large pan in 1" of water (sides of soufflé dish should not touch sides of pan). Bake for 1½-2 hours. Turn off oven and let cheesecake remain inside for 20 minutes. Then place on rack until it reaches room temperature. Unmold and garnish with apricot sauce, made by combining and cooking sauce ingredients over low heat for 5 minutes.

Mrs. Donald M. Stewart

Daiquiri Soufflé

Serves: 20-24 (small servings) *Also good frozen.*

½ cup light rum
2 envelopes unflavored gelatin
10 eggs, separated
2 cups sugar, divided
½ cup fresh lime juice
½ cup fresh lemon juice
grated rind of 2 limes
grated rind of 2 lemons
dash salt
3 cups whipping cream, divided
2-oz. package pistachio nuts, shelled and finely
 chopped
crystallized violets (optional)
slice of lime

Cut a piece of waxed paper or aluminum foil long enough to fit around a 1½ quart soufflé dish, allowing a 1″ overlap. Fold paper in half; wrap around dish, allowing paper to extend 5″ above rim of dish to form collar. Secure with tape. Lightly grease or oil soufflé dish and collar; set aside.

Combine rum and gelatin; let stand 5 minutes. Beat egg yolks until light and fluffy; gradually add 1 cup sugar, beating constantly until thick and lemon-colored.

Combine yolk mixture, fruit juices, grated rind, and salt in a 2½ quart saucepan; stir well. Cook over low heat, stirring constantly until thickened (about 12 minutes). Remove from heat; add gelatin mixture, stirring until dissolved. Allow to cool.

Beat egg white (at room temperature) until soft peaks form, gradually add ½ cup sugar and continue to beat until stiff peaks form. Combine remaining ½ cup sugar and 2 cups whipping cream in a large chilled mixing bowl; beat until stiff peaks form.

Pour cooled yolk mixture into a very large bowl (about 6 quarts), fold in beaten egg whites, then whipped cream. Pour into soufflé dish. Chill until firm.

Remove collar, gently pat crushed pistachio nuts onto exposed sides of soufflé. Whip remaining 1 cup cream until stiff peaks form, spoon in mounds on top of soufflé or use a pastry bag to decorate top. Garnish with crystallized violets and a twisted slice of lime, if desired.

Mrs. John T. Holt

Ambrosia Pie

Makes: 3-4 pies *Can be served with a bowl of whipped cream on the side.*

1 cup whipping cream
14-oz. can sweetened condensed milk
1¼ cups chopped nuts
1½ cups fresh lemon juice
8-oz. can crushed pineapple
11-oz. can Mandarin oranges, drained
3 or 4 (8″ or 9″) crumb pie shells

Whip cream; combine all other ingredients and fold into cream. Pour into crumb pie shells and chill overnight.

Mrs. Daniel O'Neil

GALLERY II
Dinner at Eight

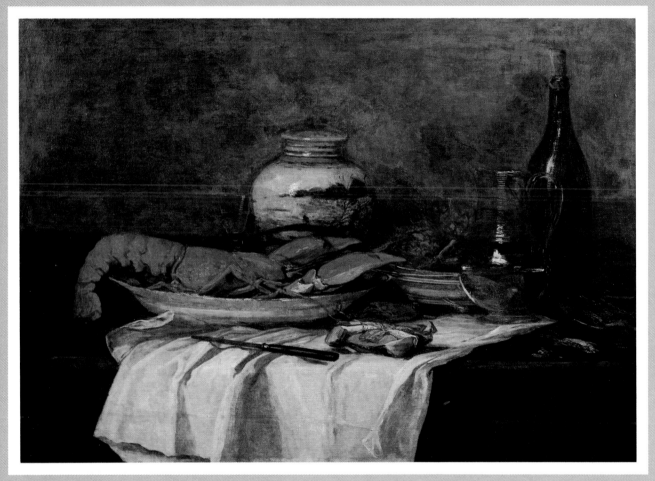

EUGENE BOUDIN (French, 1825-1898)
Still Life with Lobster on a White Tablecloth, c. 1862, oil on canvas, 22½ x 32¼ inches. Gift in memory of Lena B. Jacobs, 1970. *Color reproduction in The High Museum of Art Recipe Collection sponsored by The Midnight Sun Restaurant.*

Gallery II

Asparagus Tart

Serves: 6-8
Oven Setting: 400°

A special treat as an appetizer.

Pastry:
1¼ cups flour
6 tablespoons butter
2 tablespoons shortening
¼ teaspoon salt
3 tablespoons ice water

Filling:
2 lbs. fresh asparagus, peeled and trimmed to 3-inch pieces
¾ cup heavy cream
½ cup milk
½ stick butter
¼ cup flour
1 cup grated Gruyere cheese
salt, white pepper, nutmeg to taste

Blend first 4 ingredients. Add water, toss and chill for 1 hour. Roll pastry ⅛ inch thick and arrange in a 9-inch false-bottom pan. Chill again for 1 hour. Prick shell and place wax paper, weighted down with uncooked rice, in shell. Bake 10-15 minutes. Remove paper and rice and bake another 10 minutes.

Steam asparagus 6-8 minutes in salted water. Drain on paper towels. Scald cream and milk together. In saucepan melt butter, stir in flour and cook for 3 minutes. Remove from heat and stir in cream mixture, stirring vigorously until smooth. Stir in ½ cup Gruyere cheese, salt, pepper and nutmeg.

Assemble tart: place asparagus, tips out spoke-style, in pastry. Pour sauce over and top with remaining ½ cup cheese. Bake 12-15 minutes. Cool 5 minutes before slicing to serve.

Mrs. Michael D. Gaddis

Mushrooms Blake

Serves: 6
Oven Setting: 400°

Delicious as a luncheon entrée or just for special evenings at home.

12 large fresh mushrooms
8 tablespoons butter
2 small garlic cloves
4 scallions
⅔ cup small cooked shrimp (optional)
juice of 1 lemon
5 tablespoons flour
2 cups chicken broth
½ cup heavy cream
⅓ cup sherry
½ cup chopped fresh parsley
½ teaspoon sugar
pinch each—salt and pepper
½ cup Parmesan cheese

Sauté clean mushroom caps, with stems removed, in 4 tablespoons butter; include garlic. Sauté 8-10 minutes, until tender. Remove caps and discard garlic. Add remaining butter to pan and sauté chopped mushroom stems and chopped scallions until tender. Shrimp may be added now if desired. Add lemon juice and then flour, stirring to brown lightly. Gradually add broth, cream and sherry. Remove from heat and stir in parsley, sugar, pepper and salt if necessary. Divide mushroom caps evenly among individual baking dishes. Pour mixture over this and sprinkle with Parmesan. Bake 20 minutes.

Mrs. Robert D. Campbell

Salmon Mousse with Dill Sauce

Serves: 10 *Pretty!*

2 tablespoons gelatin
½ cup cold water
1 cup boiling water
2 tablespoons lemon juice
2 tablespoons vinegar
1 cup mayonnaise
1 cup heavy cream, whipped
2 tablespoons Worcestershire sauce
1 medium onion, grated
1-lb. can red salmon, flaked
1 cup celery, chopped finely
salt to taste

Soak gelatin in cold water to soften; then dissolve in hot water. Add lemon juice, vinegar, then cool. Add mayonnaise and whipped cream. Add other ingredients, blend and pour into an oiled mold. Chill for several hours or overnight before unmolding.

Dill Sauce:
⅔ cup mayonnaise
⅔ cup sour cream
2 tablespoons grated onion
3-4 tablespoons dill weed
1½ tablespoons parsley flakes

Combine, chill and serve with salmon mousse.

Mrs. Robert M. Day

Coquilles St. Jacques

Serves: 12 *An old favorite.*
Oven Setting: 325°

3 lbs. scallops
1 cup dry sherry
1 cup white wine
2 stems parsley, chopped
1 bay leaf
1 tablespoon chopped scallions
½ cup butter
½ lb. mushrooms, chopped
3 tablespoons flour
2 tablespoons lemon juice
salt to taste
⅛ teaspoon pepper
1 cup buttered bread crumbs
¼ cup grated Swiss or Jarlsberg cheese

Simmer scallops in sherry and wine with parsley, bay leaf and scallions for 5-10 minutes (depending on size of scallops). Strain and reserve wine broth. Sauté mushrooms in butter; add flour and cook, stirring. Add lemon juice, wine broth, salt and pepper. Stir and cook slowly until smooth and thick. Add scallops. Divide mixture into individual baking dishes or shells. Top with bread crumbs and cheese mixture. Bake for 30 minutes. Freezes well before baking.

Mrs. Thomas G. Cousins

Mushroom Pâté

Serves: 8 *Can be made ahead and*
Oven Setting: 325° *reheated before serving.*

4 slices bacon, cooked and crumbled
½ onion, chopped
8-oz. package cream cheese
8 oz. fresh mushrooms, chopped
½ cup sour cream
white pepper, optional

Sauté onion in bacon drippings. Add cream cheese until melted, add mushrooms. Heat through. Add sour cream and bacon. Bake ½ hour and serve hot with melba toast or crackers.

Ms. Pamela Long

Scampi

Serves: 6
Oven Setting: 450°

From a Boston friend. Great for a small dinner party.

1 cup butter
¼ cup olive oil
1 tablespoon chopped dried parsley
¾ teaspoon dried basil
½ teaspoon dried oregano
1 garlic clove—minced
salt to taste
1 tablespoon lemon juice
1 lb. large fresh shrimp

Preheat oven. Melt butter. Add olive oil, parsley, basil, oregano, garlic, salt and lemon juice. Mix well.

Peel and devein shrimp, leave tail intact. (Butterfly if you wish.) Place in shallow baking dish, tail end up. Pour sauce over all. Bake 5 minutes. Place under broiler for 5 minutes longer to brown. Serve with rice.

Mrs. John C. Rieser

Artichoke Soup

Serves: 8

A treat for the artichoke lover.

4 tablespoons butter
2 tablespoons onion, chopped
2 tablespoons flour
½ cup milk
2 8½-oz. cans artichoke hearts and juice
2¼ cups chicken broth
1 tablespoon fresh lemon juice
½ teaspoon nutmeg
¼ teaspoon each—salt and pepper
¾ cup heavy cream
3 egg yolks

Sauté onion in butter, add flour and stir until smooth. Add milk gradually and stir to make a smooth cream sauce. Add juice from artichokes and chicken broth. Bring to a boil. Add chopped artichoke hearts, lemon juice and seasonings. Mix egg yolks with cream and add a bit of the hot mixture to them. Gradually beat the rest of the soup in. Heat without boiling and serve.

Mrs. W. Donald Knight, Jr.

Cold Tomato and Basil Soup

Serves: 6

Serve in chilled bowls garnished with small basil leaves.

4½ cups sliced tomatoes
2 cups chopped onions
¼ cup olive oil
1 tablespoon tomato paste
1½ teaspoons salt
1 teaspoon minced garlic
1 teaspoon sugar
3 cups chicken broth
2 tablespoons flour (preferably potato flour)
2 cups water
⅓ cup lightly-packed fresh basil leaves
salt and white pepper to taste
¼ cup olive oil

In a heavy saucepan simmer the first seven ingredients over low heat for 20 minutes, stirring frequently. In a bowl combine ½ cup chicken broth with the 2 tablespoons flour and stir in the remaining chicken broth, water and basil leaves. Add the liquid to the tomato mixture. Simmer and stir for 2 minutes. Put mixture through fine disc of a food mill over a bowl, add salt and pepper and chill for several hours. Stir in olive oil in a stream.

Cream of Carrot Soup

Serves: 4-6 *Guests always love this.*

8 medium carrots, peeled
1 small onion
1 bay leaf
3 cups chicken broth
3 tablespoons unsalted butter
2 tablespoons flour
1 cup light cream
½ teaspoon salt
pepper to taste

Garnish:
grated lemon rind
finely chopped fresh parsley

In a ½-quart saucepan combine carrots, onion, bay leaf and stock. Simmer (covered) for 30 minutes. Purée in blender. Melt butter in saucepan, add flour and cook over low heat 3 minutes, stirring constantly. Add and stir in purée. Bring to boil and cook 3 minutes. Add cream. Do not boil. Taste for seasoning. Add garnish to individual servings. Serve hot or cold.

Mrs. Martha R. Taylor

Vichysquash

Serves: 6 *Lovely pale yellow, cool and delicious for a spring or summer dinner.*

2 medium onions, peeled and sliced
3 tablespoons butter
12 medium yellow squash, sliced
1 cup chicken broth
salt, freshly-ground pepper to taste
2 cups light cream or half and half
chopped fresh chives
paprika (optional)

Sauté onion in butter in a large pan. When it is wilted, but not brown, add the squash and the broth. Cover and cook briskly until the squash is very tender, about 15 minutes. Cool. Purée this mixture in food processor or blender. Season with salt and pepper. When it is cold, add the cream. Serve in chilled cups sprinkled with chopped chives and paprika.

Mrs. Linton H. Bishop

Chilled Spinach and Cucumber Soup

Serves: 8 *Serve in chilled bowls garnished with radishes, cucumbers and scallions.*

2 tablespoons butter
1 bunch scallions
4 cups diced, peeled cucumbers
3 cups chicken broth
1 cup chopped spinach
½ cup sliced, peeled potatoes
pinch salt
lemon juice—to taste
pepper—to taste
1 cup light cream
thin slices of cucumber, radishes and scallions

In saucepan sauté sliced scallions in butter until softened. Add cucumbers, chicken broth, chopped spinach, potatoes, salt, lemon juice and pepper; simmer until potatoes are tender. Transfer the mixture in batches to a blender or food processor with steel blade and purée. Transfer the purée to a bowl and add 1 cup light cream. Chill for several hours.

Vegetable Soup Nivernais

Serves: 4 *Good hot or cold.*

¼ lb. butter
1 cup each, sliced: carrots (peeled), turnips, leeks,
 celery, potatoes (peeled)
salt to taste (about 1 tablespoon)
4 cups water

Garnish:
2 tablespoons butter
1 small turnip, diced
1 carrot, peeled and diced
1 stalk celery, diced
1 cup heavy cream

Melt ¼ lb. butter in deep heavy pot. Add sliced
vegetables and salt. Cover tightly and stew over low
heat for 20 minutes. Remove vegetables, chop (this
can be accomplished easily with chopping blade in
food processor) and return to pot. Add water and
bring to a boil. Simmer for 20 minutes.

Garnish: Melt the 2 tablespoons butter in another
saucepan. Add the diced vegetables and brown
lightly. Add to the soup. Add cream, adjust the
seasonings to taste.

Mrs. Allen P. McDaniel

Fillets de Poisson Florentine

Serves: 8
Oven Setting: 375° *Everything can be cooked ahead but save the assembly until the last minute.*

Creamed Spinach:
3 (10-oz.) packages frozen spinach
4 tablespoons butter
6 tablespoons heavy cream
salt, pepper, nutmeg

Fish Fillets:
4 tablespoons butter
3 lbs. fillets (sole, snapper or flounder)
salt and pepper (¼ teaspoon each)
2 cups dry vermouth or dry white wine

Sauce Mornay:
2½ tablespoons butter
3 tablespoons flour
1 cup fish stock (from poaching liquid)
1½ cups heavy cream
pepper to taste
¼ teaspoon nutmeg
⅔ cup grated Swiss or Jarlsberg cheese

Defrost spinach enough to chop into small pieces.
Melt butter in frying pan, add spinach and cook
slowly 2 minutes to cook and dry out. Add cream and
seasonings, cook 1 minute more. Set aside.

Butter shallow baking dish. Salt and pepper fish
and arrange in 1 layer in dish. Pour wine over and dot
with butter. Poach in oven for 8-10 minutes. Strain
liquid, pour into saucepan and boil to reduce to 1 cup
for fish stock in sauce.

Mornay sauce: Melt butter, add flour and cook 2
minutes. Remove from heat and add stock, then
cream and seasonings. When thickened over heat, add
cheese and blend.

Reheat spinach and put on bottom of ovenproof
serving dish. Arrange fillets over spinach and top with
sauce. Sprinkle with additional cheese, if desired.
Broil 2-3 minutes, until golden brown.

Mrs. R.M. Smith, Jr.

Seafood Ragoût

Serves: 6-8

A very easy and quick company dish.

¼ lb. butter
2-3 tablespoons flour
¾ cup cream
1 tablespoon lemon juice
1 tablespoon Worcestershire sauce
1 tablespoon onion juice
dash cayenne pepper
4 tablespoons white wine or sherry
chopped parsley (about 2 tablespoons)
2 lbs. shrimp, cleaned and cooked
1 pint oysters, parboiled
¾ lb. boneless chicken, cooked and cut in bite-sized
 pieces
¾ lb. mushrooms, sautéed in butter

In medium saucepan, melt butter and stir in flour. Add cream, stirring constantly, until sauce thickens. Add lemon juice, Worcestershire sauce, onion juice and cayenne. Add wine and chopped parsley (about 2 tablespoons). Stir until smooth. Fold in shrimp, oysters, chicken and mushrooms. Serve hot over rice.

Mrs. Joel S. Engel

Roast Leg of Lamb with Artichokes

Serves: 8
Oven Setting: 325°

Perfect for a spring dinner.

6-7 lb. leg of lamb
1 onion, cut in slivers
Worcestershire sauce
2 teaspoons salt
1 teaspoon pepper
2 teaspoons crushed dried oregano
½ teaspoon rosemary
flour
1 or 2 (9-oz.) packages frozen artichoke hearts
1 cup tomato sauce
½ cup finely chopped onion
1 cup dry white wine
dash Tabasco sauce
1 teaspoon sugar (optional)
1 lemon, thinly sliced

Bring lamb to room temperature. Wipe lamb clean with cold water and make small slashes on top. Put small slivers of onion in slashes and any crevice you can find, along with a drop of Worcestershire sauce. Rub salt, pepper, oregano and rosemary into the lamb. Sprinkle very lightly with flour. Roast lamb on a rack in a roasting pan in a preheated oven for 1½ hours.

Thaw frozen artichokes, set aside. Combine tomato sauce, chopped onion, wine, Tabasco sauce and sugar in saucepan and simmer for 10 minutes over low heat. Remove the lamb from the oven. Drain excess fat from the juices in pan. Place the meat in the roasting pan without the rack. Lay the lemon slices on top of the lamb and surround with the artichoke hearts. Pour the tomato sauce mixture over the lamb and cook for an additional 1 hour, basting several times with pan juices. Meat thermometer should register 165° for a slightly pink, juicy lamb.

Place the lamb on a warm platter and allow to sit for 15 minutes before serving. Skim excess fat from pan juice. Surround the lamb with the artichoke hearts and a few lemon slices. Pour the warm sauce over the meat before serving.

Mrs. Crawford F. Barnett, Jr.

Georgia Mountain Trout
in Wine

Serves: 4-6 *Delicious departure.*
Oven Setting: 400°

6 good sized trout
salt
pepper
juice of 2 fresh lemons
3 large or 4 small fresh tomatoes
2 medium onions
½ cup freshly chopped parsley
¼-½ cup dry white wine (don't drown them, use
 your own discretion)
¼ cup chicken bouillon

Oil a shallow baking dish. Place in a baking dish
trout seasoned with salt, pepper and rubbed (inside
cleaned cavity) with lemon juice. Cover trout with
peeled, sliced tomatoes. Slice onions very thin and
place on top of tomatoes. Sprinkle with freshly
chopped parsley. Pour wine and chicken bouillon over
all. Bake uncovered 30 minutes. Garnish with lime
wedges and parsley. Serve with or on brown rice.

 Mrs. Robert C. Garner

Rare Roast Beef
with Horseradish Sauce

Serves: 3-rib roast will yield *Excellent.*
8 generous servings
Oven Setting: 350°

Preheat oven. Wipe roast with damp cloth. Salt
and pepper. Put in pan with no water. Cook a 2-rib
roast 1½ hours. Cook a 3-rib roast 2 hours. Cook a
4-rib roast 2½ hours without reducing or changing
heat of oven. Water is never added, juice will be held
in meat, so there will be no pan gravy. There should
be a lot of juice when meat is cut. Check oven
temperature. If temperature is correct, then meat will
always be rare.

Horseradish sauce: Whip a pint of heavy cream and
add 2 tablespoons (or more, to taste) of horseradish.
Serve with roast beef.

 Mrs. Doyle Harvey
 Ms. Tippen Harvey

Rack of Lamb

Serves: 3-4 *Serve hot with pan gravy*
Oven Setting: 400° *and mint sauce.*

3 lbs. or ½ rack of lamb
1 tablespoon Dijon mustard
2 oz. melted butter
1 cup fine white bread crumbs
1 clove finely chopped garlic
1 tablespoon finely chopped fresh parsley

Trim lamb, removing chine bones, skin and surplus
fat, exposing first ½ inch of rib bones. Cover bared
ends with foil to prevent burning. Season with salt
and pepper and place in 400° oven for 10 minutes.
Remove from oven and spread mustard over the fat
surface. Mix melted butter, bread crumbs, garlic and
parsley. Spread over mustard, cover meat and return
to oven. Roast until golden brown.

 Ms. Gloria Drinkard

Crab-Stuffed Flounder

Serves: 6-8
Oven Setting: 425°

Tantalizing blend of flavors.

¾ cup celery, minced
½ cup onion, minced
½ cup fresh parsley, minced
¼ cup shallots, minced
¼ cup green pepper, minced
1 clove garlic, minced
½ cup butter, melted
1 tablespoon flour
½ cup milk
½ cup dry white wine
8 oz. fresh lump crabmeat
1¼ cups seasoned dry bread crumbs
¼ teaspoon each—salt and pepper
6-10 flounder fillets

Mornay Sauce:
4 tablespoons butter
4 tablespoons flour
2 cups milk or fish stock
cayenne
3 tablespoons each of grated Parmesan and Swiss
 cheese

Sauté vegetables in butter and garlic until tender. Add flour and cook one minute, stirring constantly. Add milk and wine and stir till thickened. Remove from heat and add crabmeat, bread crumbs and salt and pepper. Place half of fillets in large shallow baking pan, spoon about 1 cup of crab meat stuffing on each fillet. Cut remaining fillets in half lengthwise, place a fillet half on either side of stuffed fillets, pressing gently into stuffing mixture. Top each with mornay sauce (see above) and sprinkle with paprika. Bake for 15-20 minutes.

Mornay sauce: melt butter, add flour and cook one minute, stirring constantly. Add fish stock or milk slowly, cooking and stirring until thickened. Add cayenne and cheeses. Stir to blend.

Mrs. Robert D. Jackson

Dungeness Crab au Gratin

Serves: 4
Oven Setting: 350°

Easy and elegant.

4 tablespoons butter or oleo
⅓ cup flour
½ teaspoon grated lemon peel
salt to taste
¼ teaspoon dry mustard
dash white or black pepper
1 slightly beaten egg
2 cups light cream
16 oz. or 2½ cups crabmeat
3 teaspoons sliced green onion
2 tablespoons butter/oleo, melted
1 cup bread crumbs
½ cup (2 oz.) shredded Swiss cheese

In saucepan melt 4 tablespoons butter, blend in flour, lemon peel, salt, dry mustard and pepper. Combine egg and light cream, add to first mixture. Cook and stir over medium heat until thickened. Don't boil. Stir in crab and onion. Pour into 4 individual (1 cup) casseroles or shells. Bake 15 minutes. Combine 2 tablespoons butter/oleo, bread crumbs and Swiss cheese. Sprinkle around edge of casserole. Bake 5 minutes more until cheese melts.

Ms. Lynne Ulbrand

Beef Sauté

Serves: 6

This can be prepared 'a bit' ahead of time.

½ lb. sliced fresh mushrooms
2 tablespoons butter
1 tablespoon cooking oil
3 tablespoons green onions, chopped
salt to taste
pinch of ground pepper
2 tablespoons butter
1 tablespoon cooking oil
2½ lbs. tenderloin tips, cubed
¼ cup dry vermouth
¾ cup bouillon
1 cup whipping cream
2 teaspoons cornstarch
2 tablespoons softened butter

Sauté mushrooms in hot butter and oil until lightly browned (about 4-5 minutes). Stir in green onions and cook 1 minute more. Season mushrooms with salt and pepper and remove from pan. Add butter and oil to skillet and sauté the tenderloin tips a few pieces at a time, browning outside but keeping inside red and juicy. Remove meat from skillet and discard fat. Pour wine and bouillon into skillet and cook down rapidly to ⅓ cup scraping to dislodge brown bits. Beat in whipping cream and cornstarch which have been well blended. Simmer 1 minute. Add mushrooms and simmer 1 minute more. Sauce should be slightly thickened. Season beef slightly with salt and pepper and return to skillet. When ready to serve, cover and heat to below simmer for 3-4 minutes. Just before serving, add the softened butter and baste meat with sauce until butter is absorbed.

Thin Veal Forestier

Serves: 4

Always special.

1½ lbs. veal cutlets (very thin slices)
clove of garlic or ½ teaspoon garlic salt
flour
¼ cup butter
½ pound mushrooms
salt and pepper
⅓ cup white wine
1 teaspoon fresh lemon juice
snipped fresh parsley

Pound veal with wooden mallet. Rub over with garlic clove or sprinkle with salt. Dip slices in flour, coating well. Heat butter until hot in skillet, add veal and sauté until golden brown on both sides. Heap thinly sliced mushrooms on veal; sprinkle with salt, pepper; add wine. Cover skillet and cook over low heat about 20 minutes. Add water to keep veal moist. Just before serving, sprinkle with lemon juice and parsley.

Mrs. Danny Yates

Garrou De Veau

Serves: 4-6
Oven Setting: 325°

Wonderful! Don't let the garlic deter you from trying it.

2 tablespoons oil
2 tablespoons butter
veal shanks sawed into 2-inch pieces (2-3 per person)
3 large onions, sliced
1 large carrot, sliced
4 heads garlic, separated
½ cup dry white wine
2-3 cups veal stock
salt and pepper
bouquet garni

Heat oil and butter in large cocotte. Brown shanks quickly over high heat and remove to a plate. Sauté vegetables in butter and oil until limp, then remove all fat from pan. Return shanks to the pot and add white wine. Reduce the wine a little before adding the veal stock, salt and pepper, and bouquet garni. Slowly bring to a boil. Make a foil lid for the veal, then cover and bake in a preheated oven for 1½ hours, or until very tender.

If there is more than 1½ cups sauce left, reduce it to that amount. Leave the onions and carrots in the sauce or purée them if desired. Gather all the garlic cloves in a small dish and serve them separately with toasted bread if desired.

Mrs. Nathan V. Hendricks, III

Baked Cornish Game Hens

Serves: 8
Oven Setting: 425°
then 350°

Delicious with rice and hot baked fruit casserole.

8 Cornish hens
¼ teaspoon each—salt and pepper
lemon juice
melted butter or margarine

Marinade:
¾ cup butter or margarine
¼ cup Kitchen Bouquet
1 8 oz. jar of orange marmalade

Rub salt, pepper and lemon juice on all sides of hens. Put on broiling rack in preheated 425° oven. Brush hens with butter. Baste with butter every 15 minutes. (They should be nicely browned in 40 minutes.) While hens are browning, prepare marinade, mixing well and heating until butter is melted. Spoon over hens, cover well with heavy aluminum foil, place in lower (350°) oven and bake for 1½ hours or until tender, basting often. If sauce cooks down, add a little water to pan in order to have some sauce left to accompany the hens.

Serve with long grain white and wild rice cooked according to directions on box. Place rice on an oven-proof dish, add chopped parsley, dash of cinnamon and some browned slivered almonds and a bouillon cube dissolved in 1 cup of hot water. Cover and bake in 400° oven for 1 hour or until very hot through.

Mrs. Thomas D. Hughes

Coq au Vin

Serves: 4-6 *Traditional.*

3 tablespoons butter
¼ lb. sausage
6 small onions, peeled
2 carrots, peeled and sliced
1 clove garlic, peeled and minced
8 pieces chicken, disjointed
2 tablespoons brandy, optional
2 tablespoons flour
2 tablespoons parsley, chopped
1 teaspoon chervil
1 bay leaf
½ teaspoon thyme
salt and pepper to taste
1½ cups dry red wine

Melt butter in large, heavy skillet. Add sausage, onions, carrots, garlic and brown. Push vegetables aside. Brown chicken pieces in butter. If you wish to use brandy, pour it over the chicken and ignite. When the flame dies, proceed with recipe. Stir in flour and seasonings. When well-mixed and smooth, add red wine. Cover and simmer over low heat for 1 hour. Skim off fat. Decorate with fresh parsley and serve.

Mr. Comer Jennings

Sweet and Sour Cornish Hens

Serves: 4 (large servings) *A really smashing party dish—*
Oven Setting: 425° *can be doubled easily.*
then 350° *I can enjoy my guests as it cooks.*

4 Rock Cornish Game Hens

Marinade:
¼ cup soy sauce
2 tablespoons honey
2 tablespoons cider vinegar
½ teaspoon ginger, powdered or grated fresh ginger
 root if possible
½ teaspoon minced garlic

Stuffing:
3 tablespoons oil
1 small onion, very finely chopped
¼ cup very fine egg noodles
1 cup long-grain rice
4 tablespoons butter
2 cups boiling chicken broth
salt and pepper

Hens: Defrost. Clean and marinate in marinade ingredients 4 hours or overnight.

Stuffing: Heat oil in medium saucepan. Add onion, noodles and brown lightly. Add rice, butter, broth and salt and pepper. Stir until butter is melted. Cover and cook until all liquid is absorbed. Cool. May be refrigerated overnight. When stuffing is cooled, stuff hens. Preheat oven to 425° and bake stuffed hens for 20 minutes, reserving marinade. Reduce heat to 350° Pour remaining marinade over the hens and roast another 30 minutes, basting when necessary.

Mrs. Linda Dangel

Pork Tenderloin Sauté

Serves: 6

Doubles well and makes a fine buffet table meal.

6 heart-shaped croutons cut from 3 slices of bread
 (Use a dense Pepperidge Farm type. Cut bread
 diagonally, place together, trim to heart shape.)
2 tablespoons butter
⅔ cup onion, chopped
½ lb. fresh button mushrooms
1½ lbs. pork tenderloin sliced in 1″ slices
½ cup butter + 2 tablespoons olive oil
¼ cup Madeira wine
1 cup whipping cream (heavy)
salt to taste
¼ teaspoon freshly ground pepper
mace to taste
½ cup fresh, finely chopped parsley

Fry croutons in 2 tablespoons butter until golden brown. Put aside. Sauté onions in small amount of butter, covered for 5 minutes. Add washed mushrooms, toss and cook 2 minutes longer. Put aside. Pound pork slices lightly with flat side of French chef's knife or cleaver, sauté in remaining butter and olive oil long enough to obtain a nice color on each side. Deglaze pan with Madeira wine, add sautéed onions, mushrooms and pork, mixing well. Add cream; bring almost to boiling point, correct seasonings. Pour into an entrée dish. Dip points of fried croutons in sauce, then in chopped parsley and arrange around dish. Excellent with rice to which finely chopped dried fruit has been added while cooking.

Mrs. John W.H. Miller

Veal Stew with Olives

Serves: 6
Oven Setting: 300°

My family thinks this dish is a real treat.

2 lbs. cubed stewing veal
flour for veal
salt and pepper
¼ cup salad oil
1 small onion, sliced thinly
1 minced clove garlic
¾ teaspoon rosemary
½ cup Chablis
1 tablespoon tomato paste
about 1 cup chicken stock
18 pitted ripe olives, sliced
chopped parsley

Preheat oven. Dredge veal with flour and salt and pepper. Heat oil in dutch oven, add veal and brown. Add onion and garlic and cook 3 minutes, stirring. Add rosemary, wine, tomato paste and stock to cover. Cover. Bake 2 hours. Add olives and cook 30 minutes longer. Just at serving time, top with parsley.

Mrs. Charles Dannals

Chicken Breasts Wellington

Serves: 6
Oven Setting: 375°

A fancy party dish.

10-oz. package frozen patty shells, thawed
6-oz. box long grain and wild rice mix
peel from 1 orange, grated
6 chicken breast halves, boned
seasoned salt, pepper to taste
1 egg white

Sauce:
12-oz. jar red currant jelly
½ teaspoon Dijon mustard
1 tablespoon orange juice
2 tablespoons white wine

Thaw patty shells in refrigerator. Cook rice according to package directions. Add orange peel. Cool. Pound chicken breasts to flatten slightly. Sprinkle with salt and pepper. Beat egg white until soft peaks form. Fold into rice mixture. On floured surface roll out patty shells into circles about 8" in diameter. Put a chicken breast in the center of one of the circles and put about ¼ to ⅓ cup of the rice mixture on top. Roll chicken breast up jelly-roll style, bringing edges up, and place seam side down. Repeat with remaining chicken breasts. Refrigerate overnight. Preheat oven. Do not remove chicken breasts until ready to bake. Bake uncovered for 35-45 minutes. If dough starts to get too brown, cover loosely with foil.

Sauce: Heat jelly in a small saucepan, gradually stir in mustard, orange juice and wine. Serve warm with chicken.

Ms. Pat Scott

Chicken Breasts in Cream

Serves: 4-8 (depending on size of chicken breasts)
Oven Setting: 350°

A watercress and mandarin orange salad is an excellent accompaniment.

4 whole chicken breasts (8 pieces), skinned and boned
1 egg, beaten
bread crumbs
½ cup butter
¼ cup olive oil
2 cups heavy (whipping) cream
½ teaspoon salt
5 plump cloves of garlic, crushed
½ lb. mushrooms, sliced, if desired
½ teaspoon paprika

Season chicken breasts well with salt and pepper. Dip in beaten egg and roll in bread crumbs. Sauté until golden brown. Place in large baking dish. Over chicken breasts pour 2 cups heavy (whipping) cream mixed with salt and garlic. Cover with foil. At this point you can refrigerate until ready to put in oven. Bake 45 minutes to 1 hour. Add ½ pound sliced mushrooms 15 minutes before removing from oven if desired. Dust with paprika before serving.

Mrs. John W.H. Miller

Wild Duck

Serves: 4 *Nice for mid-winter dinner.*
Oven Setting: 450° then
300°

2 wild duck, medium sized, halved
1 cup flour
salt and pepper to taste
4 tablespoons margarine or butter
2 (10½-oz.) cans beef consommé, undiluted
1 cup dry red wine
2 medium onions, sliced
2 tablespoons chopped parsley
2 teaspoons thyme
2 teaspoons marjoram
2 stalks celery, with leaves

Place duck halves in bag containing flour, salt and pepper; shake until well coated. Brown duck in butter and arrange in casserole. Add consommé, wine, onions and herbs. Place celery on top. Cover and bake at 450° for 20 minutes. Reduce heat to 300° and bake 1½ hours longer. Discard celery before serving.

It may help to soak the duck in soda water overnight before cooking. Occasionally one runs into a tough duck—don't bother cooking longer—it will not get tender.

Mrs. James L. Kelly

Roast Pork Stuffed with Prunes

Serves: 8-10 *An interesting variation.*
Oven Setting: 325°

½ of a 12-oz. package pitted prunes
1 cup boiling water
4½-5 lb. pork loin roast
¼ teaspoon pepper
1 teaspoon salt
1 teaspoon ground ginger

Gravy:
3 tablespoons flour
½ cup light cream
1½ teaspoons currant jelly
¼ teaspoon ground ginger
salt and pepper to taste

Soak prunes in boiling water 30 minutes. Drain and pat dry. Make a slit through center of roast from one end to the other and stuff with prunes. Sprinkle with pepper, salt and ginger. Roast, fat side up, in open pan 2-2½ hours or until meat thermometer reaches 170°.

Gravy: Pour off pan drippings and allow fat to separate. Return 3 tablespoons fat to roasting pan; spoon remaining fat from meat juices and discard; add enough water to make 1 cup. Stir flour into fat in pan until well blended. Gradually stir in meat juices and cook until thickened. Stir in cream, currant jelly, ginger, and salt. Serve gravy in a separate container along with carved roast.

Mrs. John L. Watson, III

Fresh Broccoli Salad

Serves: 8 *Particularly good with chicken dishes or casseroles.*

1 large bunch of broccoli, broken into florets
2/3 cup chopped green olives
1 small onion, grated
4 hard-cooked eggs, chopped
1/2 lb. fresh mushrooms, chopped
1 whole egg
2 tablespoons Parmesan cheese
1 clove garlic, crushed
1/2 teaspoon Dijon mustard
salt to taste
freshly ground pepper to taste
1/2 cup oil
1/3 cup lemon juice

Toss the broccoli, olives, onion, eggs and mushrooms in large mixing bowl. Place egg, cheese, garlic, mustard, salt, pepper in a food processor or blender. Add the oil and lemon juice alternately and blend until smooth. Pour the dressing over the salad one hour before serving.

Mrs. Thomas H. Callahan

Avocado-Grapefruit Salad

Serves: 6 *Light and refreshing.*

4 grapefruit
2 avocados
2 heads Bibb lettuce

Celery Seed Dressing:
1 teaspoon each of dry mustard, grated onion, celery seed
salt and freshly-ground pepper to taste
1/8 teaspoon red pepper
1/3 cup sugar
4 tablespoons vinegar
1 cup oil

Peel and section grapefruit. Peel and slice avocado. Arrange on lettuce-lined platter. Just before serving add celery seed dressing. To prepare dressing: combine all dry ingredients. Alternately add oil and vinegar, stirring briskly. Refrigerate.

Ms. Leigh Lambert

Orange and Olive Salad

Serves: 4 *A good way to serve those gift oranges.*

2 seedless navel oranges
lettuce, optional
8 black olives
1 teaspoon paprika
1/2 teaspoon finely minced garlic
1 teaspoon red wine vinegar
3 tablespoons olive oil
salt and freshly ground pepper to taste
2 tablespoons finely chopped fresh parsley

Trim off the ends of oranges. Peel and cut them in quarter-inch slices. Put them in a mixing bowl or arrange on four lettuce-lined salad plates. Add the olives. Blend the paprika, garlic, vinegar and oil, salt and pepper. When ready to serve, blend dressing well and pour over oranges. Sprinkle with parsley.

Editor's note: This salad is delicious also with sliced red onions in place of the olives.

Mrs. Donald H. Forsyth

Artichoke Madrilene

Makes: 6 or 7 individual molds

Makes a pretty display.

1 package unflavored gelatin
½ cup cold water
13-oz. can red Madrilene
¼ cup fresh lemon juice
¼ teaspoon salt
2 tablespoons sugar
dash pepper (to taste)
1 large grated carrot
½ cup chopped celery
8½-oz. can artichoke hearts

Soak gelatin in cold water. Heat Madrilene, then dissolve gelatin in it. Add lemon juice, seasonings. Arrange vegetables in lightly oiled ring mold or 6 or 7 small individual molds, pour gelatin mixture over and chill until set.

Ms. Eleanor W. Malone

Green Beans in Marinade

Serves: 6

Serve as a salad or hors d'oeuvre.

2 lbs. green beans, trimmed
1 onion, thinly sliced
8 tablespoons oil
1 teaspoon salt
½ teaspoon pepper
1 teaspoon Dijon mustard
1 tablespoon vinegar
½ tablespoon fresh lemon juice

Steam beans with onions in boiling water for 10 minutes until crisp and tender, drain. Mix other ingredients and pour over beans. Refrigerate. Keeps up to 2 weeks in refrigerator.

Ms. Donna Lentz

Molded Avocado Ring with Sassenage Dressing

Serves: 8

The dressing is special.

2 small avocados
4 tablespoons lemon juice
1½ tablespoons gelatin
1 cup chicken stock
¾ cup crème fraîche or sour cream
¾ cup mayonnaise
salt and Tabasco to taste

Peel the avocados and purée them with 1 tablespoon of the lemon juice. Soften the gelatin in ½ cup of the chicken stock. Then dissolve over low heat. Add the gelatin mixture, stock, crème fraîche, mayonnaise and the rest of the lemon juice to the purée and season to taste with salt and Tabasco. Pour into a lightly oiled 4-cup mold and chill for several hours until set. Unmold onto a bed of red leafed lettuce and fill the center with cherry tomatoes. Serve with Sassenage Dressing.

Sassenage Dressing:
2 cups olive oil
¼ cup red wine vinegar
1½ teaspoons salt
⅛ teaspoon freshly ground pepper
¾ teaspoon Worcestershire sauce
1½ teaspoons grated onion
¾ cup mayonnaise
4 oz. bleu cheese, crumbled

Whisk the first seven ingredients together, then add the cheese. Makes 4 cups. Keeps 4-5 weeks in the refrigerator.

Mrs. Rawson Foreman

Cucumber and Red Onion Salad

Serves: 6-8 *Good with highly-seasoned meats.*

3 cucumbers
¼ teaspoon salt
2 red onions, thinly sliced

Dressing:
⅓ cup sour cream
¼ cup sugar
⅓ cup white vinegar

Peel cucumbers, leaving some green skin. Thinly slice and salt cucumbers. Toss. Chill in refrigerator for one hour. Rinse and drain. Add onions. Combine dressing ingredients. Pour dressing over all. Chill at least 4 hours. Serve cold.

Caesar Salad

Serves: 4-6 *Easy version of a delicious classic.*

3 medium heads romaine lettuce, chilled, dried and
 crisped
⅓ cup olive oil
1-2 tablespoons white wine vinegar
salt and freshly ground pepper to taste
juice of 1 fresh lemon
1 egg, raw or one-minute cooked
5-6 tablespoons freshly grated Parmesan cheese
1 cup seasoned croutons
Optional additions: anchovies or capers

Toss lettuce with olive oil and white wine vinegar. Add salt, pepper, lemon juice, egg (if using one-minute cooked, remove from boiling water and immediately crack over salad, scraping out inside of shell) and toss thoroughly. Sprinkle with Parmesan and toss again. Add croutons and serve.

Mrs. Robert Wells

Minted Cantaloupe Mold

Serves: 8 *Refreshing and pretty for summer.*

2 envelopes unflavored gelatin
½ cup cold water
¾ cup hot water
¾ cup sugar
salt to taste
1½-2 tablespoons fresh mint leaves, chopped
¾ cup lemon juice
¾ cup cantaloupe juice (or juice and water)
1 cup orange juice
2½ cups cantaloupe balls
mint leaves
2 cups cantaloupe balls

Soften gelatin in cold water. Mix hot water, sugar, salt, mint and ¼ cup lemon juice. Heat to boil. Strain and pour over gelatin, stir. Strain cantaloupe juice (add water if necessary to make ¾ cup). Add to gelatin mixture with remaining ½ cup lemon juice and orange juice. Refrigerate until mixture is about as thick as egg whites. Add cantaloupe balls. Turn into 5-cup mold. Chill until firm. Unmold and garnish with mint leaves and cantaloupe balls to serve.

Mrs. Benjamin Selman

Zucchini Mousse au Gratin

Serves: 6
Oven Setting: 375°

This is a wonderful accompaniment to almost any main dish, meat or poultry. It is delicious!

6 medium zucchini
3 tablespoons butter
4 scallions, finely chopped
¼ cup fresh parsley, minced
¼ cup fresh dill, minced (or 1 teaspoon dried dill)
salt to taste
⅛ teaspoon pepper
⅔ cup sour cream
6 tablespoons bread crumbs
2 tablespoons freshly grated Parmesan cheese

Scrub zucchini, but do not peel. Shred or grate in food processor. Place in colander and allow to drain for 30 minutes. Then press to drain well. Melt 1 tablespoon butter in skillet and sauté scallions until wilted. Stir in zucchini, parsley, dill, salt and pepper and sour cream and cook a few minutes. Spoon mixture into a 1½ quart casserole. Top with bread crumbs, Parmesan and dots of remaining 2 tablespoons butter.* Wrap and freeze. Bake, uncovered, for 1 hour. Brown top under broiler.

*To serve without freezing, bake for 30 minutes. Brown as directed.

Mrs. Cecil D. Conlee

Ratatouille

Serves: 6-8
Oven Setting: 350°

Freezes well—nice to have on hand in mid-winter.

2 medium eggplant, peeled and cut into strips
4 medium zucchini, sliced ½" thick
flour
olive oil
2 large sliced onions
2 cloves garlic, minced
3 large green peppers, seeded and diced
5 tomatoes, peeled, seeded and quartered
2 tablespoons fresh basil, chopped (or 2 teaspoons, dried)
¼ cup fresh parsley, chopped
1 teaspoon oregano
1 teaspoon thyme
salt and pepper to taste
¼ cup fresh parsley, chopped for garnish

Sprinkle eggplant and zucchini slices with salt and let stand 30 minutes. Rinse, drain and dry slices. Dredge in flour. Heat olive oil in large sauté pan and briefly sauté in batches over medium high heat until lightly browned. Remove and drain on paper towels. Sauté onion, garlic and green pepper until soft. (Add more oil if needed.)

Preheat oven. Layer sautéed vegetables, quartered tomatoes and seasonings in 3-quart casserole. Stir gently to mix and bake, covered for 35 minutes. Uncover and bake 15 minutes longer. Garnish with ¼ cup fresh parsley, chopped and serve.

Every recipe for this dish seems to differ. Be creative. You may eliminate some of the peppers; add some celery or change the quantities according to preference and availability of fresh vegetables, keeping the total amount approximately the same. Ratatouille improves if prepared a day ahead and reheated in a slow oven. Its uses are endless. Serve as an accompaniment for roasted or grilled meats. Top with equal parts Parmesan cheese and bread crumbs and lightly broil for a vegetarian entrée—or add 1 pound previously cooked and sliced Italian sausage for the last 15 minutes of baking and you have a satisfying main dish.

Stuffed Zucchini

Serves: 4-6
Oven Setting: 350°

Filling.

4 small zucchini
3 tablespoons olive oil
½ cup chopped onion
1 clove garlic
½ cup fresh mushrooms, chopped
3 oz. cream cheese
1 egg, beaten
½ cup fresh parsley, chopped
½ cup grated Parmesan cheese
salt, pepper

Cut zucchini in half lengthwise, scoop out center leaving a ¼ inch shell. Heat oil in skillet, sauté onions until tender, add garlic, mushrooms and zucchini pulp. Cook 5 minutes, increase heat and cook, stirring until liquid is absorbed. Add cream cheese, egg, parsley and Parmesan cheese (reserve 1 tablespoon cheese). Cook slowly, stirring constantly about 5 minutes. Season to taste. Spoon mixture into zucchini shells and sprinkle tops with reserved cheese. Arrange in baking dish and bake for 10-20 minutes. Slip under broiler to brown tops.

Mrs. W. Clayton Sparrow, Jr.

Outrigger Rice

Serves: 6-8
Oven Setting: 350°

Serve with pork as a flavorful taste treat.

4 cups cooked rice
⅔ cup chopped onion
⅓ cup margarine
1 13½-oz. can pineapple tidbits, drained
½ cup seedless raisins
salt to taste
½ teaspoon curry powder
1 teaspoon ground oregano

Sauté onion in margarine. Chop pineapple into very small pieces. Stir all ingredients together and place in a baking dish. Bake 20 minutes.

Ms. Linda Cosby

Asparagus Polonaise

Serves: 6-8

Ideal for small dinner party.

Two bunches large asparagus

Polonaise sauce:
½ cup butter
¼ cup soft bread crumbs
2 hard-boiled eggs, finely chopped
1 tablespoon parsley, chopped
salt and pepper to taste

In saucepan over low heat melt butter, add bread crumbs. Cook until crumbs are well browned. Remove from heat, stir in eggs and parsley. Salt and pepper to taste.

Select two bunches of large asparagus. Peel asparagus stalks and discard tough bottom portion. Cut each asparagus crosswise into approximately 3 pieces. (A slight angle is attractive instead of straight across.) Place asparagus in deep fat fryer basket. Drop into kettle of boiling, salted water and cook about 5 minutes. Lift out and place in individual portions on a warmed platter. Pour Polonaise sauce over each portion. Garnish each portion with pimiento if desired.

Ms. Pansy Little

Baked Fresh Asparagus

Serves: 6
Oven Setting: 300°

Asparagus will be crisp and will retain natural color.

2 lbs. fresh asparagus
¼ teaspoon each—salt and pepper
4 tablespoons butter or margarine
¼ cup Chablis

Preheat oven. Trim asparagus and arrange in one or two layers in baking dish. Sprinkle with salt and pepper and put slices of butter over all. Pour Chablis over top of asparagus. Cover tightly and bake for 30 minutes.

Mrs. John L. Watson, III

Barley-Almond Casserole

Serves: 8
Oven Setting: 350°

Adds interest to a meal.

1 cup pearl barley
6 tablespoons butter or margarine
¼-½ cup slivered almonds
1 medium onion, chopped
½ cup parsley, minced
¼ cup fresh chives or green onion tops, chopped
¼ teaspoon each salt and pepper
2 (14-oz.) cans beef or chicken broth

Rinse barley in cold water and drain well. Heat 2 tablespoons of the butter or margarine in a skillet. Add almonds and brown, stirring. Remove nuts with a slotted spoon. Add the other 4 tablespoons of butter to skillet, add onion and barley. Cook, stirring, until toasted. Place in 2-quart casserole and add remaining ingredients, except for the broth. Heat the broth to boiling, pour over barley mixture and stir well. Bake, uncovered, for 1 hour. Garnish with parsley. Use chicken stock if serving with chicken, fish, etc., beef broth if serving with red meat.

Mrs. Dewey F. Locke

Mushrooms Polonaise

Serves: 6
Oven Setting: 350°

People always ask for this recipe. It goes beautifully with beef.

½ cup butter
1½ lbs. fresh mushrooms, sliced
1 onion, minced
2 tablespoons flour
1 cup sour cream
salt, pepper to taste
¼ teaspoon nutmeg, freshly ground
2 tablespoons chopped fresh parsley
¼ cup soft bread crumbs tossed in ¼ cup melted butter

Melt butter in heavy skillet. Add sliced mushrooms. Sauté over medium heat until slightly brown; add minced onion and continue to sauté until onion is soft but not brown. Stir in flour; cook 5 minutes over low heat, stirring constantly. Blend in sour cream and seasonings. Cook until mixture has thickened. Stir in parsley. Pour into 1½ quart buttered casserole; sprinkle top with buttered crumbs. Bake for about 35 minutes or until mixture has set and crumbs have slightly browned.

Mrs. Cecil D. Conlee

Green Beans with Walnuts

Serves: 4

A good wintertime dish. Easy and pretty with a ham or roast.

1 lb. fresh green beans
1 clove garlic
1 tablespoon very fine olive oil
½ cup walnut halves (or more if you like)

Clean green beans and steam until tender. (Do not over cook.) Mince garlic. Heat olive oil in a skillet and sauté garlic, beans and walnuts 2-3 minutes or until everything is warm. Serve immediately.

Ms. Alison Taylor Bivens

Zucchini Casserole

Serves: 8
Oven Setting: 350°

Perfect for a mid-summer dinner.

2 eggs, separated
8 oz. sour cream
2 tablespoons flour
salt to taste
7 zucchini squash, scrubbed and sliced
1¾ cups shredded Cheddar cheese
8 slices cooked bacon, crumbled
⅓ cup dry bread crumbs
1 tablespoon melted butter

Beat egg yolks. Stir in sour cream and flour. Beat egg whites and salt, fold into mixture. Layer half of squash in 12″ x 8″ x 2″ pan. Pour on half of egg mixture. Sprinkle on half of cheese, add bacon. Layer remaining squash, egg mixture and cheese. Combine bread crumbs and butter, sprinkle on top. Bake for 30-35 minutes.

Mrs. J.B. Stanley

Frosted Cauliflower

Serves: 6-7
Oven Setting: 350°

Easily persuades vegetable haters to eat their vegetables.

1 head cauliflower
½ cup mayonnaise
⅓ cup grated Parmesan cheese
1 tablespoon lemon juice
salt to taste
¼ teaspoon dry mustard
1½ teaspoon dried parsley flakes or 1 tablespoon finely minced fresh parsley
2 egg whites

First, steam or simmer the cauliflower head for about 20 minutes or until it is still crisp/tender. Blend ½ cup mayonnaise, ⅓ cup grated Parmesan cheese, 1 tablespoon lemon juice, ¼ teaspoon each of salt and dry mustard and 1½ teaspoons dried parsley flakes or 1 tablespoon minced fresh parsley. Beat 2 egg whites until stiff and fold these into mayonnaise mixture. Coat cauliflower with the sauce. Bake about 15 minutes or until frosting begins to brown. Remove whole to serving dish and enjoy it as quickly as possible. Can be readied early in the day except for final baking.

Mrs. Daniel J. Jordan

Baked Eggplant Parmigiana

Serves: 8
Oven Setting: 350°

Could also serve as a vegetarian entrée.

1 medium eggplant, thickly sliced
¼ cup flour blended with salt and pepper to taste
½-¾ cup olive oil
2 medium onions, chopped
3 medium tomatoes, peeled and chopped
1 clove garlic, minced
¼ teaspoon oregano
¼ cup fresh parsley, minced
¼ cup Marsala or Madeira wine
1 cup Ricotta cheese
½ cup Parmesan, grated
¼ lb. Mozzarella, shredded

Soak eggplant slices in salted water; drain and pat dry. Dust with seasoned flour; then sauté in olive oil until browned on both sides. Set aside. To same oil, add onions, tomatoes, garlic, oregano and parsley. Simmer until thickened. Add wine (and salt and pepper if needed). Pour ⅓ of the sauce into shallow (2-quart) casserole. Place ½ of the eggplant on sauce, then ½ of the Ricotta and Parmesan combined, then more sauce, eggplant, etc. Finish with sauce on top; sprinkle Mozzarella over all. Bake for 40 minutes.

Mrs. Raymond M. Warren, Jr.

Braised Endives and Carrots

Serves: 6

An interesting winter vegetable combination.

4 Belgian endives
3 carrots
2 tablespoons salad oil
2 tablespoons beef stock (or you may use canned bouillon or bouillon cube in water)
½ teaspoon thyme

Cut endives in half and quarter carrots. Heat oil in medium-sized skillet, toss vegetables in and stir well. Add beef stock and thyme. Cover and cook 15 minutes or until vegetables are tender. Stir occasionally.

Mrs. Harold Barrett

Savory Green Beans and Mushrooms

Serves: 6

Flavorful!

1½ lbs. green beans, ends removed (or 2 10-oz. packages frozen cut green beans)
8 oz. fresh mushrooms, sliced
1 tablespoon thinly sliced green onion
3 tablespoons butter or margarine
⅓ cup vegetable oil
1 tablespoon white vinegar
1 tablespoon lemon juice
1 tablespoon snipped fresh parsley
2 tablespoons snipped fresh savory leaves (or 1 teaspoon dried savory)
1 teaspoon sugar
1 teaspoon salt
⅛ teaspoon pepper
4 slices bacon, cooked and crumbled

Cook green beans uncovered in 1 inch boiling salted water in large saucepan for 10 minutes. Cover and continue cooking over medium heat until tender, about 5 minutes. Drain.

Cook mushrooms and green onion in melted butter in skillet over medium heat until tender, about 5 minutes. Toss with beans. Heat remaining ingredients in a small saucepan to boiling. Pour over bean mixture; stir to coat evenly.

Mrs. Michael D. Gaddis

Hollandaise Sauce

Makes: 1 cup

Easy to do and never fails. This was my mother's.

2 egg yolks
½ teaspoon salt
Tabasco to taste
½ cup butter, melted
1 tablespoon lemon juice

Beat egg yolks with a whisk about 1 minute. Add salt and Tabasco. Add 3 tablespoons butter (a little at a time) heating constantly. Beat in remaining butter, alternating with lemon juice. Refrigerate for at least 2 hours. Bring to room temperature before serving. (You may whisk again for fluffier consistency.) Serve with vegetables, fish, chicken or meat.

Ms. Helen Haney

Frozen Orange Soufflé Grand Marnier

Serves: 8

A perfect finale.

6 egg yolks
¾ cup sugar
2¾ cups heavy cream, whipped (2 cups for soufflé, ¾ cup for topping)
3 oz. or ⅓ cup Grand Marnier
8 cleaned orange shells (or soufflé cups)
powdered cocoa and fresh mint leaves

Beat egg yolks and sugar until stiff. Fold 2 cups of whipped cream into egg mix, then fold in Grand Marnier. Fill shells or cups with mixture and freeze for at least 2 hours. At serving time top with additional whipped cream. Sprinkle with powdered cocoa, place orange slice and mint leaf on side of plate.

Ms. Rose Jacobsen

Cointreau Soufflé

Serves: 8-10

Grated orange rind makes a pretty garnish.

3 oranges
1 lemon
¾ cup orange juice
¼ cup lemon juice
2 tablespoons unflavored gelatin
grated rind for garnish
⅓ cup Cointreau
6 eggs, separated
2 cups sugar
½ teaspoon cream of tartar
pinch salt
2 cups heavy cream

Grate rind of 2 oranges and lemon and squeeze juice. Sprinkle gelatin into ½ cup orange juice and set aside. In a saucepan, put the grated peel, ¼ cup orange juice, lemon juice, Cointreau, 6 egg yolks, 1¼ cups sugar and salt. Beat until fluffy. Stir over low heat until mixture coats back of a spoon. Remove from heat and stir in softened gelatin-orange juice mixture, stirring until gelatin dissolves. Refrigerate for 20 minutes. Beat egg whites to soft peaks. Beat in ¾ cup sugar, 1 teaspoon at a time, add ½ teaspoon cream of tartar and beat until stiff and glossy. Beat 2 cups heavy cream until soft peaks form. Fold in egg whites. Then turn whipped cream mixture into egg yolk custard and pour into 6-cup soufflé dish with waxed paper collar. Refrigerate overnight. Remove collar and garnish.

Mrs. Frederick L. Muller

Dacquoise au Café
(Coffee Meringue Dessert)

Serves: 4-6
Oven Setting: 250°-300°

Any flavoring can be substituted for coffee.

5 egg whites
pinch cream of tartar
10 oz. granulated sugar
4 oz. blanched, finely ground almonds
½ pint whipping cream
1 rounded teaspoon instant coffee granules

Topping:
4 fluid oz. whipping cream, whipped
powdered sugar

Whip egg whites until stiff and dry and add cream of tartar. Fold in sugar and almonds. On greased, waxed-paper-lined baking sheet, spread 2 8"rounds of meringue and bake until dry, for about 1 hour in slow oven. Whip ½ pint of cream and flavor with coffee mixed with very little hot water and sugar to taste. Make a sandwich of meringues with flavored cream in the middle. Dust with powdered sugar and pipe rosettes of cream on top.

Mrs. R.M. Smith, Jr.

Mousse aux Apricots

Serves: 8-10

Serve with sugared grapes.

1 cup firmly packed dried apricots (6-oz. package)
½ cup water
⅔ cup sugar
1 teaspoon vanilla
2 eggs
1½ cups heavy cream, whipped

Cook apricots in a heavy pan with the water and ⅓ cup of the sugar until they are soft, about 10 minutes. Purée apricots in a blender or food processor with the other ⅓ cup of sugar, vanilla and eggs. Whip the cream and fold in the purée. Freeze in a 5-cup mold for about 2 hours or until just solid.

Mrs. Rawson Foreman

Walnut Roll

Serves: 8
Oven Setting: 350°

Pure joy.

Cake:
7 eggs
¾ cup sugar
1½ cups finely ground walnuts
1 teaspoon baking powder

Cream:
1 cup heavy cream
confectioner's sugar, to taste
1 teaspoon vanilla extract

Brush a 10" x 15" jelly-roll pan with oil, line it with wax paper and oil the paper. Separate the eggs. Using a whisk, beat the yolks with the sugar until the mixture is pale in color and thick enough to "ribbon." Beat in walnuts and baking powder. Fold in the egg whites, stiffly beaten. Spread batter in the prepared pan and bake 15-20 minutes or until golden. Cool in the pan, cover with a damp towel and chill.

Dust the cake generously with sifted confectioner's sugar and turn it out on a board covered with two overlapping sheets of wax paper. Carefully strip paper from bottom of the cake. Spread the cake with the cream, whipped and flavored with sugar and vanilla, to taste. Roll the cake, using the wax paper as an aid and slide onto a flat serving plate. Sprinkle the roll with more confectioner's sugar. If cake cracks while rolling, just cover with a little extra sugar.

Ms. Susan Saudek

Fresh Fruit Grand Marnier

Serves: 6-8

I put it in cantaloupe halves and take it to Chastain Park for dessert.

Fruit:
4 navel oranges, peeled and sliced
2 medium apples, peeled and diced
2 medium bananas, peeled and sliced
*1 pint fresh strawberries, halved
*1 pint fresh blueberries
1½ cups seedless green grapes, whole

Sauce:
4 egg yolks
½ cup sugar
1 teaspoon cornstarch
1 cup warm milk
¼ cup Grand Marnier
1 teaspoon vanilla
1 teaspoon orange rind
½ cup heavy cream, whipped

When not in season, use frozen whole berries.

Combine fruit in large bowl and refrigerate while preparing sauce. Put egg yolks, sugar and cornstarch in processor and mix until yolks are pale yellow and ribbon when dropped from a spoon. Add warm milk and blend well. Remove to heavy saucepan and cook over low heat while beating with a whisk until custard thickens and coats spoon. Remove from heat. Add Grand Marnier, vanilla and orange rind. Cool completely and refrigerate a few hours.

Just before serving, whip cream and add to sauce with a whisk. Drain fruit and pour sauce over.

Editor's note: This also looks beautiful with fruits layered in a glass soufflé dish; serve sauce separately.

Mrs. David R. Bockel

Kahlua-Chocolate Mousse

Serves: 4-6

This is based on the mousse Jacqueline Kennedy served as First Lady in the White House. It is so simple and absolutely delicious!

6 oz. semi-sweet chocolate bits
2 tablespoons Kahlua
1 tablespoon orange juice
2 eggs
2 egg yolks
1 teaspoon vanilla
¼ cup sugar—extra fine
1 cup heavy cream
additional cream, whipped, shaved unsweetened
 chocolate, candied violets as garnish

Melt chocolate bits in 2 tablespoons Kahlua in top of double boiler. In blender mix orange juice, eggs and egg yolks, vanilla and sugar. Add melted chocolate and Kahlua. Blend. Add heavy cream and blend again. Pour into serving dishes and refrigerate 4-6 hours. Serve with whipped cream, shaved chocolate, candied violets.

Ms. Marilyn Wenner

Strawberry Grand Marnier Sorbet

A wonderful light summer dessert for Atlanta. A beautiful color.

3 pints fresh strawberries
2 cups sugar
¾ cup lemon juice (fresh)
1½ cups orange juice (fresh)
⅓ cup Grand Marnier

Wash strawberries, remove stems. Place strawberries and sugar in a bowl with fresh squeezed lemon juice and orange juice. Let stand about 2½ hours. Put the mixture into blender or food processor and purée. Add Grand Marnier and pour into 2 large freezing trays. Freeze until mixture is frozen about 1" on all sides. Beat mixture. Return to freezer and completely freeze. May also be frozen in ice cream freezer.

Mrs. R. Mark Wilkiemeyer

White Chocolate Cake with White Chocolate Frosting

Makes: about 12 slices
Oven Setting: 350°

A very rich and special cake. Good for adult birthdays, Easter or christenings.

Cake:
⅓ cup white chocolate (cut in small pieces)
½ cup hot water
1 cup butter (no substitute)
1½ cups sugar
4 egg yolks, unbeaten
1 teaspoon vanilla
2½ cups cake flour
1 teaspoon baking soda
1 cup buttermilk
4 egg whites, stiffly beaten

Melt white chocolate in hot water; cool. Cream butter and sugar until light and fluffy. Add egg yolks. Beat. Add white chocolate and vanilla. Sift flour and soda together, add alternately with buttermilk to creamed mixture. Fold in stiffly beaten egg whites. Pour into 3 greased and floured 9" layer pans. Bake 30-35 minutes in preheated oven. Frost with following frosting.

Frosting:
½ cup + 2 tablespoons sugar
6 tablespoons evaporated milk
¼ cup butter
2 cups white chocolate (cut in small pieces)
1½ teaspoons vanilla
optional—toasted nuts for garnish

Combine milk, sugar and butter in saucepan. Bring to full, rolling boil and boil 1 minute. Remove from heat and add white chocolate and vanilla. Stir until candy is melted. Beat until spreading consistency. Frost 3-layer cake. (Spread slowly, cool if icing is too loose, heat if too stiff.)

Mrs. A. Park McGinty
Mrs. Thomas Henry Nickerson, IV

GALLERY III
Before the Game and After the Show

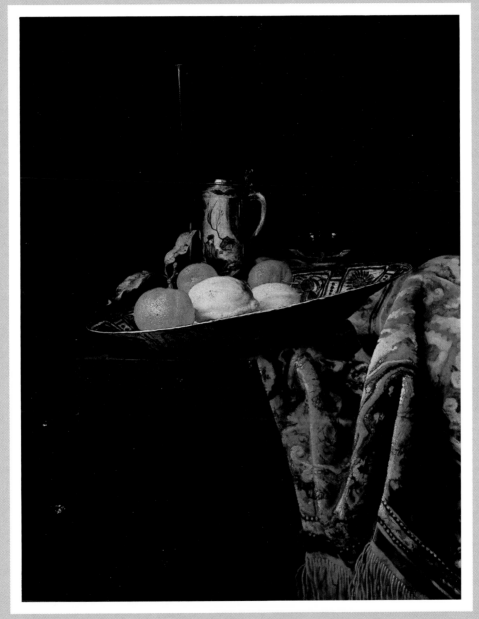

HENDRIK VAN STREEK (Dutch, 1659-after 1719)
Still Life with Rug, late 17th century, oil on canvas, 40 x 32½ inches. Museum purchase with special funds allocated by The Atlanta Arts Alliance Board of Trustees, 1973. *Color reproduction in The High Museum of Art Recipe Collection sponsored by Carter & Associates.*

Gallery III

Pasta Primavera

Serves: 4-6 for main course
6-8 for first course

Pasta — the dish of the decade.

½ cup unsalted butter
1 medium onion, minced
1 teaspoon garlic, minced
1 lb. fresh asparagus, trimmed and cut diagonally in ¼" slices
1 medium zucchini, cut into ¼" rounds
1 small carrot, cut into wafer-thin slices
½ lb. mushrooms, sliced
1 cup whipping cream
½ cup chicken stock
2 tablespoons fresh basil, chopped (or 1 teaspoon dried)
1 cup frozen peas, thawed
2 oz. prosciutto, chopped
3 green onions, chopped
salt and freshly ground pepper
1 lb. fettuccine or spaghetti, cooked al dente and drained
1 cup freshly grated imported Parmesan cheese
⅓ cup pine nuts, toasted

Heat a large skillet over medium-high heat. Add butter, onion, and garlic and sauté until onion is softened—about 2 minutes. Add asparagus, zucchini, carrot and mushrooms and stir fry no longer than 2 minutes. Increase heat to high and add cream, stock and basil. Boil mixture until liquid is slightly reduced—about 3 minutes. Stir in peas, prosciutto, and green onions and simmer 1 minute. Taste, add salt and pepper, adjust seasonings. Add pasta, cheese and pine nuts, tossing until thoroughly mixed and pasta is warm. Turn onto warmed platter and serve immediately or serve at room temperature.

Mrs. Alan H. Hunt

Mushroom Quiche

Makes: 2 pies,
6-8 servings each
Oven Setting: 375°

May be used for hors d'oeuvres or with a tossed salad for a meal.

2 tablespoons minced shallots
3 tablespoons butter
1 lb. sliced, fresh mushrooms
1 teaspoon salt
1 teaspoon fresh lemon juice
2 tablespoons white wine
3 eggs, beaten
1½ cups whipping cream
pinch of nutmeg
⅛ teaspoon black pepper
2 frozen pie shells, unbaked
½ cup grated Swiss cheese

Sauté shallots in butter. Stir in mushrooms, salt, lemon juice and wine. Cover and simmer over moderate heat for 8 minutes. Uncover and raise heat; boil until liquid is gone. Mix eggs, cream, nutmeg and pepper. Blend well, gradually stirring in mushroom mixture. Pour into pie shells and sprinkle with cheese. Dot with butter. Bake 25-30 minutes.

Ms. Judy Highsmith

King Crab Quiche

Serves: 6
Oven Setting: 375°

A recipe from The Cross Roads, an Atlanta seafood restaurant.

1 unbaked deep-dish pie crust (9") or 6 individual tart shells
2 tablespoons butter or margarine
1 clove garlic, crushed
½ cup onion, thinly sliced
¼ cup green pepper, diced
¼ cup pimiento, diced
salt and white pepper to taste
2 tablespoons sherry
1 cup Alaskan King crabmeat
2 eggs and 2 egg yolks
1 cup half and half
¼ cup grated Swiss cheese

Melt butter. Add garlic clove. Sauté vegetables in butter and garlic. (Note: Vegetables should not be cooked until soft, just until they are tender and still retain their natural colors.) Add seasonings. (Be careful with salt—crabmeat tends to be salty.) Drain butter. Remove garlic. Add sherry and reduce until no liquid is remaining. Cool vegetables. Add crabmeat. Set aside.

Beat eggs and yolks with half and half until fluffy. Pour vegetables into unbaked pie shell(s). Pour egg and cream mixture over crab meat and vegetables. Bake 25 to 30 minutes or until knife inserted in middle comes out clean.

Mr. Allan Ripans

Eggs Baked in Cheese Sauce

Serves: 6
Oven Setting: 325°

A tablespoon of sherry added to the cream sauce makes it even better.

3 tablespoons butter or margarine
3 tablespoons flour
1½ cups milk
salt to taste
⅛ teaspoon pepper
¼ lb. cheddar cheese, shredded
6 large eggs

About 45 minutes before serving, make cream sauce with first three ingredients: melt butter in saucepan, mix in flour until smooth, then add milk slowly. Stir until sauce thickens. Add seasonings and cheese. Pour half of sauce in 8" square baking pan. Carefully break eggs into sauce. Cover with rest of sauce. Bake about 20 minutes. Serve over English muffins with bacon or ham.

Mrs. J. Dexter Kearny

Sautéd Chicken Livers

Serves: 8

Serve with scrambled eggs.

1½ lbs. chicken livers, trimmed
1½ cups milk
1½ teaspoons salt
freshly-ground pepper to taste
1 cup flour
4 tablespoons unsalted butter
2 tablespoons oil

Soak chicken livers in milk for 30 minutes. Drain and pat dry. Sprinkle livers on both sides with salt and pepper. Roll in flour, covering completely. Heat butter and oil in large frying pan. Add livers and cook until crisp on underside, turn and repeat. (Total cooking time 4-5 minutes.) Livers should be crisp on outside, soft and barely pink inside.

Cheese Blintz Soufflé

Serves: 8-10
Oven Setting: 300°

Fast company-is-coming-for-lunch/ brunch, what-should-I-serve dish.

Batter:
2 sticks melted butter
½ cup sugar
2 eggs, beaten
1 cup flour
3 teaspoons baking powder
½ cup milk
pinch salt
1 teaspoon vanilla

Filling:
2 lbs. Farmers cheese or 1 lb. cream cheese, grated
1 lb. cottage cheese
2 eggs, beaten
½-1 cup sugar
pinch of salt
juice of 1 lemon

Mix all the batter ingredients in one bowl and the filling ingredients in another. Pour ½ batter in 9" x 13" casserole. Pour filling over batter. Pour on remaining batter. Bake for 45 minutes. Can be served at brunch with a salad or at dinner as a side dish. Can be garnished with stewed fruit.

Ms. Rose Jacobsen

Blinis

Serves: 60-75 (depending on size)

Wonderful for a late supper served with a salad and dessert, or in mini-version at a cocktail party.

¾ cup buckwheat flour
½ cup all purpose flour
1 teaspoon sugar
salt to taste
1 package yeast
1¼ cup milk
¼ cup water
1½ tablespoons butter
2 eggs, separated
2 additional egg whites
caviar, melted butter and sour cream

Combine dry ingredients in mixer bowl. Combine milk, water and butter in small saucepan. Heat to warm up, butter doesn't have to be completely melted. Add liquids to dry ingredients and beat 2 minutes. Add egg yolks and beat 2 more minutes. Cover with tea towel and let rise until doubled in bulk (1-2 hours). Beat egg whites stiff and fold in. Cook in buttered skillet using 1 tablespoon batter for each cake. Keep warm in a 120° oven and serve with melted butter, caviar and sour cream.

Mrs. Nathan V. Hendricks, III

Shirred Eggs in Custard Cups

Serves: 8
Oven Setting: 350°

An easy way to cook eggs.

8 teaspoons butter
8 teaspoons fresh parsley, minced
8 eggs
salt and pepper to taste
8 teaspoons half and half
8 teaspoons butter

Grease custard cups with 1 teaspoon butter each; sprinkle with 1 teaspoon parsley each. Break an egg into each cup, season to taste, add 1 teaspoon cream and 1 teaspoon butter to each one. Place cups in a pan of hot water; cover with waxed paper and bake for 15-20 minutes or until eggs are set. Unmold on hot buttered toast or English muffins.

Hot Ham-on-Rye Sandwiches

Oven Setting: 375° *Quick and tasty.*

rye bread
mayonnaise
Dijon mustard
ham, sliced thinly
sour cream
Jarlsberg cheese, sliced thinly

Toast rye bread. Spread each piece with equal parts mayonnaise and mustard. Place 3 thin slices lean ham on toast. Top each with heaping tablespoon of sour cream. Top sour cream and ham with 3 thin slices of Jarlsberg. Bake until cheese melts.

Curried Grape and Shrimp Salad

Serves: 4 *Good for brunch or for a ladies' luncheon, winter or summer.*

1 lb. cooked, cleaned shrimp
2 cups green seedless grapes
1 cup cashew nuts
½ cup sour cream
½ cup mayonnaise
2 tablespoons minced onion
2 tablespoons green pepper, chopped
⅛ teaspoon ginger
1½ teaspoon curry powder
dash salt
1 tablespoon fresh lemon juice

Cut shrimp into pieces, halve grapes and place in a large bowl with cashews. Mix all other ingredients together, pour over shrimp mixture and mix well. Chill several hours. Serve on lettuce with crispy French bread.

Ms. Marilyn Wenner

Hot Tarragon Chicken Salad

Serves: 6-8 *A flavorful variation.*
Oven Setting: 425°

2 cups celery, chopped
2 teaspoons grated onion
2 tablespoons butter
2 tablespoons flour
1 cup milk
½ teaspoon salt
2 tablespoons fresh lemon juice
¼ cup mayonnaise
½ cup cheddar cheese, grated
¼ teaspoon dried tarragon (or more, to taste)
4 chicken breasts, cooked and diced (about 3-4 cups)
½ cup slivered almonds

Grease 2-quart casserole. Preheat oven. Sauté celery and onion in butter. Add flour, stir until smooth. Add milk slowly, stir and cook until smooth and thick. Add salt, lemon juice, mayonnaise, cheese and tarragon. Combine with chicken and put into prepared dish. Sprinkle with almonds. Heat 20-30 minutes.

Ms. Albie L. Boston

Salade Niçoise

Serves: 4 *Filling and good.*

Sauce:
1 clove garlic
salt
1 tablespoon each lemon juice and wine vinegar
½ teaspoon dry mustard
½-⅔ cup olive oil
freshly ground pepper

3 or 4 boiling potatoes
1 tablespoon minced shallots or scallions
salt and pepper
2-3 tablespoons white wine
2-3 tablespoons water
1 large head Boston lettuce
4 ripe tomatoes, quartered
½ lb. fresh green beans, blanched and chilled
2-3 hard-boiled eggs
5 anchovies
2-3 tablespoons capers
½-⅔ cup Greek olives
6½-oz. can tuna

Make a sauce vinaigrette by crushing the garlic clove and adding the other sauce ingredients. Cook the potatoes until barely tender (about 20 minutes). Peel and slice. Toss while warm with shallots, salt, pepper. Then toss with wine and water. Let sit 5 minutes and toss again. Then fold in ¼ cup of the vinaigrette sauce and chill.

Assemble the salad in a wide bowl the moment before serving. Toss lettuce with a little dressing and arrange leaves around edge of bowl. Place potatoes in the middle. Arrange the quartered tomatoes (or cherry tomatoes) around the potatoes. Toss beans with dressing and arrange between tomatoes. Distribute eggs, anchovies, capers and olives. Break up tuna and arrange at intervals. Dribble dressing over all.

Fettuccine alla Romana

Serves: 2-4 *A quick, filling late supper, coaxed from a great Italian chef.*

⅓ cup whipped butter
3 cloves garlic, crushed
2 tablespoons minced prosciutto
⅓ cup cooked green peas
½ cup heavy cream
½ lb. fettuccine noodles, cooked al dente
1 egg, slightly beaten
4 tablespoons freshly grated Parmesan cheese

Melt butter slowly in wok or saucepan and add garlic. As butter bubbles, add prosciutto and peas. Add cream. Add pasta, whole egg and cheese, tossing gently with 2 large spoons until cheese is melted. Serve with crisp green salad, fresh Italian bread and your favorite wine.

Ms. Pat Reeves

Best Pizza

Makes: One large pizza *Make two at a time.*
Oven Setting: 350°- 375° *They go fast.*

¾ cup tepid water
¾ tablespoon (or 1 package) yeast
½ teaspoon salt
1 teaspoon sugar
2 tablespoons olive oil
2 cups flour (1⅓ cups whole wheat, ⅔ cup white)
 makes crust thick, yet not too soft
thick tomato sauce
Mozzarella cheese (sliced or diced)
Parmesan cheese, grated
Your favorite pizza topping: pepperoni, sausage,
 bacon, ham, mushrooms, black olives, browned
 ground beef

Dough: Dissolve yeast in tepid water. Stir in salt, sugar, oil and flour. Form into ball; set aside, covered, in bowl, in warm place (on top of preheating oven is good) for 15-20 minutes, to rise. Oil hands and spread dough on oiled pizza sheet (spread out dough, do not squash it down). Form edge on crust (so melting cheese doesn't run over). Cover with tomato sauce. Sprinkle on toppings in large pieces. Cover with Mozzarella. Cover with Parmesan. Bake 30-40 minutes until crust looks golden and cheese is bubbly. Let cool.

Takes about 2 hours from beginning to eating. Prepare ahead, or make it part of the party! Watch oven temperatures carefully.

Mr. Brian H. Head

Chili

Serves: 8-10 *The plum tomatoes make it special.*

1 lb. dried red kidney beans, washed and sorted
2 quarts cold water
4 large onions, peeled and cut into slim wedges
2 large garlic cloves, peeled and crushed
3 tablespoons butter
2 lbs. lean beef chuck, ground coarsely
⅓ cup chili powder
1 bay leaf, crumbled
½ teaspoon thyme
¼ teaspoon marjoram
1½ teaspoons salt
¼ teaspoon pepper
1 large can Italian plum tomatoes

Soak the beans in the water overnight. Next day, drain the beans and reserve the soaking water. Measure soaking water and add enough cold water to total 1 quart. Return beans and water to the kettle. Set over moderate heat, cover and simmer about 1 hour, or until beans are almost tender. Meanwhile, coarsely chop the onions (This can be done in food processor with metal blade, one onion at a time, using 2 or 3 fast bursts of speed for each batch.)

Add chopped onions to a large heavy kettle to which you have already added the garlic and butter. Sauté the onions over moderate heat until limp and golden, about 10 minutes. Add the coarsely ground beef to the kettle and stir-fry for 10-12 minutes, until beef is no longer pink. Sprinkle chili powder over beef, add other seasonings and heat and stir about 5 minutes. Drain the kidney beans well, reserving the cooking water. Add beans to kettle along with 1 cup of the water, the salt and pepper. Add tomatoes.

Reduce heat to low, place lid partially on kettle and simmer 1-1½ hours, or until beans are tender and flavors are well blended. If mixture seems too thick, thin with a little additional reserved bean-cooking water. Taste for salt and add more if needed. Serve with grated sharp cheddar cheese and chopped scallions if desired.

White House Sandwich

Serves: 4
Oven Setting: Broil

One of our presidents used to eat it when he came to Atlanta and liked it so well he requested the recipe to serve at the White House!

2 whole chicken breasts, cooked
4 slices white bread, toasted
sharp cheddar cheese, grated

Sauce:
4 tablespoons butter
4 tablespoons flour
2 cups stock, strained

Slice chicken breasts and set aside. Make sauce as follows: Heat butter until melted. Add flour and stir until smooth. Stir in stock slowly to make cream sauce. Cook slowly for 10 minutes, stirring often. Arrange slices of chicken on toast in oven-proof casserole dish. Pour sauce over chicken and top with grated cheese. Place under broiler for 4-5 minutes. Serve very hot. Good light supper with fruit salad.

You may wish to cook a 4-5 lb. chicken or the breasts alone in 5 cups water seasoned with salt, onion, carrot, celery and leaves, a bay leaf, thyme and marjoram—this will give you the flavorful stock needed in the sauce. Of course you may substitute canned chicken broth.

Mrs. Spencer S. Sanders

Crabmeat Sandwich

Serves: 5 or 6
Oven Setting: 325°

Very good for luncheon or Sunday night supper.

8-oz. package cream cheese
1 package frozen crabmeat, thawed and drained
1 teaspoon grated onion
juice of 1 whole lemon
Worcestershire sauce and Tabasco to taste
Holland Rusk
tomato slices
sharp cheddar cheese slices

Mix first six ingredients. Pile on Holland Rusk. Add a slice of tomato. Top with a slice of cheese. Bake in moderate oven 15 to 20 minutes.

Mrs. John D. Bansley

Mushroom, Shrimp and Egg Casserole

Serves: 8
Oven Setting: 300°

A make-ahead dish.

8 eggs, medium or small
mayonnaise
curry powder
2 lbs. fresh mushrooms, cut in half
1 lb. cooked shrimp
2 tablespoons butter
2 tablespoons flour
2 cups milk
½ teaspoon salt
¼ teaspoon pepper
½ cup cheese, grated

Hard boil and devil eggs with mayonnaise and curry powder to taste. Sauté mushrooms in butter until moisture is evaporated. Spread the mushrooms in the bottom of a shallow, large baking dish. Add the layer of shrimp and top with deviled eggs. (At this point it may be covered with a layer of wax paper and sealed with foil and refrigerated for a couple of days.) Make a cream sauce by melting butter, stirring in flour and milk, adding cheese and seasonings and stirring until smooth. Pour over eggs and bake until bubbling.

Oyster Loaf

Serves: 4-6
Oven Setting: 350°

We have this after a show, movie or on a Sunday afternoon.

1 large round sourdough loaf
¼ lb. butter
10-oz. package chopped frozen spinach
3 eggs, beaten
¾ cup mayonnaise
salt, pepper, Worcestershire sauce, cayenne, to taste
bread crumbs, toasted
15 medium raw oysters
2 medium tomatoes, sliced thin
½-1 cup Swiss cheese, grated

Remove top of bread, scoop out inside, leaving a shell. Toast top and insides for bread crumbs. Butter inside of loaf shell. Thaw spinach and drain thoroughly. Mix spinach with eggs and mayonnaise. Add seasonings. Layer the oysters, spinach mixture, tomatoes, crumbs and then cheese. Repeat layering until loaf is full. Place on cookie sheet and put in preheated oven. Bake 30-40 minutes.

Cut this in wedges and serve with a green, simple salad. (People do get tired of quiche!)

Ms. Helen Swint

Seafood Shells

Serves: 6-8
Oven Setting 350°

This works beautifully for brunch or as a ladies' luncheon entrée. It's also nice as a first course for small dinner parties.

1 lb. crabmeat, fresh or frozen
¾ lb. raw, peeled and deveined shrimp
6 tablespoons melted butter
¼ cup flour
1 teaspoon salt
¼ teaspoon pepper
1½ cups milk
2 tablespoons dry sherry
1 cup seasoned bread crumbs or herb stuffing mix
2 tablespoons melted butter
½ cup shredded cheddar cheese

Thaw crabmeat if necessary. Lightly sauté crabmeat and shrimp in 6 tablespoons of melted butter for 4-6 minutes. Remove shrimp and crabmeat. Stir flour, salt and pepper into butter. Add milk gradually and cook, stirring constantly, until thickened. Add sherry. Fold in crabmeat and shrimp. Spoon into individual baking shells or ramekins. Combine dry stuffing mix, 2 tablespoons butter and shredded cheddar cheese. Sprinkle over seafood mixture. Bake for 15-20 minutes or until bubbly. Serve immediately.

Ms. Charlotte Taylor

Pineapple-Chicken Open Sandwich

Serves: 8

For a bridal shower, I add a heart-shaped slice of jellied cranberry sauce!

¾ cup mayonnaise
¼ cup chili sauce
2 tablespoons chopped green onion
9-oz. can pineapple tidbits, drained
½ cup heavy whipping cream, whipped until stiff
8 slices diagonally-cut French bread, toasted and buttered

Eight servings each of:
crisp lettuce
2 tomato slices
sliced, cooked chicken breast
3 or 4 hard-cooked egg slices
seasoned salt and pepper

To prepare dressing: Combine first 4 ingredients and fold into whipped cream. Cover and chill. This will hold up several hours in the refrigerator.

To assemble sandwiches: On individual serving plates, top each slice of toast with, in order—lettuce; 2 tomato slices; sliced, cooked chicken breast; 3 or 4 hard-cooked egg slices; seasoned salt and pepper. Spoon pineapple dressing over each serving. Since this is a complete luncheon, it requires little more than a sprig of parsley or watercress.

Mrs. J. Bronson Overbey

Scrambled Eggs for a Party

Serves: 8 *They stay moist.*
Oven Setting: 140°-150°

16 eggs
⅔ cup light cream
1½ teaspoons salt
pepper to taste
1 cup medium white sauce (see below)
¼ cup butter
chopped fresh parsley

Whisk eggs with cream, salt and pepper. Make white sauce. Melt ¼ cup butter in large frying pan. Pour in egg mixture, stirring occasionally over low heat, until eggs are almost set. Fold in white sauce. Keep warm in a **very slow** oven. Sprinkle with parsley and serve.

White Sauce:
2 tablespoons butter
1½ tablespoons flour
1 cup milk

Melt 2 tablespoons butter over low heat, blend in flour, stir in milk slowly; cook and stir until smooth and creamy.

Apricot Ring Mold

Serves: 8-10 *Colorful dish for a brunch, a buffet,*
 or an elegant dinner.

2 envelopes unflavored gelatin
½ cup sugar
pinch salt
2 cups apricot nectar
¾ cup water
1 cup white wine
1 cup sour cream
Fresh fruit: cantaloupe, honeydew, strawberries,
** pineapple chunks, etc.**

In a saucepan combine first five ingredients. Cook on low heat and stir until gelatin dissolves. Stir in wine and remove pan from heat. Gradually blend in sour cream. (This can be whipped with a hand mixer to break up sour cream and give a smoother consistency.) Pour into 5½-cup mold. Chill until set. Unmold and fill ring with fresh fruit.

Mrs. John P. Thornton

Fresh Fruit Salad Sauce

Makes: 2½ cups *This is truly delicious!*

½ cup sugar
salt to taste
1 orange (juice and ½ teaspoon grated peel)
1 lemon-(juice and ½ teaspoon grated peel)
2 beaten eggs
4 teaspoons cornstarch
1 cup pineapple juice
8 oz. cream cheese

Combine all ingredients except cream cheese in the top of a double boiler. Cook until thick. Chill until cold. Whip the cream cheese and fold the other mixture into it. Serve over fresh fruit.

Mrs. Neal Ray

Crabmeat Stuffed Potatoes

Serves: 4
Oven Setting: 425° then
350°

Men love these potatoes!

4 medium baking potatoes
salad oil
6-oz. package frozen crabmeat
½ cup melted butter or margarine
½ cup half-and-half
teaspoon salt
dash pepper
4 teaspoons grated onion
1 cup shredded cheddar cheese
paprika

Wash potatoes and rub skins with oil. Bake at 425° for 45 minutes or until done. Allow potatoes to stand until cool to touch. Slice skin away from top of each potato. Carefully scoop out pulp, leaving shells intact; mash pulp. Combine potato pulp and remaining ingredients except paprika, stirring well. Stuff shells with potato mixture. Sprinkle with paprika. Bake in foil for about 30 minutes at 350° or until thoroughly heated.

Mrs. Kevin Heeney

Frosted Melon

Colorful and unusual on a buffet. A "how did you do it" dish.

1 medium-sized honeydew or cantaloupe
3-oz. package raspberry gelatin
1 cup hot water
10-oz. package frozen raspberries
 (may substitute your choice of fruits)
2 tablespoons milk
8-oz. package cream cheese

Peel whole melon, cut a slice from one end, remove the seeds and drain. Dissolve the gelatin in hot water. Chill slightly until thickened. Fold in raspberries and fill the melon. Chill until gelatin is firm. Blend milk and cream cheese until smooth and cover outside of melon. Place on a platter covered with lettuce. Slice to serve.

Mrs. J. Walter Coursey

Celery Seed Dressing

Can be used as a dip for melon balls and fresh pineapple squares, excellent on fruit salad and avocado salad.

½ teaspoon grated onion
½ cup sugar
1 teaspoon dry mustard
1 teaspoon salt
2 tablespoons cider vinegar
1 cup salad oil
2 more tablespoons vinegar
1 tablespoon celery seed

Mix first five ingredients in a mixing bowl with electric mixer; slowly pour in salad oil, beating continuously. Then add the 2 more tablespoons of vinegar and celery seed and blend well. Store in refrigerator. Keeps well.

Mrs. Lindsey Hopkins, Jr.

Oyster Rockefeller Casserole

Serves: 8 *Excellent served with turkey.*
Oven Setting: 450°

1 quart raw oysters
1 stick butter
1 onion, chopped
1 rib celery, chopped
½ cup parsley
10-oz. package frozen chopped spinach
¼ teaspoon anise seeds (optional)
¼ cup Worcestershire sauce
½ cup bread crumbs
salt, pepper, cayenne to taste
1 cup sharp cheese, grated
bread crumbs

Drain oysters. Sauté celery and onion in butter for 5 minutes. Add parsley, thawed spinach, anise seed, Worcestershire sauce, bread crumbs, salt, pepper, cayenne. Grease a shallow casserole. Arrange oysters in one layer only. Cover with Rockefeller mixture. Bake for 30 minutes. Remove and sprinkle with cheese and a very thin layer of bread crumbs. Return to oven 10 minutes.

Mrs. F. C. Steinmann, Jr.

Bourbon Nut Bread

Yield: 3 loaves *Freezes well.*
Oven Setting: 350°

8 eggs, separated
3 cups sugar
1 lb. butter
3 cups sifted flour
½ cup bourbon
2 teaspoons vanilla
2 teaspoons almond extract
1 cup pecans, chopped

Beat egg whites until soft peaks form. Gradually add 1 cup sugar, beating until stiff peaks form. Cream butter and remaining sugar. Add egg yolks one at a time, beating well after each egg. Add flour in thirds, alternating with bourbon. Mix well. Stir in vanilla, almond extract and pecans. Fold in egg whites. Pour into 3 greased 9″ x 5″ loaf pans. Bake for 1 hour or until done.

Mrs. Thorne Winter

Applesauce Brulée

Serves: 6-8 *Makes a nice autumn dish.*

4 cups homemade applesauce
1 pint sour cream
brown sugar

Applesauce:
3 lbs. Granny Smith apples
½-1 cup brown sugar (depends on tartness of apples, to taste)
salt to taste
2 tablespoons butter
2 teaspoons cinnamon
1 teaspoon freshly grated nutmeg

First make applesauce by cooking pared, cored apples with a little water until soft (but not mushy). Add brown sugar, butter and seasonings and continue to cook for a few minutes. Place applesauce in a soufflé dish or in individual ovenproof dishes. Cover with sour cream and sift brown sugar heavily over top. Place under the broiler, watching closely, until sugar caramelizes.

Lemon Cream Puffs

Makes: filling for 12
large puffs

Lemon curd will keep in a glass jar in refrigerator for several weeks.

Lemon curd:
grated rind of 2 large lemons
⅔ cup sugar
5 large egg yolks
juice of 2 large lemons (about ½ cup)
½ cup unsalted butter, melted
¾ cup heavy cream
confectioner's sugar

Combine lemon rind, sugar, egg yolks and lemon juice in top of double boiler over hot, not boiling, water. Stirring constantly, add melted butter and cook very slowly until thickened (this may take up to 30 minutes). Remove from heat and cool. Whip cream until stiff. Fold in lemon curd. Fill cooled cream puffs and sprinkle with confectioner's sugar. (Fill puffs not more than 3 hours before serving.) Use with cream puff recipe on page 21.

Scot Rock Cakes

Makes: 4 dozen
Oven Setting: 375°

I acquired this recipe on the Hebrides island of Iona. My family loves them for snacks or for breakfast.

2 sticks butter
4 cups self-rising flour
¾ cup sugar
3 whole eggs, beaten
2 tablespoons currants or raisins
1 oz. chopped crystallized ginger
milk, approximately 1 cup (or enough to make a stiff
** dough)**

Cream the butter, flour and sugar. Add beaten eggs, raisins, ginger and mix well. Add milk gradually to make a stiff dough. Drop by teaspoonfuls onto an ungreased cookie sheet. Bake 15 minutes. Serve warm with butter, jam or jelly, or plain.

Mrs. Frank H. Maier, Jr.

Apricot Squares

Makes: 40
Oven Setting: 325°

From a good friend in Philadelphia.

1 cup flour
1 teaspoon baking powder
½ teaspoon salt
½ cup butter, soft
1 egg beaten
1 tablespoon milk
12-oz. jar apricot preserves
⅛ lb. melted butter
1 cup sugar
1 cup coconut
1 beaten egg

Sift together flour, baking powder, salt. Add butter, egg and milk. Beat until smooth. Pat mixture into 10″ x 15″ pan. Spread thin. Spread apricot preserves on dough. Top with melted butter, sugar, coconut and egg mixture. Bake approximately 25 minutes until top and bottom are golden. Cool in pan before cutting into small squares. Delightful for morning coffees or teas, as a cookie with ice cream or fruit.

Mrs. R. Mark Wilkiemeyer

Apple Pecan Squares

Makes: 24
Oven Setting: 350°

Better the second day; moist and delicious.

2 cups flour
2 cups firmly packed brown sugar
½ cup butter
1 cup pecans
1 teaspoon cinnamon
1 teaspoon baking soda
¼ teaspoon salt
2 large, peeled, tart apples
1 egg
1 cup sour cream
1 teaspoon vanilla

Preheat oven. Lightly grease 9" x 13" baking dish. Combine first three ingredients in work bowl of food processor fitted with metal blade, and process until mixture is crumbled (resembles oatmeal). Add pecans and process again, 2-3 quick turns, to chop nuts and blend them into the flour mixture. Press 2 cups of mixture evenly into bottom of prepared dish.

Empty the remaining crumb mixture into another bowl and add the cinnamon, soda and salt, and blend well. Place the apples, sliced into large chunks, into the work bowl and process until finely chopped. Add the crumb mixture, the egg, sour cream and vanilla and process quickly until smooth and well-blended.

Spoon evenly over crust in baking dish. Bake about 35-40 minutes, until cake begins to pull away from sides of dish. Let cool completely in pan. Cut into squares. Serve for brunch, or top with vanilla ice cream, whipped cream or hot caramel sauce for dessert.

Applesauce-Oatmeal Muffins

Makes: 14 regular-sized muffins or 25 small muffins
Oven Setting: 350°

Perfect especially when made in tiny muffin tins.

½ cup margarine or butter
¾ cup light brown sugar, packed
1 egg
1 cup flour, lightly spooned into cup
½ teaspoon cinnamon
1 teaspoon baking powder
¼ teaspoon salt
¾ cup applesauce
½ cup raisins and 1 apple, chopped finely
1 cup rolled oats (oatmeal)
½ cup chopped nuts (optional)

Cream butter and gradually add brown sugar. Cream until light and fluffy. Add egg and beat well. Mix in the next 4 ingredients and add applesauce to the creamed mixture, stirring well. Then add raisins, apple and oats (and nuts if desired). Spoon into well-greased muffin cups or muffin papers. Bake in preheated oven for 25-30 minutes.

Mrs. Linda Dangel

German Apple Pie

Makes: 1 pie, 6-8 servings
Oven Setting: 15 minutes
400° then 35 minutes at 350°

Serve hot with coffee ice cream.

2 tablespoons flour
⅛ teaspoon salt
¾ cup sugar
1 egg
1 cup dairy sour cream
1 teaspoon vanilla
¼ teaspoon ground nutmeg
2 cups sliced, peeled apples
1 pie shell or deep-dish equal

Nut topping:
 ¼ cup sugar, ¼ cup flour, ¾ teaspoon ground cinnamon, ¼ cup chopped nuts (or oatmeal), ¼ cup butter; mix until crumbly.

Combine flour, salt, sugar, egg, sour cream, vanilla and nutmeg; beat well with spoon or fork—do not use blender. Fold in apples. Pour into either a pie shell (unbaked) or into a deep dish of equal volume. Bake in 400° oven 15 minutes. Reduce oven to 350° and bake 35 minutes longer. Remove from oven, sprinkle with nut topping. Return to oven 10 minutes or until lightly browned.

Ms. Jane Stanaland

Amaretti Torte

Serves: 6-8
Oven Setting: 350°

The best "moist" cake we've tasted. Stupendous!

10 amaretti (Italian macaroons), to make ½ cup of crumbs
1 cup unsalted butter, at room temperature
1 cup granulated sugar
5 eggs, separated
½ cup all-purpose flour
4 squares (4 oz.) semisweet chocolate, finely grated
confectioner's sugar

Preheat oven. Pulverize amaretti in electric blender. Cream together butter and sugar and beat in the egg yolks, one at a time. Continue beating for 10 minutes. Gradually add flour and amaretti crumbs, beating after each addition. Fold in the chocolate. Beat the whites until stiff and fold them in. Pour into a 10" x 2" round pan that has been well-greased with butter and lightly sprinkled with flour. Bake 35-45 minutes. Before serving, sprinkle with confectioner's sugar.

Ms. Gale F. Barnett

GALLERY IV
Contemporary Concepts

HARRY BERTOIA (American, 1915-1978)
Tension, 1967, Stainless steel sculpture, 37 inches high. Gift of the Helena Rubinstein Foundation in honor of the Rich's Inc. Centennial, 1967. *Color reproduction in The High Museum of Art Recipe Collection sponsored by Concept Capital Corporation.*

Gallery IV

Boursin at Home

Serves: a crowd
Food Processor

Spread on thinly-sliced beef and roll up for an unusual hors d'oeuvre.

2 large, fresh cloves garlic
2 (8-oz.) packages cream cheese (room temperature)
8-oz. package whipped sweet butter (room temperature)
⅓ teaspoon fresh ground pepper
½ teaspoon each of salt, thyme, basil, oregano, dill, marjoram

Drop garlic into food processor fitted with chopping blade and mince. Add rest of ingredients and process until blended, soft and creamy. Refrigerate overnight or freeze.

Ms. Yardley Williams

Emergency Beef Dip

Serves: 6
Oven Setting: 350°
Food Processor

It couldn't be easier.

1 onion, chopped
3 tablespoons green pepper, chopped
8-oz. package cream cheese
2 tablespoons milk
2½ oz. dried beef, shredded
½ cup sour cream
½ cup pecans
dash pepper

Use steel blade to chop onion and green pepper. Remove onion and pepper, leave steel blade in place. Add cream cheese (cut in cubes) and milk and blend. Add remaining ingredients and blend. Bake for 30 minutes. Serve hot.

Mrs. Edward C. Bivens

My Very Own Pâté

Makes: about 2 cups
Food Processor

It disappears in no time!

2 cups chicken stock
2 cups water
1 stalk celery, cut in 4 pieces
1 tablespoon parsley
¼ teaspoon pepper
1 lb. chicken livers
1 medium onion, halved and sliced
1½ teaspoons salt
1 pinch cayenne pepper
1 cup butter, softened
½ teaspoon nutmeg
2 teaspoons dry mustard
¼ teaspoon garlic powder
2 tablespoons brandy or cognac

Bring water and chicken stock to a boil. Add celery, parsley and pepper. Reduce heat and simmer 5 minutes. Add the washed, deveined chicken livers and onion. Cook, covered for 10 minutes. Drain livers, remove celery, and grind livers and onion in food processor until smooth. Add salt, cayenne, butter, nutmeg, mustard, garlic and brandy. Blend thoroughly. Pack in 3-cup container and chill. Garnish with sliced green olives if desired.

Mrs. Frederick L. Muller

Green Yogurt Soup

Serves: 6-8
Food Processor or Blender

Light summer fare.

6 scallions, chopped
2 tablespoons butter
3 cucumbers, peeled, seeded and chopped
1 cup spinach, chopped
3 medium potatoes, peeled and quartered
3 cups chicken broth
1 cup plain yogurt
salt and freshly ground pepper to taste
juice of ½ lemon
watercress

Sauté scallions in the butter. Add cucumbers, spinach and potatoes. Cover with chicken broth, bring to a boil and simmer, covered, until potatoes are tender (about 20 minutes). Purée mixture in food processor or blender. Pour into a bowl, add yogurt, and mix well with a whisk. Add salt, pepper and lemon juice. Refrigerate for several hours. To serve, decorate with watercress.

Mrs. Dewey F. Locke

Blender Gazpacho

Serves: 6
Blender

This spicy cold soup from Spain makes an appetizing first course.

1 slice stale bread
wine vinegar
salad oil
1 clove garlic, minced or pressed
28-oz. can of whole tomatoes
1 small onion, chopped
1 green pepper, chopped
1 cucumber, peeled and sliced
cayenne
Tabasco sauce
lemon juice (fresh)

Crumble stale bread in a bowl. Add enough vinegar and oil to thoroughly moisten the bread. Add minced garlic. Mix, pressing garlic into bread bits. Set aside for an hour. Then place in a blender, adding a half cup of the juice from can of tomatoes. Purée. Add chopped onion, green pepper and cucumber. Blend at a low speed.

Add all tomatoes and remaining juice from can. Blend. Add cayenne pepper and Tabasco sauce to taste. Add dash of lemon juice. Refrigerate. Serve very cold. Garnish with croutons, chopped green peppers, chopped celery or chives.

Editor's note: Consistency of gazpacho can vary from crunch-coarse to smooth, according to your taste.

Ms. Paula Hancock

Chilled Broccoli Soup

Serves: 6-8
Food Processor

Reserve enough broccoli florets to float one in each bowl.

3 tablespoons butter
1 cup onion, coarsely chopped
1 bunch broccoli
2 Idaho potatoes, peeled and diced
6 cups chicken broth
salt and freshly ground pepper to taste
⅔ cup fresh parsley leaves
1 cup half and half (optional)

Melt butter in heavy saucepan. Add onions and cook until transparent; do not brown. Wash and trim broccoli, you may use the stems but peel first (as asparagus) then slice. Add broccoli, potatoes and broth to onions in pan. Bring to a boil and season with salt and pepper. Simmer covered until broccoli is tender, 20-30 minutes. Set aside to cool.

Blanch parsley 3 minutes. Drain and cool. Drain broth from cooked vegetables and purée the broccoli mixture in processor. When just a little texture remains, add the blanched parsley and purée a few seconds. Combine with broth, stirring well. Refrigerate until needed. Can be made 5 days ahead.

Serve this soup hot or cold. If you don't mind the extra calories, add 1 cup half and half.

Fresh Vegetable and Cheese Pie (Crustless)

Serves: 6
Oven Setting: 350°
Food Processor

A vegetarian entrée.

1 medium eggplant, peeled and cubed
2 medium zucchini, peeled and diced
1 large onion, diced
¼ lb. mushrooms, sliced
olive oil
2 large tomatoes, peeled and chopped
2 tablespoons minced parsley
¼ teaspoon each basil and oregano
dash of cayenne pepper
1 teaspoon salt (or to taste)
¼ teaspoon pepper
3 eggs
1 cup grated Romano cheese
¼ lb. thinly-sliced Mozzarella cheese

Chop vegetables coarsely in a food processor. Sauté eggplant, zucchini, onion and mushrooms in olive oil until vegetables are softened (8-10 minutes). Add tomatoes and simmer, covered, for 5-10 minutes. Add seasonings. Uncover and cook over high heat, stirring constantly, until moisture has evaporated. Transfer to a mixing bowl and cool.

Beat eggs with ½ cup Romano cheese and seasonings and mix in with vegetables. Pour half of mixture into a greased deep 9″ pie plate and cover with remaining Romano cheese. Spread remaining vegetables in pie and cover with sliced Mozarella cheese. Bake for 30-35 minutes or until pie is set and cheese is browned.

Pie may be made the day before and baked just before serving, or it may be baked earlier and reheated before serving.

Mrs. Neal Ray

Tuna Popovers

Makes: 4
Oven Setting: 400°
Food Processor

Pretty, light and tasty.

Filling:
1 cucumber
1 green pepper
2 (7-oz.) cans tuna, well-drained
salt and pepper to taste
1 tablespoon lemon zest
1 cup mayonnaise

Popovers:
1 cup milk
1 cup all-purpose flour
2 large eggs
2 tablespoons unsalted butter, melted and cooled
½ teaspoon salt

lettuce leaves
paprika

Filling: Peel and seed the cucumber. Position knife blade in food processor and chop cucumber and green pepper. Drain well. Combine tuna, cucumber, green pepper, salt, pepper, lemon zest and mayonnaise. Store in refrigerator.

Popovers: Combine milk, flour, eggs, butter and salt in a food processor or blender and blend well. Butter 4 6-oz. custard cups and chill until butter is hardened. Divide the popover batter among the cups. Set the cups on a preheated baking sheet and bake in a preheated oven for 40 minutes. Cut a slit in the side of each popover and bake 5 minutes more. Remove popovers from custard cups and let cool. Slit the popovers open lengthwise and remove and discard any uncooked dough. Place on lettuce leaves, mound tuna on top, sprinkle with paprika, add a sprig of parsley.

Mrs. G.A. Barnes

Beef Burgundy

Serves: 6
Crock Pot

An easy attractive main dish, very tasty with vegetables or tossed salad.

2 slices bacon, chopped
2 lbs. sirloin tip or round steak cut into 1-inch cubes
¼ cup flour
½ teaspoon seasoned salt
½ teaspoon marjoram
½ teaspoon thyme
¼ teaspoon pepper
garlic salt to taste, if preferred
1 beef bouillon cube, crushed
1 cup Burgundy wine
¼ lb. sliced mushrooms, fresh or canned
2 tablespoons cornstarch (optional)

In slow-cooking pot with browning unit or large skillet, cook bacon several minutes. Remove bacon and set aside. Coat beef with flour and brown on all sides in bacon fat. Combine beef, bacon and drippings, seasonings, bouillon and burgundy in slow-cooking pot. Cover and cook on low for 6-8 hours or until meat is tender. Turn control to high. Add mushrooms. If fresh, cook on high 15 minutes; if canned, cook on high 5 minutes. To thicken sauce, if desired, add cornstarch (dissolved in 2 tablespoons cold water) with mushrooms.

Ms. Carol Burch Tooke

Mulligatawny

Serves: 8
Food Processor

The apples make it good.

1 3½-lb. chicken, cut into pieces
3 tablespoons butter
1 medium onion
2 small carrots
1 medium green pepper
2 Granny Smith Apples
2 tablespoons curry powder
2 tablespoons flour
6 cups chicken broth
½ cup grated coconut
1 tablespoon sugar
1 teaspoon salt
4 whole cloves
3 small tomatoes, peeled, seeded and quartered
2 tablespoons fresh parsley
1½ cups cooked rice

Brown chicken pieces in butter in a large kettle. Remove the chicken pieces from the kettle. In a food processor finely chop the onion, carrots, green pepper and apples. Place the chopped vegetables and apples in the kettle and cook until the mixture is lightly browned.

Blend in the curry powder and flour. Simmer 5 minutes. Add the chicken broth, coconut, sugar, salt and cloves, stirring after each addition. Add the browned chicken pieces. Simmer at low boil for 30 minutes.

In a food processor, finely chop the tomatoes and parsley together and add them to the soup. Cook an additional 15 minutes. Remove the chicken from the kettle. Discard the skin and bones and cube the meat by hand. Set aside. Purée the soup in a food processor. This will have to be done in several batches. Return the soup to the heat. Add cubed chicken. Serve hot. Garnish with spoonfuls of cooked rice.

Mrs. Albert L. Cook, III

Chicken Mediterranean

Serves: 4-6
Crock Pot

This is a great dish for golfers, tennis players, or bridge players. Prepare it, plug it in and enjoy your day!

1 cut-up frying chicken
1 lb. fresh or canned mushrooms
¼ teaspoon ground black pepper
1 teaspoon salt
1 lb. can of tomatoes
½ cup chopped onions
1 bay leaf
2 teaspoons basil leaves
2 medium zucchini, cut into 2-inch chunks
1 green pepper, cut into strips

Put chicken into crock pot. Add rest of ingredients. Cook on low temperature for 6-8 hours. When ready to serve, if desired, you may slightly thicken the sauce and serve with rice or noodles.

Mrs. George Goodwin

Pesto Genovese (Green Pasta Sauce)*

Serves: 4 *Stores well.*

1 cup basil leaves, fresh
10 sprigs fresh parsley
½ cup pine nuts
3 garlic cloves, peeled
¼ cup Parmesan cheese, freshly grated
¼ cup Romano cheese, grated
4 tablespoons olive oil
2 tablespoons soft butter
¼ teaspoon salt

Place all ingredients in bowl of food processor and blend thoroughly.

*This is a famous Italian sauce for any kind of freshly-made pasta—fettuccine, linguini or spaghetti. (After cooking and draining the pasta, toss well with the pesto.) It is also an excellent final enrichment for minestrone or vegetable soup. Just before serving soup, swirl a tablespoonful of pesto per serving into the heated soup. Stores well in an air-tight glass container in the refrigerator for weeks or can be frozen for up to 6 months if cheeses are not added until serving time. If oil separates during storage, reprocess briefly.

Mr. Ward Morris

Perfect Microwave Scrambled Eggs

eggs
1 teaspoon butter per egg
1 tablespoon milk per egg

Place butter in a glass measure or casserole. Microwave at HIGH until melted. Scramble eggs with the melted butter and milk and place in microwave. Estimate ¾ minute per egg and microwave at HIGH for ½ of total time. Stir set portions from the outside to the center. Repeat 1 or 2 times during remaining cooking period. Take eggs out of oven when they are just past the runny stage. Let eggs stand 1 or 2 minutes on counter and they will set. (The secret is not to try to cook the eggs in the microwave until they look done because when they set they will become too hard and stringy.)

Fresh Peach Jam

Makes: 6-7 cups *Excellent with mid-summer*
Microwave *Georgia peaches.*

4 cups peeled, pitted and finely chopped fresh peaches
2 tablespoons lemon juice
1 box (1¾ oz.) powdered fruit pectin
6 cups sugar

In 3-quart casserole place peaches, lemon juice and pectin. Stir well. Cover. Microwave at HIGH 8 to 10 minutes, or until mixture is at a full rolling boil. Stir. Add sugar to boiling mixture, stirring well. Microwave at HIGH 7 to 9 minutes, uncovered, stirring after 4 minutes, until mixture reaches a full rolling boil. Then time for 1 minute more of boiling. Skim off foam and stir jam about 5 minutes before spooning into sterilized jars. Seal.

Mrs. Terry Lee Nevel

Tabouli

Serves: 4
Food Processor

A break in the same-old-salad routine.

6 medium tomatoes
½ green bell pepper
1 small bunch parsley
1 small bunch green onions
½ cup bulgur wheat

Dressing:
juice of 2 lemons
½ cup corn oil
1 teaspoon dried mint, crushed
salt

Chop tomatoes, pepper, parsley and green onions in a food processor. Put the bulgur in a large mixing bowl. Add the chopped tomatoes, pepper, parsley and onions. Mix the dressing ingredients together and pour over salad. Place the salad in refrigerator for at least 30 minutes prior to serving. Salt salad to taste just before serving.

Mrs. Mary Salem Thomas

Mandarin Orange Salad with Tarragon Dressing

Serves: 4
Food Processor

Colorful.

Salad:
3 green onions
¼ cup pecans
small handful of fresh parsley
lettuce leaves (Boston lettuce)
2 cups mandarin oranges
1 cup purple grapes, halved and with seeds removed

Dressing:
3 tablespoons vinegar
¼ teaspoon salt
¼ teaspoon white pepper
1 tablespoon dried tarragon
½ cup vegetable oil

Position slicing disc in food processor bowl and slice green onions. Remove disc and onions and dry bowl. Position steel blade in bowl, add nuts and pulse until coarsely chopped. Remove nuts and chop parsley the same way. Drain the mandarin oranges. Mix all the above ingredients together in a bowl and add grapes.

Leave steel blade in place and add vinegar, salt, pepper and tarragon. Pulse. Add the vegetable oil a little bit at a time until all the oil is absorbed. Pour ¼ cup of the dressing over the salad and refrigerate at least 30 minutes before serving. Arrange lettuce leaves on individual salad plates and mound orange mixture on top. Add the remaining dressing.

Mrs. Cecil Levans

Amaretto-Coconut Pie

Serves: 8
Oven Setting: 350°
Food Processor

Easy to prepare since it does not require a pie crust.

¼ cup margarine
1 cup sugar
2 eggs
¾ cup milk
¼ cup Amaretto
¼ cup self-rising flour
½ (3½ oz.) can flaked coconut

Cream margarine and sugar in food processor or mixer. When smooth, add eggs, blending well. Add milk, Amaretto and flour, continuing to beat. Remove bowl from processor or mixer, stir in coconut. Lightly grease a 9″ pie plate with margarine and pour in mixture. Bake for 45 minutes or until center firms.

Mrs. Frank Steinbruegge

Cassis Cream

Serves: 6-8
Food Processor

A treat for blackberry lovers.

12-oz. package frozen blackberries
1 cup sugar
1 cup Creme de Cassis (black currant liqueur)
½ gallon "good" vanilla ice cream
blackberry or currant preserves (optional)

Purée blackberries and sugar in food procesor with some of the liqueur. Add ice cream and remaining liqueur gradually and process until smooth. You may process this mixture to a nearly liquid stage and serve in stemmed goblets, or leave the mixture with more substance and serve in bowls. If desired, top it with blackberry or currant preserves blended with additional Creme de Cassis.

Curried Fruit Compote

Serves: 4-6
Microwave

Garnish with mint if you like.

17-oz. can apricots
29-oz. can pear halves
20-oz. can pineapple slices
29-oz. can peach halves
maraschino cherries to taste
⅓ cup butter
¾ cup light brown sugar
2½ tablespoons curry powder
fresh, chopped mint leaves (optional)

Drain fruit well. Place fruit in a large casserole. Blend butter, brown sugar and curry. Spoon over fruit. Microwave, uncovered on HIGH for 8 minutes, then turn. Continue baking on HIGH for 2 to 7 more minutes. Serve warm.

Mrs. Terry Lee Nevel

Sorbet aux Pamplemousse

Serves: 8 *Low-calorie.*
Blender or Food Processor

4 pink grapefruit
1¼ cups sugar
⅓ cup water
3 egg whites
¼ teaspoon cream of tartar
pinch of salt

Remove the zest from one of the grapefruit. You should have about 1 tablespoon. Use only the colored part of the fruit, not pulpy white part.

Peel the grapefruit and cut out the sections, removing the seeds. Purée the pulp and zest in a blender or food processor. You need 3 cups of purée.

Make a sugar syrup of the sugar and water by boiling them together uncovered until a candy thermometer registers 238° (soft-ball stage). This takes about 5 minutes.

While the sugar syrup is boiling, beat the egg whites. When soft peaks form, add the cream of tartar and a pinch of salt. When stiff peaks begin to form, add the sugar syrup and continue beating until the meringue cools.

Gently stir in the purée and pour the mixture into a large shallow pan. Freeze until the mixture begins to set (about 1 hour), then whisk it to break up the ice crystals. Do this two or three times (about every 45 minutes) before putting the sherbet into a mold or other serving container for the final freezing. Allow to soften 30 minutes in the refrigerator before serving.

Mrs. Rawson Foreman

Microwave Ice Cream Pie

Serves: 6 *A make-ahead dish.*
Microwave

6 tablespoons (¾ stick) butter
¾ cup flour
3 tablespoons packed brown sugar
¾ cup finely ground pecans
1 quart "good" ice cream, vanilla or other

Caramel sauce:
½ lb. vanilla caramels
½ cup whipping cream

Heat butter in a 4-cup measuring cup until melted, 30-40 seconds. Stir in flour, brown sugar and half the pecans, stirring to mix well. Pat mixture gently but firmly onto bottom and sides of 9" glass pie plate.

Microwave 1½ minutes, rotate half turn and cook 1 more minute. Allow to cool. Slightly soften ice cream (you can place container on a plate and heat ½ minute). Fill shell with ice cream and sprinkle with remaining pecans. Freeze until just before serving. Serve with caramel sauce.

Caramel sauce: Place caramels and cream in 4-cup glass measuring cup. Heat 1½-2 minutes. Stir. Heat 1½-2 minutes more and mix until smooth. Serve warm.

Banana Pudding

Serves: 6-8
Microwave

Serve warm or chilled.

¾ cup sugar
2 tablespoons cornstarch
¼ teaspoon salt
2 cups milk
2 eggs, well beaten
2 tablespoons butter
1 teaspoon vanilla extract
1 box vanilla wafers
5 to 6 fully ripe bananas, sliced

In 1-quart casserole blend together sugar, cornstarch and salt. Gradually stir in milk, mixing well. Microwave on HIGH 5 to 7 minutes; stir every 3 minutes, until mixture is smooth, thickened and clear. Stir a small amount of hot pudding quickly into eggs. Return egg mixture to hot pudding, mixing well. Microwave at MEDIUM HIGH 1 to 3 minutes, stirring after 1 minute, until smooth and thickened. Add butter and vanilla. Stir until butter is melted. Spread small amount of pudding on bottom of 1½-quart casserole. Cover with layer of vanilla wafers. Top with layer of sliced bananas. Pour some of pudding over bananas. Continue to layer wafers, bananas and pudding in that order until pudding is used.

Mrs. Terry Lee Nevel

Scrumptious Nut Brittle

Makes: 1 pound
Microwave

Candy cooks so well in a microwave!

½ cup white corn syrup
1 cup sugar
1 cup pecan halves or raw cashews
1¼ teaspoons butter
1 teaspoon vanilla extract
1 teaspoon baking soda

In 1½-quart casserole stir together corn syrup and sugar. Microwave at HIGH 4 minutes. Stir in nuts. Microwave at HIGH 3 to 5 minutes, until light brown. Add butter and vanilla to syrup, blending well. Microwave at HIGH 1 to 2 minutes. The syrup will be very hot and the nuts will be slightly browned. Add baking soda and gently stir until light and foamy. Pour mixture on Teflon cookie sheet or lightly greased cookie sheet. Let cool ½ to 1 hour. When cool, break into pieces and place in a closed container.

GALLERY V
From Alfresco to Barbecue

JOHN SINGER SARGENT (American, 1856-1925)
Portrait of Ralph Curtis on the Beach at Scheveningen, 1880, oil on board, 11 x 14 inches. Gift of the Walter Clay Hill and Family Foundation, 1973. *Color reproduction in The High Museum of Art Recipe Collection sponsored by J. T. Holding Company.*

Gallery V

Lemonade Sangria

Makes: approximately
2 quarts

Refreshing!

1 quart inexpensive burgundy
1 quart prepared lemonade
½ cup sugar
lemon and orange slices

Mix all ingredients together and chill overnight. Much better when prepared ahead.

Ms. Sal Henley

Strawberry Tea

Yield: 4 glasses

Use very ripe berries.

1 pint fresh, ripe strawberries
4 cups strong English breakfast tea, chilled
½ cup fresh lemon juice
½ cup sugar

In blender or food processor purée 1¼ cups sliced strawberries. Strain purée through a sieve into a pitcher. Add the tea, lemon juice and sugar. When ready to serve, pour over ice and garnish with whole strawberries. Add extra sugar if necessary.

Mrs. Thomas Henry Nickerson, IV

Cold Plum Soup

Serves: 6-8

Marvelous for an outdoor supper on a hot evening.

1 (1 lb. 3 oz.) can plums
1 cup water
⅔ cup sugar or ½ cup honey
1 cinnamon stick
¼ teaspoon pepper
pinch of salt
½ cup heavy cream
½ cup red wine
1 tablespoon cornstarch
2 tablespoons fresh lemon juice
1 teaspoon grated lemon rind
1 cup sour cream
3 tablespoons brandy (optional)
additional sour cream and cinnamon for garnish

Drain, pit and chop plums, reserving syrup. Combine plums, syrup, water, sugar, cinnamon, pepper and salt and bring to a boil. Reduce heat and cook for 5 minutes. Stir in heavy cream and red wine mixed with cornstarch. Continue cooking and stirring until thick. Add lemon juice and rind and remove from heat. Whisk one cup of soup with sour cream and brandy in a separate bowl until smooth, then add to rest of plum mixture. Chill, covered, at least 4 hours. Garnish with additional dollop of sour cream and sprinkle of cinnamon if desired.

Mrs. E. Lewis Hansen

Shrimp Gazpacho

Serves: 8 *A great gallery-going energizer!*

½ lb. cooked shrimp
5 freshly squeezed lemons
2½ cups tomatoes (canned or fresh, remove peel)
½ cup V-8 juice
1½ cups Mr. and Mrs. T (tomato cocktail mix)
Adjust juices depending on how spicy you like your
 gazpacho.
2 cups finely chopped cucumbers, peeled and seeded
½ cup finely chopped onions
½ cup finely chopped green peppers, seeded
¼ cup minced parsley
3 teaspoons salt
1 teaspoon Tabasco sauce
⅓ cup olive oil

Peel and clean shrimp. Cover with lemon juice.
Refrigerate to chill while the rest of the gazpacho is
being prepared. Combine remaining ingredients.
Some of the vegetables can be chopped in the blender
by adding small amounts of the tomato juice with
them. Blended vegetables should be crunchy, not
pulverized. Add chilled shrimp and lemon juice. Blend
and enjoy!

Mrs. Wicke Chambers

Cream of Sorrel Soup

Serves: 6 *A triumph. Serve hot or cold.*

⅓ cup minced green onions or yellow onions
3 tablespoons butter
3-4 cups of sorrel leaves, cut in fine shreds
salt
3 tablespoons flour
5½ cups boiling chicken broth, fresh or canned
2 egg yolks
½ cup whipping cream
1-2 tablespoons softened butter

Cook onions slowly in the butter in covered
saucepan for 5-10 minutes until tender and
translucent, but not brown. Stir in sorrel and salt,
cook (covered) about 5 minutes or until tender and
wilted. Sprinkle with flour and stir over moderate
heat for 3 minutes. Off heat, beat in boiling stock.
Simmer for 5 minutes and correct seasoning. (May be
set aside uncovered at this point. Reheat to simmer
before proceeding.) Blend egg yolks and cream in a
mixing bowl. Beat a cupful of soup into them in
dribbles. Gradually beat in rest of soup in a thin
stream. Return soup to saucepan and stir over
moderate heat a minute or two to poach egg yolks,
but do not simmer. Take off heat, stir in the 1 or 2
tablespoons of butter a tablespoon at a time. To serve
cold: Omit final butter and chill.

Mrs. Robert Milburn Smith

Grilled Beef Brochettes

Serves: 6 *Prepare the night before.*

5 lb. sirloin cut in chunks

Marinade:
1 cup soy sauce
¼ cup oil
1½ cups white wine
¾ cup brown sugar
½ tablespoon ground ginger
3 bay leaves
½ cup onion, chopped
dash thyme

Mix all ingredients together for marinade. Marinate
steaks overnight. Skewer meat and grill to taste.

Mrs. Donald Brown

Mixed Grill
(lamb chops, sausage and chicken livers)

Serves: 6

Great served with rice pilaf, tossed green salad and a hearty red wine. Men especially love it.

Marinade:
1 medium onion, chopped
2 tablespoons parsley, chopped
1 teaspoon salt
¼ teaspoon fresh ground pepper
½ teaspoon fresh rosemary, chopped or ¼ teaspoon dried
¼ teaspoon dry mustard
½ teaspoon Worcestershire sauce
¼ cup vegetable oil
1 garlic clove, minced

Meats:
6 lamb chops
6 pork sausages
12 chicken livers

Vegetables:
12 medium mushrooms
12 green pepper pieces
6 red onion pieces (optional)
12 cherry tomatoes

Mix above marinade ingredients together and pour over lamb and chicken livers. Marinate, turning occasionally, for one to six hours before grilling, depending on intensity of flavor desired. Precook sausages in a covered skillet with a small amount of water for 5 minutes. Drain. Add to other meats in marinade.

Arrange all the meats on one set of skewers. Arrange mushrooms, green pepper and red onion (if used) on another set. Arrange cherry tomatoes on one more skewer. (The number of pieces on each skewer will depend on the size of your grill and the area of live coals.) Grill meats and vegetables, turning as needed, until done. (About 10-15 minutes over medium heat.) Brush with the extra marinade during cooking. Add skewer of cherry tomatoes for the last 2-3 minutes of cooking.

Mrs. C.W. Morris

Beef Vinaigrette

Serves: 4-6

This recipe travels nicely for a picnic.

¼ cup wine vinegar
1 cup salad oil
1 teaspoon salt
freshly ground black pepper
1 tablespoon Dijon mustard
1 clove garlic, minced
2 tablespoons fresh parsley, chopped
2 tablespoons chives, chopped
⅓ cup sour pickles or Cornichon, chopped
1½ pounds cold cooked roast beef sliced ⅛" thick and cut into strips approximately ½" x 2"
1 Vidalia onion, thinly sliced (or other mild onion)

Combine all ingredients except beef and onion in jar and shake well. Place beef strips and onion slices in bowl and pour dressing over. Marinate in refrigerator for 3-6 hours. Serve on a bed of romaine or spinach leaves, garnish with sliced fresh mushrooms and tomato wedges.

Meat can be increased to 2 lbs. if you have hearty eaters.

Serve with Parmesan bread. Split a long loaf of French or Italian bread lengthwise. Spread cut sides with ⅓ cup Parmesan cheese, place on baking sheet and bake at 400° for 10 minutes.

Broiled Honeyed Chicken

Serves: 4
Oven Setting: Broil

Excellent for light summer supper.

2 broiler chickens, split or quartered
juice of 2 lemons
½ teaspoon salt
¼ teaspoon freshly-ground pepper
½ cup honey
¼ lb. butter
1 teaspoon rosemary
¼ teaspoon garlic powder

Sprinkle both sides of chicken with lemon juice, salt and pepper. Brush both sides lightly with honey. Blend butter, rosemary and garlic powder together. Spread half of this mixture over side of chicken which will face broiler or grill. Broil 10 minutes. Turn and spread remaining mixture on other side of chicken. Broil an additional 10 minutes, or until done.

Mrs. C.W. Morris

Lemon-Soy Chicken Legs

Serves: 4

If you want your grill to look fancy while chicken cooks, ask for all right or left legs.

8 whole chicken legs
1 stick (¼ lb.) butter
juice of one lemon
1 cup of soy sauce

The chicken legs may be marinated for several hours in the last three ingredients, but it is not necessary. Melt the butter over low heat and add the lemon juice and the soy sauce. Brush the chicken legs on both sides with the baste and cook on the grill slowly, turning and basting frequently until they are dark brown and the skin is crisp. It will take an hour or more depending on the size of legs and all other cooking-out variables.

Herbed Roast Leg of Lamb

Serves: 8
Oven Setting: 400°

Can be cooked in oven or barbecued.

6-8 lb. leg of lamb (boned and flattened, ask your butcher to do this for you)
½ cup fresh parsley, minced
1 clove garlic, minced
½ teaspoon dried sage leaves, crumbled
1 teaspoon rosemary leaves, crushed
1 teaspoon salt
¼ teaspoon freshly ground pepper
2 tablespoons olive oil
¼ teaspoon salt

Preheat oven. Combine parsley, garlic, sage, rosemary, 1 teaspoon salt and pepper. Spread meat flat; rub with 1 tablespoon olive oil. Sprinkle with the herb mixture. Roll lamb, tucking in the ends. Tie into an even roll with clean white cord. Rub outside of meat with remaining 1 tablespoon oil, sprinkle with ¼ teaspoon salt. Place on rack in open shallow roasting pan, fat side up. Roast about 1½ hours for rare or 2 hours for medium. Transfer to heated platter.

Lamb can be cooked on a Weber grill or on a spit. Delicious for an outdoor barbecue.

Oven-Barbecued Shrimp

Serves: 4 (can be doubled)
Oven Setting: 450°

Interpretation of a
a New Orleans recipe.

1½ sticks lightly salted butter (not margarine)
1 cup + 4 tablespoons vegetable oil
2 teaspoons finely minced garlic
4 whole bay leaves, crushed fine
2 teaspoons washed and dried rosemary leaves
½ teaspoon dried basil
½ teaspoon oregano
½ teaspoon salt
½ teaspoon cayenne (more to taste)
1 tablespoon paprika
¾ teaspoon freshly ground black pepper
1 teaspoon fresh lemon juice
2 lbs. whole fresh shrimp in the shell (preferably large)

In heavy ovenproof pan or saucepan melt butter, add oil and mix well. Add all other ingredients **except** shrimp. Cook over medium heat, stirring constantly until sauce boils. Reduce heat, simmer 7-8 minutes, stirring frequently. Remove pan from heat and let stand uncovered at room temperature for at least 30 minutes. (This can be done early in the day.) To prepare shrimp, add shrimp in shell to sauce over medium heat, cook for 6-8 minutes until shrimp turn pink. Put in preheated oven, bake for 10 minutes. Eat with fingers.

Serve shrimp with sauce ladled over. French bread is great for soaking up extra sauce. Salad and corn on the cob are good accompaniments.

Ms. Ruth L. Reiter

Picnic Curried Chicken

Serves: 4-5

Works as a main course or as a
party appetizer.

4 cooked chicken breasts, boned and cut in chunks
2 tomatoes, diced
2 unpeeled cucumbers, thickly sliced
½ cup salad oil
¼ cup cider vinegar
2 teaspoons salt
dash pepper
1 teaspoon curry powder

Combine chicken, tomatoes and cucumber in a bowl. In a separate bowl, mix everything else and beat until thick. Pour over chicken and stir gently. Cover and keep in refrigerator. Serve cold.

Ms. Cynthia A. Joiner

Exotic Shrimp Salad

Serves: 12 *Delicious summer fare!*

4 lbs. cooked, cleaned shrimp
2 cups sliced water chestnuts
½ cup minced green onions
½ cup diced celery
1 cup toasted, slivered almonds
lettuce

Dressing:
1½ cups mayonnaise
4 teaspoons curry powder
4 tablespoons soy sauce

Mix dressing ingredients thoroughly, using wooden spoon. Cut shrimp in **large** pieces. Add water chestnuts, onion, celery, mix gently. Add dressing, toss gently. Refrigerate overnight, if possible, for flavors to blend. Arrange salad portions on crisp lettuce cups or in large glass bowl lined with crisp lettuce. Garnish with toasted, slivered almonds just before serving. Serve with blueberry, honey or bran muffins and sweet butter.

 Mrs. G. Patterson Littell

Stuffed Flank Steak

Serves: 4-6 *Economical and good.*
Oven Setting: Broil or grill

1½-2 lbs. flank steak
1 cup red wine
½ cup chopped onion
⅓ cup soy sauce
¼ cup oil
¼ teaspoon salt
¼ teaspoon pepper

Stuffing:
½ cup chopped onion
¼ lb. sliced mushrooms
¼ cup chopped celery
1 tablespoon butter
½ cup beef broth or water
1 teaspoon crushed thyme
pepper
2 cups bread, cubed

Cut pocket in the flank steak and score the surfaces. Combine wine, onion, soy sauce and oil, salt and pepper in shallow glass or enamel pan, mix well. Marinate steak in mixture at least 3-4 hours, preferably overnight.

Sauté onion, mushrooms and celery in butter until tender. Stir in broth and thyme and pepper. Bring mixture to a boil. Stir in bread cubes. Remove steak from marinade. Place stuffing in pocket. Pin side together with metal skewers (or tooth picks). Broil or grill 5-7 minutes on each side, slice diagonally for serving.

 Ms. Jane J. Sasser

Chicken, Avocado and Bacon Salad

Serves: 8

This is a summertime favorite and great for concerts in the park.

2 (3½-lb.) chickens
2 onions, halved and stuck with a clove
2 carrots, sliced
¾ cup cider vinegar
1 stalk of celery, sliced
cheesecloth bag containing: 4 sprigs of parsley, 1 bay
 leaf, ½ teaspoon thyme
2 teaspoons salt
1 cup minced celery
⅔ cup minced scallions
2 avocados, peeled, quartered, pitted, and sliced
 crosswise
⅓ cup fresh lemon juice
1 lb. lean slab bacon cut crosswise into ¼″ thick
 lardoons
Bibb lettuce
old-fashioned boiled dressing (see below)

In a stainless steel or enameled kettle combine chicken with onions, carrots, ½ cup of cider vinegar, stalk of celery, cheesecloth bag and salt. Add enough water to barely cover the chicken, bring the liquid to a boil over moderately high heat, skimming the froth that rises to the surface. Reduce heat until the liquid barely simmers. Poach the chicken, covered, for 45 minutes. Transfer to a platter, reserving the stock, and let cool. Remove and discard skin and bones, keeping the meat in large pieces. Transfer the meat to a bowl and add ¼ cup cider vinegar and enough of the reserved stock to cover. Chill the mixture, covered, for 2 hours or overnight.

Let the chicken stand at room temperature for 20 minutes, or until the gelled stock has melted. Pour off the stock and reserve it for another use. Cut chicken into bite-size pieces and add minced celery and scallions.

In another bowl gently toss the avocados with the lemon juice. Sauté the bacon until it is crisp and golden. Drain. Add drained avocados and bacon to the chicken mixture and toss gently. Line a large platter with Bibb lettuce, mound ⅓ of the chicken mixture on it, and drizzle 3 tablespoons old-fashioned boiled dressing over it. Continue to mound the remaining mixture and drizzle it with dressing in the same manner. Garnish the salad with 2 tablespoons minced green scallion tops. Serve the remaining boiled dressing separately if desired.

Old-Fashioned Boiled Dressing:
1 cup chicken stock
½ cup cider vinegar
1 egg, lightly beaten
1 tablespoon each of sugar and flour
1 teaspoon dry mustard
¾ cup light cream
salt and pepper

In a stainless saucepan cook chicken stock over high heat until it reduces to ½ cup. Remove from the heat, let the stock cool and add vinegar, egg, sugar, flour and mustard. Whisk in cream. Bring the mixture to a boil over moderate heat, whisking constantly and strain it through a fine sieve into a bowl. Let the dressing cool to room temperature, thin it to the desired consistency with light cream, if necessary, and season it with salt and pepper. Makes about 1⅔ cups.

Mrs. Kenneth H. Storz

Shrimp and Leek Salad

Serves: 4-6 *A good picnic dish.*

4 leeks
3 tablespoons oil
1 tablespoon white wine vinegar
salt and pepper
dry mustard
sugar
3 hard-boiled eggs
4 oz. shrimp, cooked, shelled and deveined
¼ pint mayonnaise
paprika

Wash leeks well and split lengthwise. Boil in salted water until just tender (10-12 minutes); drain. Cut into 1½-inch pieces, blot dry and arrange on serving dish. Mix oil and vinegar with salt, pepper and dry mustard, adding a little sugar to taste. Marinate shrimp and sliced egg whites until serving time. Add shrimp mixture to leeks in serving dish. Add a little hot water to mayonnaise until it is coating consistency and spread over shrimp and leeks. Sprinkle with sieved egg yolk and paprika. Serve very cold.

Mrs. R.M. Smith, Jr.

Mexican Salad Bowl

Serves: 6-8 *Quite filling! Super for picnics!*

1 lb. ground beef, browned and drained
8 oz. cheddar cheese, grated
15-oz. can kidney beans, drained
1-2 fresh, ripe tomatoes, coarsely chopped
2 ripe avocados, peeled, pitted, and diced
1 medium onion, peeled and chopped
8-oz. jar taco sauce
¾ cup thousand island dressing
½ head shredded Romaine or iceberg lettuce
5½-oz. bag taco-flavored tortilla chips, crushed

In a serving bowl, combine all ingredients except the lettuce and tortilla chips. Chill. Add lettuce and crushed tortilla chips and toss.

Ms. Sue R. Willingham

Chicken Coronation

Serves: 6-8 *Adapted from a dish served when the Queen of England was crowned in 1953. A good cold party dish.*

1 chopped onion
1 clove garlic, minced
2 tablespoons oil
1 teaspoon curry powder
1 teaspoon tomato purée mixed with ½ cup water
salt to taste
2 slices lemon
1 tablespoon apricot jam
½ pint mayonnaise
1 chicken, cooked, boned, and cut in chunks

Soften onion and garlic in oil. Add curry powder, cook 2-3 minutes. Add tomato purée and water, simmer 8 minutes. Add salt and lemon slices, squeezing juice from lemons. Add jam. Boil for 1 minute. Strain. Cool. Add mayonnaise. Use this sauce to coat chicken. Toss very gently.

Serve cold over rice which has been cooked, cooled and tossed with French dressing, chives, parsley, coarsely chopped tomatoes, cucumbers, corn, peas and onions.

Ms. Rose Jacobsen

Grilled London Broil with Herb Butter

Charcoal Grill *Simple.*

London broil, ½-1 inch thick
olive oil
Worcestershire sauce
salt, freshly ground pepper to taste

Herb Butter: (combine)
½ cup butter, softened
1 tablespoon fresh lemon juice
½ teaspoon salt
dash pepper
2 tablespoons chopped parsley
1 tablespoon chopped chives
½ teaspoon tarragon leaves

Lightly score steak on both sides. Sprinkle both sides with equal parts olive oil and Worcestershire sauce. Leave at room temperature for 2-3 hours. Grill over charcoal for approximately 6 minutes per side. Season. Slice diagonally and serve with herb butter.

Beef Kabobs

Serves: 4-5 *Always appreciated.*

½ cup fresh lime juice
½ fresh lemon juice
½ cup olive oil
1 teaspoon salt
⅛ teaspoon freshly ground pepper
½ teaspoon rosemary
2 lbs. trimmed sirloin steak, cut into 1½-inch cubes
12-15 fresh mushrooms
onion wedges
green pepper, cut into 1-inch squares
cherry tomatoes

Mix first six ingredients for marinade. Place marinade, sirloin cubes and mushrooms in covered container and refrigerate overnight. Blanch onion wedges and green pepper squares in boiling water. Alternate on skewers with mushrooms, meat and cherry tomatoes. Cook over medium-hot coals to desired doneness.

Layered Coleslaw

Serves: 8 *Very pretty for a picnic. A trick with a food processor is to shred half the cabbage and thinly slice the other half.*

1 head cabbage
1 large green pepper
2 medium onions
1 cup sugar
1 teaspoon dry mustard
2 teaspoons sugar
1 tablespoon salt
1 teaspoon celery seed
1 cup white vinegar
¾ cup salad oil
1 cup cherry tomatoes, halved

In large straight-sided glass bowl, make layers of thinly sliced cabbage, green pepper rings, onion slices. Sprinkle 1 cup sugar over top. In saucepan, combine mustard, 2 teaspoons sugar, salt, celery seed, vinegar and oil. Mix well. Bring to a full boil while stirring. Pour over slaw. Cover and refrigerate for at least 4 hours. To serve, add tomatoes, toss salad and garnish.

Mrs. Robert Wells

"La Mayonnaise Essentielle"

Serves: 4 (large servings)

My most-asked-for recipe. From a very dear landlady in an old French provincial kitchen shortly after WWII.

1 egg yolk
1 teaspoon powdered sugar
1 teaspoon Dijon mustard (2 teaspoons for fish)
salt and pepper
1 cup salad oil
1 tablespoon wine vinegar or lemon juice
1 additional tablespoon vinegar or lemon juice

In small, deep bowl blend egg yolk, sugar, mustard, salt, pepper on low speed with electric beater, then froth for a few seconds at high speed. Begin adding the oil while beating, **first by droplets** then in a steady stream as mixture thickens. Finally blend in additional tablespoon of vinegar or lemon. At this point any additional spices or herbs can be folded in. Refrigerate, up to 3 days in tight jar.

For hors d'oeuvres try it heaped around a boiled egg, adding chopped green onions and caviar for Russian eggs; in salad with shrimp, pineapple, curry; with any leftover mix, aspic, or salad.

Ms. Catherine Evans

Summer Stuffed Tomatoes

Takes advantage of summer's special taste blessings.

tomatoes—all about the same size, summer quality
salt or herbed salt and pepper
a selection of crisp, fresh raw vegetables such as cucumbers, celery, carrots, pickles or dilled green beans, if available
fresh basil or dill (optional)
mayonnaise

Prepare tomatoes, peeled or unpeeled as desired, by scooping out pulp and seeds leaving a substantial wall. Rub with salt or herb salt inside and drain upside down in refrigerator. Chop fine the tomato pulp and a combination of the other vegetables in quantity sufficient to stuff the tomato cases. Minced fresh basil or dill may be added to mixture to taste. Sprinkle the mixture with salt or herb salt and drain in strainer in the refrigerator. Shortly before serving, combine the vegetables with mayonnaise and stuff the tomato cases. Serve on lettuce or with a cold meat platter.

Bleu Cheese-Walnut Salad

Serves: 6-8

1 head romaine lettuce
5 tablespoons imported olive oil
1 tablespoon red wine vinegar
½ teaspoon salt
⅛ teaspoon freshly ground black pepper
¼ lb. bleu cheese
½ cup shelled walnuts, coarsely chopped

Clean the romaine, dry and tear into bite-sized pieces.

Put the olive oil, vinegar, salt and freshly ground pepper into a salad bowl. Beat with a fork until well combined. Add half the bleu cheese and mash it into the oil mixture. Add half the chopped walnuts, stir. Add the romaine pieces and toss. Top with the remaining cheese, crumbled and the rest of the walnuts.

Dr. Simpson's Spinach Salad

Serves: 6 *Dressing is also good for fruit salad.*

¼ cup vinegar
2 tablespoons water
8-oz. package Italian salad dressing mix
3 tablespoons light brown sugar
2 teaspoons Dijon mustard
juice of 1 lemon
⅔ cup salad oil
2 lbs. spinach, washed and torn
bean sprouts
sesame seeds, toasted

Pour vinegar into jar and add water. Add dressing mix and shake. Add brown sugar, mustard, lemon juice and oil. Shake again. Use liberally on salad of spinach leaves and sprouts. Sprinkle salad with sesame seeds.

Ms. Catherine Inabnit

Avocados Apollo with Honey-Lime Dressing

Serves: 8 *Perfect for a midsummer dinner.*

2 small avocados
lemon juice
2 large oranges
1 small onion, diced
½ cup diced celery
¼ cup stuffed sliced olives
1 teaspoon rosemary
crisp greens (Bibb lettuce)
¼ cup stuffed olives to garnish

Honey-Lime Dressing:
1 teaspoon salt
1½ teaspoons prepared mustard
1 teaspoon paprika
¼ teaspoon pepper
¼ cup lime juice
⅜ cup olive oil
⅓ cup honey

Cut avocados in quarters, remove seed and peel. Sprinkle generously with lemon juice. Wrap in plastic wrap and refrigerate until just before serving. Peel, section and dice oranges. Combine in bowl with onions, celery and olives and toss lightly. Add rosemary and dressing just to moisten. Toss again. Cover and refrigerate until ready to serve. Place avocados on greens and fill with orange mixture. Garnish with whole stuffed olives.

Dressing: Blend salt, paprika, mustard, and pepper in a bowl. Add lime juice, oil and honey; whisk together. Refrigerate and whisk well just before serving.

Mrs. Joseph Clamon

Sardinian Tomato Salad with Feta Cheese Dressing

Serves: 4-6

This is a beautiful salad, best served when all ingredients are fresh and at their peak.

Salad:
4 large, ripe tomatoes
8 oz. mozzarella cheese, sliced
1 red onion
2-oz. can anchovy filets (optional)
8-12 black Greek olives

Dressing:
1 cup Feta cheese, crumbled
1 cup mayonnaise
2 small cloves garlic
¼ cup red wine vinegar
½ teaspoon each basil, rosemary, thyme, oregano
½ tablespoon Worcestershire sauce
2 tablespoons olive oil

For salad, slice tomatoes thinly. Cut slices of cheese in thirds. Slice onion thinly. Drain anchovies and olives. Arrange alternate slices of tomato, cheese and onion decoratively on a platter. Arrange anchovies (if used) and olives around tomatoes. When ready to serve, pour dressing over all.

Dressing: Combine all ingredients in blender or food processor and blend until well combined. This makes about 1 pint and will keep for weeks in glass jar in refrigerator. If a smooth dressing is not desired, Feta cheese may be omitted from ingredients to be blended and then crumbled over salad before dressing.

Editor's note: Salad is salty. Use regular black olives instead of Greek for a less salty salad.

Mrs. C. W. Morris

Barbecue Sauce

Makes: 1 quart

Sauce of The Society of Friends of Sir Reginald St. Denis.

1 quart dark vinegar
1 teaspoon coarse black pepper
1 teaspoon red pepper
1 teaspoon red pepper flakes
2 tablespoons Grandma's molasses
¼ teaspoon dry mustard
3 lemons, sliced thick as pencil
6-oz. can tomato paste
2 tablespoons Worcestershire sauce
1 stick real butter

Simmer vinegar, peppers, molasses, mustard and lemon slices until pulp comes out of lemons, and remove rind. Baste meat with above. Add tomato paste, Worcestershire sauce, and butter and simmer very slowly 15-20 minutes. **Do not boil.** Serve with hickory-smoked pork barbecue.

Mr. Thomas Henry Nickerson, IV

Grilled or Broiled Zucchini

Serves: 4
Oven Setting: Broil
 or grill

*Quick and easy. Excellent
for summer cooking on the grill.*

4 small, young zucchini
½ stick butter
½ teaspoon lemon-pepper seasoning
dash of garlic salt
2 tablespoons Parmesan cheese

Wash, dry and halve lengthwise the zucchini and arrange in a single layer on a greased broiler pan or hinged grill. Score zucchini diagonally. Melt butter and add lemon-pepper seasoning, and garlic salt. Brush on cut side of zucchini. Sprinkle with cheese. Broil 8 minutes or grill until tender and cheese browns. No need to turn.

Mrs. C. W. Morris

Sausage Stuffed Tomatoes

Serves: 4
Oven Setting: 350°

Great with a steak and salad.

½ lb. sausage meat*
2 large, ripe tomatoes
¼ cup seasoned bread crumbs
¼ cup grated Parmesan cheese
salt and pepper to taste
butter

Cook and drain sausage well. Cut tomatoes in half. Scoop out insides leaving a firm shell. Chop tomato pulp and put in bowl with sausage, crumbs, cheese, salt and pepper. Mix well. Divide the filling equally into 4 tomato shells. Dot with butter. Cook for 20 minutes (or no longer than 30).
*Bacon can be substituted (about 6 strips).

Mrs. Katherine Edmonds Hill

Cheese-Topped Tomato Slices

Serves: 6-8
Oven Setting: Broil

*Can be assembled ahead of time
and kept in the refrigerator.*

3 large, firm tomatoes
1 cup sour cream
½ teaspoon salt
¼ teaspoon (or less) pepper
1 tablespoon flour
2 tablespoons chopped green onion
2 tablespoons chopped canned green chilies
1 cup cheddar cheese

Peel tomatoes if desired. Slice thickly and place in shallow pan. Mix all other ingredients except cheese and pour over tomato slices. Top with cheese. Broil about 4 minutes until cheese is melted and tomatoes are heated through.

Mrs. J. Richard Watson

Parmesan Potato Sticks

Serves: 6-8
Oven Setting: 450°

Excellent with steak in place of a baked potato.

4 large potatoes
4 tablespoons melted butter
MSG or Accent powder
onion salt
paprika
Parmesan cheese (to taste)

Peel potatoes and cut into sticks, as for french fries. Arrange in a single layer in a shallow baking pan. Brush with melted butter. Sprinkle with MSG, onion salt and paprika. Bake in hot oven 20-30 minutes or until potatoes are tender and brown; turn occasionally. Remove from oven and sprinkle with Parmesan cheese, tossing gently to coat. Serve at once. (Potatoes can be peeled, cut and placed in ice water until ready to make. Be sure to dry thoroughly before starting dish.)

Mrs. Richard S. Lambert

Cheesy New Potatoes

Serves: 6-8
Oven Setting: 350°

Men and kids love this.

12 medium new potatoes
salt and pepper
16 slices crumbled bacon
½ cup melted butter
2 cups grated Old English Cheese
¼ cup chopped parsely for garnish

Wash and cube potatoes (don't peel), and cook in boiling water until just *barely tender.* Remove from heat, drain and season to taste with salt and pepper. In a 2-quart casserole, place layer of potatoes, half the bacon, half the butter and half the cheese. Repeat the layers. Heat for 20-30 minutes or until cheese is bubbly. Remove from oven and garnish with parsley. Delicious with steaks and hamburgers.

Mrs. Walter Sprunt

Baked Zucchini

Serves: 8-10
Oven Setting: 350°

A blend of three cheeses.

8 medium zucchini
½ cup butter
¾ cup grated Gruyere cheese
½ cup grated cheddar cheese
1 cup sour cream
¼ cup chopped onion
½ teaspoon salt
dash paprika
1 cup cornbread stuffing, crumbled
grated Parmesan cheese

Cook whole zucchini in boiling salted water for 8 minutes and drain. Melt butter in skillet, add the Gruyere and cheddar and melt. Add the sour cream, onions and seasonings. Cut the zucchini in rounds and lay overlapping in a spiral circle in a round quiche dish. Pour cheese mixture over the zucchini, sprinkle with breadcrumbs and Parmesan cheese. Bake 30 minutes.

Gingered Rice

Serves: 8-10

Unusual dish for picnics and Chastain Park concerts.

2½ cups water
1 teaspoon salt
2-3 tablespoons chopped green onions
2 tablespoons salad oil
1 cup uncooked regular rice
3 tablespoons fresh lemon juice
1 tablespoon sugar
¼ cup mayonnaise
½ cup chopped salted cashews
¼ cup seedless raisins
¼ cup chopped crystallized ginger
1 cup halved seedless green grapes
Bibb lettuce leaves

Combine water, salt, onion and salad oil in saucepan, bring to a boil. Add rice and cook over low heat 20-25 minutes until rice is tender and liquid is absorbed. Remove from heat and add remaining ingredients except lettuce leaves. Chill thoroughly, serve on lettuce.

Mrs. W. Scott Brooks, Jr.

Easy Lemon Ice Cream

Very delicate and lemony.

2 cups sugar
juice of 4 lemons
1 quart milk
1 pint heavy cream

Put sugar in ice cream freezer and add lemon juice. Add milk and then cream. Blend well. Freeze in ½ gallon freezer.

Mrs. Harold D. Hartshorn

Horse Race Pie

Yield: 10" pie
Oven Setting: 350°

Adapted from traditional recipe from the Kentucky Derby.

4 whole eggs
¾ cup white sugar
¼ cup brown sugar
1 teaspoon vanilla
2 tablespoons bourbon
1 cup white corn syrup
1 stick melted butter
1 tablespoon flour
1 cup chopped pecans or walnuts
1 cup chocolate chips
1 unbaked 10-inch pie shell

Beat the eggs. Add to them the sugars, vanilla, bourbon, corn syrup, butter and flour. Mix well. Distribute nuts and chips in the bottom of the pie shell. Pour the filling on top. Bake for 45 minutes. Best served *warm*. Garnish with whipped cream. Serve very small slices because pie is very rich.

Mrs. Daniel J. Jordan

Chocolate Delight

Serves: 24 2" squares
Oven Setting: 350°

More moist the longer it is around, but usually not around for very long.

Cake:
1 cup plain flour
1 teaspoon baking powder
⅛ teaspoon salt
1 stick margarine
1 cup sugar
4 eggs
16-oz. can Hershey's chocolate syrup
1 teaspoon vanilla extract

Icing:
1 cup sugar
1 stick butter (not margarine)
½ cup chocolate chips
⅓ cup evaporated milk
½ teaspoon vanilla extract
½ cup chopped pecans

Sift flour, baking powder and salt together. In a large bowl cream margarine adding sugar gradually. Add eggs, one at a time. Alternate adding dry ingredients and chocolate syrup. Beat until well mixed. Add vanilla. Pour into greased and floured 13" x 9" x 2½" pan. Bake for 30 minutes. Always check cakes when ¾ of the cooking time is over.

Fudge Icing: Put all ingredients except vanilla and nuts in a heavy saucepan. Blend over medium heat, stirring constantly, until mixture begins to boil. Boil 3 minutes. Remove from heat and add vanilla and nuts. Beat icing with a spoon until it cools and thickens. Spread *quickly* on cake.

Mrs. Carter D. Cathell

Mixed Fruits With Walnuts and Liqueur

Serves: 6

Summer desserts never had it so good!

1 lemon
5 oranges
⅔ cup sugar
1 cup water
1 red delicious apple (cut into ½-inch cubes with skin)
1 ripe pear
2 ripe bananas
2 stems fresh mint
½ lb. fresh raspberries, strawberries or Bing cherries
⅓ cup chopped walnuts
4 tablespoons orange liqueur such as Grand Marnier or Benedictine

Juice lemon and 2 of the oranges into enamel saucepan. Add sugar and water. Stir ingredients over heat until sugar is melted and the syrup has reached the thread stage (about 230°). Let cool. Peel and cut 3 remaining oranges into sections. Remove seeds. Add diced apple and pear, sliced bananas, 1 stem mint and toss all with syrup. Refrigerate 2-3 hours. One-half hour before serving, add raspberries or strawberries or cherries and walnuts and liqueur. Garnish with remaining mint.

Mrs. R. Mark Wilkiemeyer

Key Lime Pie Extraordinaire

Yield: 1 9" pie *Guests always find room for this!*

1 envelope unflavored gelatin
½ cup sugar
¼ teaspoon salt
4 eggs, separated
½ cup lime juice
¼ cup water
1 teaspoon grated lime peel
few drops green food coloring
½ cup sugar
1 cup whipping cream, whipped
9" baked pastry shell
1 cup whipping cream, whipped for garnish

Thoroughly stir gelatin, ½ cup sugar and salt in large saucepan. Beat egg yolks, lime juice and water. Stir into gelatin mixture. Cook, stirring constantly until mixture comes to a boil. Remove from heat. Stir in peel. Add food coloring (sparingly). Chill, stirring occasionally until mixture mounds, when dropped from spoon. Beat whites until soft peaks form. Gradually add ½ cup sugar and beat to stiff peaks. Fold gelatin mixture into whites. Fold in 1 cup heavy cream, *whipped* (reserving other cup for garnish). Pile mixture into pastry shell. Chill until firm (several hours). Spread 1 cup whipped cream over center of pie, leaving 2" of green around edge. Garnish with thin slices of limes or grated peel.

Mrs. Robert M. Edney

Greek Butter Cookies

Makes: 7½-8 dozen
medium-sized
Oven Setting: 350° *Keep on hand for drop-in guests as well as for special picnics.*

2 cups butter (clarified)
½ cup confectioner's sugar
2 egg yolks
1 tablespoon whiskey
½ cup toasted almonds, chopped fine (optional)
6 (approximate) cups flour
2 cups confectioner's sugar

Beat butter, then add sugar, beating until creamy. Add egg yolks and whiskey and beat for 15-20 minutes. Add almonds, then flour. Knead well for about 10 minutes. Shape into desired shapes, crescent or round, and place on ungreased cookie sheet. Bake until light brown. Dust with remaining confectioner's sugar while warm. May be kept in tight container for a month. Freeze well for several months.

Mrs. Platon Constantinides

Almond Cheesecake Brownies

Makes: 15 1½″ squares
(very rich)
Oven Setting: 350°

Ever dream of chocolate cheesecake?

Cheese mixture:
16 oz. cream cheese (2 packages)
2 eggs
⅔ cup sugar
½ teaspoon almond extract

Chocolate mixture:
4 (1-oz.) squares unsweetened chocolate
1 cup margarine
4 eggs
2 cups sugar
1½ cups flour
1 teaspoon baking powder
1 teaspoon salt
sliced almonds

Combine ingredients for cheese mixture (can be done quickly in food processor). Set aside. Melt chocolate and margarine; cool. Beat eggs, add sugar and chocolate mixture. Sift together flour, baking powder and salt. Add to chocolate mixture and mix well. Pour ½ chocolate mixture into greased 13″ x 9″ x 2″ pan. Spread cream cheese mixture on top. Top with remaining chocolate mixture. Sprinkle with almonds. Bake for 45 minutes or until knife is clean from center.

Editor's note: If you prefer, you may use vanilla extract and pecans in place of almond extract and almonds. These are better and moister the second day; we recommend making a day before serving.

Lee and Meryl Abramson

Raspberry-Walnut Shortbread Bars

Makes: 18
Oven Setting: 350°

Irresistible. Like a Linzer Torte.

1¼ cups sifted all-purpose flour
½ cup sugar
½ cup butter
⅓ cup raspberry jam
2 large eggs
½ cup brown sugar, packed
1 teaspoon vanilla
2 tablespoons flour
pinch salt
⅛ teaspoon baking soda
1 cup walnuts, chopped

Combine 1¼ cups flour and ½ cup sugar. Cut in butter until mixture is like fine meal. Press over bottom of lightly-greased 9″ square baking pan. Bake for 20 minutes, just until edges become brown-tinged. Remove from oven and spread raspberry jam over the shortbread. Beat eggs with brown sugar and vanilla until well blended. Stir in the 2 tablespoons flour mixed with salt and baking soda, then walnuts. Spoon over jam and spread lightly to corners of pan. Return to oven and bake 20-25 minutes longer, until top is set. Cool in pan, then cut into bars.

Mrs. T. G. Cousins

GALLERY VI
The Pantry . . . for Giving and Keeping

MARGARET BOURKE-WHITE (American, 1906-1971)
Still Life, Twentieth century, photograph on paper, 18¾ x 8⅞ . Museum purchase with funds from a Friend of the Museum, 1974. *Reproduction in The High Museum of Art Recipe Collection sponsored by The Atlanta Gallery of Photography.*

Gallery VI

Garlic Vinegar and Garlic Salt

Superior to store-bought.

Garlic buds, fat and healthy
Vinegar
Salt

Garlic vinegar: place the cloves from one fat, fresh garlic bud in a quart of white vinegar. Let mature about three weeks, shaking occasionally. Store in the refrigerator. The vinegar may be replenished without adding more garlic.

Garlic salt: add a clove or two of garlic to ½ cup of table salt. Keep tightly closed. Add more garlic if the flavor weakens.

Helpful hint: garlic will keep for a long time if you peel the cloves, cover them with olive oil, store in an air-tight container, and keep them in the refrigerator. You will also have a supply of garlic-flavored oil.

Mrs. Robert F. McDowell

Herb Vinegar

A particularly fine vinegar can be made with opal basil which produces a beautiful red.

Fresh herbs
White vinegar

Fill a wide-mouth jar of any size with fresh herbs and pack lightly. (You may use a single herb such as basil, rosemary or savory, or a combination of herbs.) Fill the jar with vinegar and close tightly. Let it mature away from sunlight for about three weeks. Try to remember to shake the jar once a day. For gifts, strain through cheesecloth to remove sediment. Cider vinegar may be used, but it is not as attractive because it turns very dark. Storing vinegars in the refrigerator will preserve their flavor more effectively than storing in cupboard.

Mrs. Robert F. McDowell

Bouquet Garni

Yield: about 18

For giving as gifts, put several bags in small baskets or decorated glass jars.

cheesecloth
¼ cup ground marjoram
¼ cup thyme leaves
¼ cup parsley flakes
2 tablespoons ground savory
1 tablespoon ground sage
1 tablespoon crumbled bay leaf
½ cup celery flakes (a ⅜-oz. package)

Cut cheesecloth into eighteen 2-inch squares, double in strength. Mix all herbs together well. Divide herbs equally among the cheesecloth squares and tie tightly with string to make small bags. Drop one bag into soup or stew during the last hour of cooking time or simmer with gravy. Remove bouquet garni before serving.

Mrs. Richard B. Goodsell

Fresh Vegetable Relish

Yield: 1 pint

Use as an accompaniment to sandwiches, etc.

small cheesecloth square
2 teaspoons dried sweet basil
⅓ cup white wine vinegar
4 teaspoons sugar
1¼ teaspoons salt
1 small clove garlic, minced

choice of vegetables:
1 small bunch celery cut in ½-inch strips
or 3 medium carrots, thinly sliced
or 3 small zucchini, thinly sliced
or 2 cups cauliflowerets

Tie basil securely into cheese cloth to make a small spice bag. In a glass bowl, mix vinegar, sugar, salt and garlic, stirring until sugar and salt are dissolved. Arrange one of the prepared vegetables and the spice bag in a 1-pint jar and pour the vinegar mixture over all. Cover and refrigerate overnight. This relish keeps ten days, if refrigerated.

Dilled Carrot Sticks

Yield: 6 pints

A different, crunchy and low-calorie gift.

4 lbs. carrots, peeled and cut into thin sticks
cold water
6 cups water
½ cup pickling salt
2 cups white wine vinegar
fresh garlic and fresh dill

Soak carrot sticks overnight in cold water. Heat the 6 cups water, pickling salt and wine vinegar to boiling point. Sterilize 6 pint jars. Put a clove of fresh garlic and a bunch of fresh dill in each one. Fill jars with carrot sticks (jam them in closely). Pour boiling solution into jars and seal. Wait six weeks, chill and serve.

Mrs. Ned Rand

Squash Pickle

Yield: 7 pints:

Serve ice cold. Good with anything!

8 cups squash, thinly sliced (Buy small, straight squash.)
4 bell peppers, sliced in very thin strips
salt to taste
2 cups white vinegar
3 cups sugar
2 teaspoons celery seed
2 teaspoons mustard seed

Combine sliced squash and peppers; cover with cold water and ice cubes. Add salt and let stand one hour. Drain well. Combine the vinegar, sugar, celery seed and mustard seed and bring to a boil. Pour over squash, bring back to a boil and boil for 4 or 5 minutes. Pour into hot, sterilized pint jars and seal.

Mrs. Lindsey Hopkins, Jr.

Old Fashioned Chili Sauce

Makes: 10 pints *Nice to give as gifts at Christmas.*

1 peck (8 quarts) tomatoes
3 large or 5 medium onions
5 hot peppers
3 tablespoons Kosher salt
3 large green peppers
1 teaspoon cinnamon
1 teaspoon ginger
½ teaspoon ground cloves
½ teaspoon mace
½ teaspoon allspice
1 tablespoon pepper
1 tablespoon dry mustard
2 cups brown sugar
2 cups vinegar
4 (6-oz.) cans tomato paste

Peel, seed and dejuice the tomatoes, then quarter. Chop the onions and peppers. (This can be done in processor.)

Put all ingredients except the tomato paste in a large kettle. Simmer for 2 hours, beating every now and then with an egg beater to break up the tomatoes.

Add the tomato paste and cook 1 hour more or until desired thickness. Put into sterilized jars. Nice to have on pantry shelf.

Sun Strawberry Preserves

Yield: 2 pints *A special gift—actually made in the sunshine.*

½ cup hot water
2 lbs. sugar
2 lbs. strawberries, cleaned and hulled
cheesecloth
paraffin

Combine water and sugar in large, heavy saucepan; boil and stir until sugar is dissolved. Add strawberries and simmer for 2 minutes. Pour berries and syrup into large shallow pans and cover with cheesecloth. Place the pans in the sun for 3 or 4 days on a sunporch or outside. When berries are deep red and syrup is gelled, pack in sterilized jars. Cover with thin layer of paraffin.

Brandied Georgia Peaches (for the freezer)

Yield: 7-8 pints *Tastes good in the middle of winter with ice cream or mixed with available fresh fruits.*

3 cups sugar
1 quart water
4 rounded teaspoons Fruit Fresh
8-10 pounds ripe peaches
peach brandy

Dissolve the sugar in the water by bringing to a boil and stirring well, then boil for 5 minutes. Allow to cool and add the Fruit Fresh.

Peel the peaches and slice into freezer containers (pint size) into which you have poured ½ cup of the syrup and 2 tablespoons of peach brandy. Press fruit down, cover with syrup and keep fruit submerged by placing a crumpled piece of plastic wrap on top. Cover with container top, label, date and freeze. To serve: Leave at room temperature for 3 hours or overnight in refrigerator.

Six-Week Bran Muffins

Yield: 5 dozen muffins
Oven Setting: 400°

Makes a nice "welcome to the neighborhood gift."

2 cups boiling water
2 cups whole bran cereal
3 cups sugar
1 cup shortening, melted
4 eggs, beaten
1 quart buttermilk
5 cups flour
4 cups bran flakes or raisin bran
5 teaspoons baking soda
2 teaspoons salt

Pour the boiling water over the whole bran cereal and let stand. Mix sugar well with melted shortening. Beat in eggs and buttermilk. Add the wet bran mixture. Combine flour, the rest of the bran, baking soda and salt. Stir into liquid combination. The mixture thickens as it stands. Store in a crockery-type cookie jar in the refrigerator for up to 6 weeks. Spoon mixture into paper-lined muffin tins and bake for about 20 minutes. Do *not* stir the mixture when you take it out each time. This is nice to give in decorative glass jars with the cooking instructions attached.

Robbie Richter

Millionaires

Yield: 42

A gift for the caramel lover.

14-oz. package caramels
3 to 4 tablespoons milk
2 cups pecans, chopped
¼ bar paraffin
12-oz. package semi-sweet chocolate morsels

Melt caramels in milk over low heat. Add pecans. Drop by teaspoons onto buttered, waxed paper. Chill. Melt paraffin and chocolate in a heavy saucepan over low heat. Dip candy into chocolate and return to waxed paper. Chill.

Mrs. Sidney Holderness

Cranberry-Basil Jelly

Yield: 5 8-oz. jars

Prepare 6 jelly glasses although this recipe rarely makes more than 5 jars plus a small dividend.

2 cups cranberry juice
½ cup fresh basil leaves (lightly packed)
3½ cups white sugar
½ bottle pectin (1 foil package)

Reduce the cranberry juice by simmering to 1½ cups to intensify flavor. Steep the basil leaves in a small amount of boiling water in covered container for 15-30 minutes. Strain. Add the sugar to cranberry juice and bring to a boil to dissolve the sugar. Add the basil infusion. Bring liquid to a full rolling boil and add the pectin. Bring to a boil again and boil for one minute exactly. Put into sterilized jelly glasses.

Mrs. Robert Milburn Smith

Mint Green Tomato Chutney

Yield: About 12 pints

A gift that's always appreciated.

4 tablespoons rock salt
12 cups sliced green tomatoes
2 cups of vinegar
1½ cups of honey or sugar
5 cloves of garlic
1 cup of currants
6 ounces of candied ginger, finely chopped
4 cups peeled and sliced apples
5 cups sliced onions
⅔ cup chopped mint

Sprinkle salt over tomatoes and let stand overnight. Drain and add rest of ingredients. Bring to a boil and let simmer until thickened. Stir often. Seal in sterilized jars.

Cranberry Nut Bread

Yield: 1 loaf
Oven Setting: 350°

A perfect gift straight from your kitchen.

2 cups flour
1 cup sugar
1½ teaspoons baking powder
½ teaspoon baking soda
1 teaspoon salt
¼ cup shortening
¾ cup orange juice
1 tablespoon grated orange rind
1 egg, beaten
½ cup chopped pecans
1 cup fresh cranberries, chopped

Sift flour with sugar, baking powder, baking soda and salt into a bowl. Cut in shortening until mixture resembles cornmeal. Combine orange juice and orange rind with egg. Pour into flour mixture. Mix just until flour is dampened. Fold in nuts and cranberries and pour into a floured and greased loaf pan. Bake in a preheated oven for 1 hour. Package your gift in an attractive wicker or reed basket. Don't forget to use a pretty ribbon.

Ms. Lola Sander

Assorted Fruits in Madeira

Serve as a relish with almost any meat or fowl.

Any dried fruits such as: raisins, prunes, apples, peaches, apricots
Madeira to cover

Wash the fruit and place in a large, clean crock. Cover with Madeira. Allow to stand at least a week. Check every 2 or 3 days. Add more Madeira as the liquid is absorbed. Pack the fruit in small jars after it is saturated. It will keep indefinitely if covered with Madeira.

Pumpkin Nut Bread

Yield: 1 loaf
Oven Setting: 350°

This was favorite of Mayor Hartsfield's.

1½ cups sifted flour
1¼ teaspoons baking soda
1 teaspoon salt
1 teaspoon cinnamon
½ teaspoon nutmeg
1 cup pumpkin, canned or fresh*
1 cup sugar
½ cup buttermilk
1 egg
2 tablespoons soft butter
1 cup pecans, chopped

Preheat oven. Sift together flour, baking soda, salt and spices. Combine pumpkin, sugar, buttermilk and egg in a mixing bowl. Add dry ingredients and butter; beat until well blended. Stir in nuts and spread mixture into a well-greased loaf pan. Bake for one hour or until toothpick inserted in center comes out clean.
*Fresh pumpkin should first be boiled until the consistency of a purée. It freezes well and can be used for this recipe if thawed first.

Mrs. William B. Hartsfield

Coffee-Butterscotch Sauce

Yield: 2 cups
(enough for 8-10 desserts)

Nice to have on hand.

½ cup dark brown sugar
1 cup + 2 tablespoons light or dark corn syrup
2 tablespoons butter
2 tablespoons strong coffee

Boil ingredients together in small saucepan for one minute. Cool and serve at room temperature over coffee ice cream.

Zucchini Bread

Yield: 2 large or 4 small loaves
Oven Setting: 350°

Wonderful spread with cream cheese.

3 eggs
1 cup oil
2 cups sugar
2 cups grated zucchini
1 tablespoon vanilla
3 cups flour
1 tablespoon cinnamon
1 teaspoon salt
1 teaspoon baking soda
1¼ teaspoons baking powder
¾ cup nuts, chopped

Beat eggs. Continue to beat and add oil, sugar, zucchini and vanilla. Stir all dry ingredients together, and add to the egg mixture. Fold in nuts. Spoon mixture into greased and floured loaf pans (⅔ full). Bake one hour for a large pan—slightly less for smaller pans—until golden brown on top and a toothpick comes out clean.

Mrs. Dal M. Covington

Granola

Yield: about 12 cups
Oven Setting: 300°

A sugarless gift.

5 cups rolled oats
1 cup natural almonds, sliced
1 cup pumpkin seeds
1 cup sunflower seeds
1 cup sesame seeds
1 cup unsweetened coconut, shredded
1 cup wheat germ, untoasted
¾ cup honey
1 teaspoon vanilla
¾ to 1 cup safflower or soybean oil
½ to 1 cup dark, seedless raisins

Combine oats, almonds, pumpkin seeds, sunflower seeds, sesame seeds, coconut and wheat germ in a large bowl. Blend honey, vanilla and oil; pour over dry ingredients. Mix thoroughly. Spread into 13" x 9" baking pan. Bake about 45 minutes. Stir every 10 minutes and add the raisins during the last 10 minutes of baking. Remove from oven. Cool. Store in air-tight container.

Mrs. Robert F. Dennis

Curried Pecans

Yield: 1 lb.
Oven Setting: 350°

Pack curried pecans in lacquered jars for gift giving.

1 lb. pecan halves
2 tablespoons brown sugar
¼ cup cooking oil
1½ tablespoons curry powder
1 tablespoon ground ginger
½ cup butter, melted
salt to taste
1 tablespoon chutney

Place pecans in shallow pan and toast for 10 minutes. Combine other ingredients and pour over pecans. Stir well. Turn oven off and put pecan mixture back in oven for 15 minutes. Drain pecans on paper towels. When cool, store in air-tight containers.

Mrs. Charles Smathers

Spicy Chicken Salad

Serves: 6-8

Nice to bring when you are a weekend guest.

4 breasts or 1 whole chicken, cooked and chopped
1 8-oz. can pineapple, crushed or chunks
1 apple, chopped
2 stalks celery, chopped
handful chopped walnuts
2 tablespoons mayonnaise
2 tablespoons lemon juice
4 tablespoons half and half
4 tablespoons ketchup
10 drops Tabasco
salt, pepper, all-purpose seasonings

Combine all ingredients and mix well. Chill.

Ms. Sherry Wren

Krispy Cheese Rounds

Yield: 50-60
Oven Setting: 375°

These keep well in a tin and freeze beautifully.

2 cups grated cheddar cheese (sharp)
1 cup (2 sticks) margarine
2 cups flour
½ teaspoon salt
¼ teaspoon cayenne pepper
2 cups Rice Krispies
½ cup pecans, chopped

Soften and mix grated cheese and margarine. Add the flour, salt and pepper and blend well. Add the Rice Krispies and pecans and mix well. Drop in small rounds on an ungreased cookie sheet. Flatten slightly and bake 10-15 minutes. Don't let them brown. Remove from oven and cool on a rack. Can be reheated in a microwave or conventional oven.

Mrs. E. M. Ruder

Chicken and Water Chestnut Soup

Serves: 4-6

Wonderful gift for a friend who is recuperating.

6 cups chicken broth
1 whole chicken breast, skinned, boned and sliced thin
8-oz. can sliced water chestnuts, drained
¼ lb. fresh mushrooms, sliced
1 teaspoon cornstarch
2 teaspoons cold water
1-2 tablespoons sherry
salt to taste
¼ teaspoon sesame oil
spring onions, chives or parsley for garnish

In large saucepan bring chicken broth to a boil. Add chicken, water chestnuts and mushrooms. Reduce heat to low; cover pan and simmer 5 minutes. Meanwhile, blend cornstarch and cold water. Add sherry and cornstarch mixture to soup. Cook over medium high heat, stirring constantly, until soup thickens slightly. Stir in sesame oil. Garnish with tops of spring onions (chopped), chives or parsley.

Mrs. Raymond M. Warren, Jr.

Pâté

Yield: 3 cups

The pâté spice mixture may also be given as a gift with instructions for the completed pâté.

Pâté Spice:
2 tablespoons cinnamon
1 tablespoon crushed bay leaf
1 cup salt
1 tablespoon thyme
1 tablespoon mace
1 tablespoon rosemary
1 tablespoon basil
2 teaspoons Spanish paprika
1½ teaspoons ground cloves
1 teaspoon white pepper
½ teaspoon ground allspice

Pâté:
1 cup onion, minced
3 tablespoons chicken fat or lard
½ lb. chicken or duck livers
1½ cups cooked meat (chicken with the skin, pork, veal or beef)
¾ cup butter
½ cup lard or chicken fat
3 tablespoons cognac
1 tablespoon pâté spice
salt to taste

Combine all the pâté spice ingredients and crush thoroughly in a blender, with the steel blade of a food processor or with a mortar. Force the mixture through a fine sieve 2 or 3 times. Return any spices that won't go through to be crushed again and sieve them. Repeat until all the spices are fine enough to pass through the sieve. Store in a tightly-covered jar. The spices will keep for years.

Sauté the onion in 3 tablespoons of lard or chicken fat. Add livers and sauté until cooked through. Cool. Process in a food processor with steel blade or put through a grinder 2 or 3 times until very fine. Next put the 1½ cups cooked meat through a grinder 2 or 3 times or process until very fine. In the bowl of an electric mixer combine the ground meat and the liver mixture, butter, lard or chicken fat, cognac, 1 tablespoon of pâté spice (more if you like) and salt. Or place all the ingredients in the bowl of a processor with a steel blade and process until smooth and well-blended. Place in a mold or bowl and chill thoroughly. Serve with French bread or crackers. Will keep in top condition in the refrigerator for about a week.

Mrs. Robert Milburn Smith

Fudge Pie

Yield: 1 pie
Oven Setting: 350°

So easy and delicious! A thoughtful gift when time is short.

3 tablespoons cocoa
1 teaspoon flour
1¼ cups sugar
½ stick margarine, melted
1 teaspoon vanilla
½ cup evaporated milk
2 eggs beaten
1 unbaked pie shell

Mix dry ingredients together. Mix liquid ingredients together. Combine all dry and all liquid ingredients. Pour into unbaked pie shell and bake for 45 minutes.

Mrs. James G. Sweeney

Forgotten Cookies

Yield: 24
Oven Setting: 400°

Easy on the cook.

2 egg whites
1 teaspoon vanilla
pinch salt
⅔ cup sugar
1 cup pecans, chopped
6 oz. chocolate chips

Beat egg whites until stiff. Add vanilla, salt and beat in sugar. Stir in pecans and chocolate chips. Drop a teaspoon of mixture on shiny side of foil placed on a cookie sheet. Preheat oven to 400°. Place cookies in oven; turn off the heat; take cookies out the next morning.

Mrs. Everett P. Bean

The Farmer's Wife Pecan Cookies

Yield: 36
Oven Setting: 350°

Cookies like mother used to bake.

1¼ cups plain flour, sifted
¼ teaspoon baking soda
⅛ teaspoon salt
¼ lb. (1 stick) butter
1¼ cups light brown sugar (firmly packed)
½ teaspoon vanilla
1 egg, beaten
1 cup pecans, chopped medium-fine
36 pecan halves

Sift flour, baking soda and salt into a bowl and set aside. Melt butter over low heat. Remove from heat and stir in sugar using a wooden spoon. Add vanilla, egg and finally the dry ingredients, stirring until smooth. Stir in chopped pecans last. Place rounded teaspoons of dough 2″ apart on foil-lined cookie sheets. Gently press a pecan half into each. Bake for 12-14 minutes. Cool on racks. Will freeze.

Mrs. Jerry Minge

Chocolate Pound Cake with Chocolate Glaze

Yield: 1 cake
Oven Setting: 325°

Makes a fine contribution to a cooperative dinner.

3 cups flour, sifted
½ cup cocoa
1 teaspoon salt
½ teaspoon baking powder
1 cup butter
½ cup shortening
2¼ cups sugar
5 eggs
1 teaspoon vanilla
1 cup milk

Sift together flour, cocoa, salt and baking powder and set aside. Cream the butter and shortening. Gradually add the sugar to this mixture, creaming well. Blend in the eggs, one at a time, and add the vanilla. Add the dry ingredients alternately with the milk, beginning and ending with the flour mixture. (If using an electric mixer, set on low speed.) Turn into a 10″ tube pan, well-greased on the bottom only. Bake for 75 to 90 minutes or until cake springs back when touched in the center. Glaze with chocolate if desired.

Chocolate Glaze:
1 oz. (1 square) unsweetened chocolate
1 tablespoon butter
¾ cup confectioner's sugar, sifted
1 teaspoon vanilla
2 to 3 tablespoons milk

Melt chocolate and butter in the top of a double boiler over boiling water. Remove from heat and blend in the confectioner's sugar and vanilla. Add 2 to 3 tablespoons milk to make the glaze the proper consistency.

Chocolate Rum Balls

Yield: 40 *Good for Christmas giving.*

1 cup vanilla wafer crumbs
1 cup pecans, finely-chopped
2 tablespoons powdered Dutch cocoa
1 cup confectioner's sugar
1½ tablespoons light Karo Syrup
¼ cup or more Jamaican rum

Mix all the above ingredients together. Shape into small marble-sized balls. Roll in confectioner's sugar.

Mrs. Ronald B. Wolff

Pecan Pralines

Yield: 24-28 *A classic.*

1 lb. dark brown sugar
1⅔ cup white sugar
1 cup half and half
½ stick (4 tablespoons) unsalted butter
1 teaspoon vanilla extract
1 lb. pecan halves

Dissolve brown and white sugars in half and half in a heavy, 3-quart saucepan over medium-high heat. Stir frequently until mixture boils. Turn heat down to medium and stir constantly while boiling for 5 minutes. Add butter and vanilla. Continue stirring while boiling for 10 more minutes until mixture reaches soft-ball stage. Add pecans and remove from heat. Continue stirring. Mixture will begin to thicken as it cools. When mixture has thickened, spoon onto sheets of aluminum foil on counter top to form pralines 3″ in diameter. When cooled remove from foil and wrap individually in plastic wrap.

Editor's note: Pralines may be pulverized in a blender or food processor to make a praline powder which can be used on ice creams and custards.

Dr. Charles E. Johnson

Sugar and Spice Cookies

Yield: 40
Oven Setting: 375° *Nice on a winter evening with hot cider or mulled wine.*

¾ cup softened shortening
1 cup granulated sugar
2 cups + 2 tablespoons flour
1 egg
1 teaspoon ginger
1 teaspoon cinnamon
1 teaspoon powdered cloves
¾ teaspoon salt
2 teaspoons baking soda
¼ cup molasses
extra granulated sugar

Mix ingredients together using electric mixer or by hand. Form dough into small balls (approximately one teaspoon each) and roll in granulated sugar. Bake on greased cookie sheets for 12 to 14 minutes. Will freeze.

Ms. Kathleen Williams

Honey Walnut Bread

Yield: 1 loaf
Oven Setting: 325°

A gift of homemade bread is always welcome.

1 cup milk
1 cup honey
½ cup sugar
¼ cup butter, softened
2 egg yolks
2½ cups flour
1 teaspoon baking soda
1 teaspoon salt
½ cup walnuts, chopped

Scald milk in a large saucepan. Add honey and sugar and stir over medium heat until sugar is dissolved. (This mixture will curdle—a reaction that is normal and harmless.) Cool. Beat in softened butter and egg yolks. Sift together flour, baking soda and salt and stir into batter. Beat well. Add nuts. Pour batter into buttered and floured loaf pan and bake for about 1 hour or until it tests done. Turn out on wire rack after it cools partially. Will freeze.

Dr. Charles E. Johnson

Swedish Tea Rings

Yield: 2 rings
Oven Setting: 375°

A Christmas tradition in our house. Good for giving and for eating on Christmas morning.

Dough:
¾ cup milk
¼ cup butter
½ cup sugar
1 teaspoon salt
2 packages dry yeast
½ cup lukewarm water
2 eggs, beaten
4½ cups flour, sifted

Filling:
½ cup butter, melted
1 cup brown sugar
2 teaspoons cinnamon
½ cup pitted dates, chopped
½ cup walnuts or pecans, chopped

Icing:
1 cup powdered sugar, sifted
1 to 2 tablespoons warm milk
½ teaspoon vanilla extract

Scald milk and pour over butter, sugar and salt. Dissolve yeast in water. Add well-beaten eggs and yeast to milk mixture. When it is cooled to lukewarm, beat in flour to make a soft dough. Turn out on a floured board and knead until smooth. Form into a ball and place in a large, greased bowl. Cover and let rise until doubled in size.

Shape into rectangular sheets about ¼" thick. Combine filling ingredients and spread filling over each sheet. Roll each sheet like a jelly roll and then form each roll into a ring. Place on greased baking sheets and cut with sharp knife at 1" intervals, almost through rings. Cover and let rise till double.

Bake for 20 to 30 minutes. Combine icing ingredients and drizzle over warm rings. (Rings may be frozen. If frozen, thaw before icing.) Any filling can be substituted. A simple butter, sugar and cinnamon mixture or a fruit jam will also do.

Mrs. Lawrence Goudy

Date Balls

Yield: 48 *Good after dinner with coffee.*

½ cup butter
1 cup brown sugar
7½-oz. package dates, chopped
2 cups Rice Krispies
1 teaspoon vanilla
½ teaspoon salt
powdered sugar

Combine butter, brown sugar and dates in a large saucepan. Cook over low heat until mixture bubbles. Simmer 5 minutes longer and remove from heat. Add remaining ingredients. Shape into balls and roll in powdered sugar. Will freeze.

Mrs. A. E. Patton

Sour Cream Candy

Yield: about 20 pieces *Better than fudge.*

2 cups sugar
1 cup sour cream
1 cup chopped walnuts or pecans
½ cup chopped raisins

Combine sugar and sour cream in a pan and cook over fairly low heat. Stir often to prevent sticking. Mixture is ready when it forms a soft ball when dropped in cold water. Cool slightly. Add nuts and raisins. Beat until firm and the same consistency as fudge. Pour into a buttered pan. When cool and set, cut into squares.

Mrs. Spencer S. Sanders

Chocolate Turtle Cookies

Makes: 24 medium or *Make in a waffle iron.*
48 small

2 oz. semisweet chocolate
⅓ cup margarine
2 eggs, beaten
¾ cup sugar
1 teaspoon vanilla
1 cup flour
pecan halves, for garnish

Four-Minute Chocolate Frosting:
2 cups sugar
½ cup cocoa
⅔ cup milk
1 stick butter or margarine
1 teaspoon vanilla

Combine chocolate and margarine; melt over low heat. Cool. Combine eggs, sugar and vanilla; blend with chocolate mixture. Add flour and mix well. Heat waffle iron, drop batter by teaspoonfuls onto iron, 2 inches apart. If smaller cookie is desired, use less batter. Bake 1½ minutes. Cool. Frost tops with chocolate frosting and add a pecan half.

Frosting: Mix sugar and cocoa in a saucepan. Add milk and stir thoroughly. Let mixture come to a boil over high heat, then reduce heat to medium and boil for four minutes. Remove from heat, add butter and cool for fifteen minutes. Then add vanilla and beat until creamy before using on cookies.

Mrs. James H. Joyner

GALLERY VII
Heritage

CHARLES WILLSON PEALE (American, 1741-1827)
Portrait of Senator William H. Crawford (1772-1834), 1818, oil on canvas, 24 x 20 inches.
Gift of Mr. and Mrs. Granger Hansell, 1960. *Color reproduction in The High Museum of Art Recipe Collection sponsored by Marchman and Marchman, Inc.*

Gallery VII

Apple Relish

Yield: about 7 pints

This recipe was passed down from my great grandmother.

12 sweet peppers (red or green)
14 medium apples (peeled and cored)
8 medium onions
4-5 pods hot peppers
1 quart vinegar
2 cups sugar
1 tablespoon salt

Remove seeds and membranes from peppers. Pour boiling water over peppers and let stand 15 minutes. Drain. Grind apples, peppers, onions and hot pepper together using vegetable blade of food chopper. Heat vinegar, sugar, salt in large sauce pan. Add chopped ingredients and bring to a boil. Put into sterilized jars immediately and seal.

Ms. Emily Rule

Pear Relish

Makes: 7 jars

This recipe was created by my mother, Mrs. J.A. Cosby, who has made it for years.

1 peck of pears (8 quarts)
3 red bell peppers
3 green bell peppers
6 onions
2 lbs. sugar
1 tablespoon salt
5 cups vinegar
1 tablespoon pickling spices

Chop pears, peppers and onions very finely. Add sugar and salt and let the mixture sit overnight. The next day add vinegar and pickling spices. Heat this mixture almost to a boil, turn down and simmer for 30 minutes. Remove from heat and let this sit for 5 hours. Reheat and bring to a hard boil. Put in jars and seal. This is very good served as a relish with vegetables.

Ms. Linda Cosby

Raisin Sandwiches

Makes: 20-24

An old-fashioned delicacy, nice for picnics or tea picnics.

1 whole lemon, quartered
1½ cups white raisins
mayonnaise
thinly-sliced white or whole wheat bread, crusts trimmed

Grind together the lemon (peel and all) and raisins, using medium or small blade of hand meat grinder, (this can be done in food processor with metal blade). Mix with enough mayonnaise to make it spreadable. (The mixture will keep in refrigerator without mayonnaise, so mix only the amount you need.) Spread on thinly-sliced bread to make tea sandwiches, cut in half.

Mrs. Lindsey Hopkins, Jr.

Pimento Cheese Spread

Makes: about 1 quart (4 cups)

A special pimiento cheese recipe from Mississippi.

1 4-oz. can pimientos (drained and chopped)
¼ teaspoon red pepper
2 garlic cloves, minced
½ cup mayonnaise
1 tablespoon Dijon mustard
¼ cup Durkee's sauce
⅓ cup fresh parsley, chopped
2 tablespoons Grand Marnier
1 lb. mild cheddar cheese, grated

Mix all ingredients except cheese thoroughly. Add cheese, mix well and chill.

Col. Alton R. Taylor

Hungarian Goulash

Serves: 4-6

I was born in Hungary and this is my family's recipe for basic Hungarian Goulash.

2 tablespoons cooking oil
2-3 large onions, chopped
1 lb. beef, cubed
1 tablespoon sweet paprika
1 teaspoon salt
¼ teaspoon pepper
1 tablespoon tomato paste
2 cups water
1 green pepper, sliced

Brown onion in oil. Remove from heat and add beef, sweet paprika, salt and pepper. Stir tomato paste and 1 cup water together and pour over meat. Cover and cook on medium high heat for 15 minutes. Add 1 cup water and cook 15 more minutes, stirring constantly. Sprinkle green pepper over meat and cook 10 more minutes. Serve hot with rice or mashed potatoes.

Mrs. A. Alan Cosby

Pensacola Fish Chowder

Serves: 6

My family settled in Pensacola when it was a Spanish colony; this chowder recipe has been popular with several generations.

2½ tablespoons bacon drippings (melted)
2½ tablespoons flour
1 medium onion, chopped
½ bell pepper, chopped
3 medium potatoes, cubed
1 lb. can whole tomatoes
1 can (3 cups) water
1½ teaspoons salt
1 teaspoon pepper
5 whole allspice
1½ lb. fish (grouper or snapper)
lemon for garnish

Using a heavy 10" skillet, brown flour in bacon drippings to make a roux the color of coffee with cream. Sauté onion and bell pepper until onion is transparent. Lightly sauté potato, which has been cubed in good-sized chunks (1 square inch). Turn into 5-quart pot and add tomatoes and water.

Simmer 1½ hours, or until potato is tender. Fifteen minutes before done, add seasonings and raw fish, cut into large bite-size pieces. Correct seasoning to taste. Lay a thin slice of lemon in a soup bowl and ladle in the chowder. Serve with green salad and vinaigrette dressing, French bread.

Ms. Eleanor W. Malone

Chicken Fricassee

Serves: 4-6

Chicken for a traditional Sunday dinner.

2½ quarts boiling water
2 stalks celery
salt
pepper
1 large stewing chicken

Gravy:
6 tablespoons butter, melted
4 tablespoons flour
2 cups chicken broth, skimmed
2 or 3 egg yolks, beaten

Boil 2½ quarts water with celery, salt and pepper. Add chicken when water is fully boiling and let it cook slowly until tender; allow 3 hours. Remove chicken and when cool remove meat from bones. Skim broth and reserve. Make gravy with melted butter and flour, stirring until smooth; thin with skimmed broth. Add chicken pieces and just before serving, add the well-beaten yolks. Serve with rice.

Ms. Clarkson Terrill

"Pine Bark Stew"

Serves: 6

A traditional supper entree from the Pee Dee Region (Northeastern) of South Carolina. So tasty even pine bark would be good in it, if you don't catch any fish!

½ lb. chopped streak-o-lean
2 large onions, chopped
1-quart 14-oz. can V-8 juice
2 (1-lb.) cans stewed tomatoes
1 tablespoon Worcestershire sauce
Tabasco sauce to taste
1 bay leaf
2 teaspoons sugar (or 1 packet Sweet and Low)
1-1½ lbs. fresh, cleaned fish or 2 (10-oz.) packages of frozen fish fillets

Sauté streak-o-lean until lightly brown. Remove pieces and reserve. Sauté onions in pork fat until tan. Remove onions to dutch oven. Add reserved meat bits and all other ingredients except fish. Simmer 30 minutes. Add fish and simmer until fish flakes, about 20 minutes, but is not falling apart. Serve over a large hunk of toasted homemade bread in a soup bowl. Accompany with a tart cole slaw.

Mrs. James A. Summers

Pork Barbecue

Serves: 8-10
Oven Setting: 350°

Serve on buns with Brunswick Stew.

4-5 lb. pork roast
½ cup vinegar
1 chopped onion
water to cover

Sauce:
1 tablespoon each chili powder, salt, celery seed
1 teaspoon paprika
¼-½ cup molasses or dark brown sugar
1½ cups tomato juice
½ cup vinegar
3 tablespoons liquid from meat

Cover meat with water in a large, heavy pot on top of stove. Add vinegar and onion and simmer, covered 4-5 hours. Let cool, then remove meat, reserving liquid. Shred meat, removing fat and put in heavy covered pan (or crock pot). Simmer meat in above mild sauce (or your favorite barbecue sauce) about 2 hours more. (In crock pot, cook 3-4 hours.)

Mrs. E. Lewis Hansen

Old Fashioned Brunswick Stew

Serves: 8-10 *Hearty.*

1 (4-5 lb.) hen
2 lbs. fresh pork
1 lb. round steak (or ground beef)
2 large onions, chopped
2 large potatoes, peeled and diced
½ cup vinegar
4 cups fresh tomatoes (or 2 1-lb. cans)
2 (1-lb.) cans creamed corn
2 sticks (16 tablespoons) butter
1 tablespoon Worcestershire sauce
salt and freshly ground pepper to taste
hot pepper sauce to taste

Simmer chicken, pork and beef together in 1½ quarts water (salted to taste) in large, covered container 3-4 hours until meats are very tender. Remove meats, reserving 2 quarts stock. Cool chicken, pork and beef; discard skin and all bones. Grind in food chopper or cut in very small pieces. In reserved juices cook onions and potatoes 30 minutes. Add vinegar, tomatoes, corn, butter and Worcestershire, salt and pepper. Return meats to stock and vegetables. Cover and simmer, stirring occasionally until mixture is thick, about 2 hours. Adjust seasonings, adding additional salt and pepper and hot pepper sauce if desired.

Mrs. John J. McLanahan

Baked Kibbie with Pine Nut Stuffing

Serves: 4 *This is a traditional Lebanese*
Oven Setting: 325° *dish taught to me by my mother.*

1½ cups bulgur (medium crushed wheat)
1 medium onion
1½ lbs. extra-lean ground beef
salt and pepper to taste
2 tablespoons corn oil

Stuffing:
4 tablespoons clarified butter
1 large onion, chopped
¼ cup pine nuts, whole

Wash bulgur until water is clear. Leave enough water to cover bulgur. Add ice cubes to bulgur and let sit until soft. Drain and squeeze out excess moisture. Grate onion into large mixing bowl. Mix ground beef and onion. Add bulgur to ground beef and mix well.

Stuffing: Melt clarified butter in frying pan. Add onion and cook until translucent. Add pine nuts and cook about five minutes. Smooth ½ of meat mixture in bottom of a 8″ x 8″ baking dish which has been coated with 2 tablespoons of corn oil. Smooth stuffing over this. Place other half of meat mixture on top. Spread a teaspoon of corn oil over top of kibbie. Run a knife around the edges. Bake kibbie for 20 minutes or until brown.

Mrs. Mary Salem Thomas

Labin—Yogurt in a Pot

This recipe was passed down to me by my grandmother who was raised in Lebanon.

1 quart whole milk
3 tablespoons culture (plain yogurt), may use plain Dannon yogurt
2 tablespoons warm milk

Put about 1" of water in bottom of pan. Bring to a boil. Pour off. (This will prevent milk from sticking.) Add milk and cook at a medium temperature. Bring milk to a boil. A skim will form on top of milk, break the skim, this will stop the boiling. Bring to boil two more times. After third time, cool milk by stirring frequently. Before milk has come to room temperature, add culture which has had 2 tablespoons warm milk added to it. Stir gently. Pour milk in a container and store without moving for 8 hours. Cover but do not seal. Refrigerate. Serve after chilled.

Can be served as a dessert with fruit and honey or with a salad of sliced cucumbers.

Mrs. Mary Salem Thomas

Stewed Apples

Serves: 6

Serve with bacon, biscuits, cheese eggs for a quick late-night meal or a cozy breakfast.

3½ cups sliced (green, tart) apples
bacon (depends on family size)
1 cup sugar or honey
2-3 teaspoons cinnamon

Wash apples, slice and cover with cold water. Line the bottom of deep skillet with bacon and fry, reserving the grease. Next, place apples in grease. Sprinkle with sugar or honey, cinnamon and cook over high heat for 5 minutes then simmer until soft.

Mrs. Arthur M. Cole, Jr.

Aunt Annie's Cole Slaw

Serves: 6

This recipe comes from a great aunt in Southwestern Pennsylvania; one of the all time great cooks. This slaw has been hailed as a gustatory victory by men, women, children and strays.

½ head cabbage
¼ cup cream, whipped
3 tablespoons sugar
3 tablespoons vinegar
pinch of salt
pepper

Chop cabbage. Whip cream and add sugar, vinegar, salt and pepper just before the cream stiffens. Fold into cabbage. Good also on sliced cucumbers and onions.

Ms. Betty Frey

Old Fashioned Wilted Lettuce

Serves: 4

This is an old family recipe from my grandmother's North Carolina farm.

leaf lettuce (enough for 4 large servings)
small bunch of spring onions, thinly sliced
vinegar, salt and pepper to taste
½ cup bacon drippings
2 eggs, beaten
1 cup milk

Break lettuce in small pieces and add onions. Add vinegar, salt and pepper to taste. Heat ½ cup bacon drippings in saucepan until warm. In bowl, combine eggs and milk. Add egg mixture to drippings and heat, stirring constantly until mixture thickens. Pour over lettuce and toss. Serve immediately with crumbled bacon as topping.

Mrs. Robert M. Edney

Creamed Fresh Corn

Serves: 6

They don't make it like this anymore!

6 ears corn
3 slices bacon
⅔ cup water
1 teaspoon salt
½ teaspoon sugar
¼ cup milk
2 teaspoons flour
pinch pepper
1 tablespoon butter

Cut kernels from ears of corn and scrape cobs with a spoon to get all the juice. Cook bacon until crisp, remove from pan and reserve. Stir corn into hot bacon drippings and add water, salt and sugar. Cook 5 minutes, uncovered. Gradually stir milk into flour mixing until smooth. Add milk and flour mixture to corn and cook over medium heat, stirring until thick. Mix in pepper and butter. Serve topped with crumbled bacon.

Mrs. William T. Kennedy

Spoon Bread Soufflé

Serves: 4-6
Oven Setting: 400°

Wonderful with a ham.

½ cup corn meal
½ teaspoon sugar
½ teaspoon salt
1 tablespoon butter
1 pint milk
4 eggs, separated
1 tablespoon butter

Mix meal, sugar, salt and 1 tablespoon butter in double boiler over boiling water. Add milk and cook, stirring, to mushy consistency. Drop in yolks, one at a time and whip. Beat whites until stiff. Fold mixtures together. Melt 1 tablespoon butter in baking dish, pour in mixture and bake for 20 minutes. Serve immediately, with butter if desired.

Baked Brown Bread

Makes: One large loaf
Oven Setting: 350°

This recipe was found in a file box in a lake cottage in New Hampshire. The cottage had belonged to two spinsters near the turn of the century. The recipe has been converted from one that was to be cooked in or on a fireplace.

1 pint buttermilk or VERY sour milk
1 cup flour
2 cups graham flour or whole wheat pastry flour
½ cup cornmeal
½ cup dark molasses
½ cup sugar
1 teaspoon salt
2 teaspoons soda

Mix all ingredients and pour into greased and lightly floured large loaf pan. Batter is very thick. Bake about 45 minutes. This is a very dense bread so care must be taken to ensure that it is done all the way through without over baking. If desired, raisins and/or chopped walnuts may be added.

Ms. Linda Hall

Rhubarb Bread

Makes: 1 loaf
Oven Setting: 325°

Contains very little sugar but almost sweet enough to be a dessert.

½ cup milk
½ teaspoon fresh lemon juice
¾ cup dark brown sugar
⅓ cup vegetable oil
1 small egg
½ teaspoon vanilla
1¼ cups flour
½ teaspoon salt
½ teaspoon baking soda
½ lb. diced rhubarb
¼ cup chopped walnuts
¼ cup sugar
1 tablespoon melted butter

Combine the milk and lemon juice in a small bowl and let sit for at least 5 minutes. In a large bowl combine ¾ cup brown sugar, vegetable oil, egg and vanilla. Sift together flour, salt and baking soda. Add the milk and flour mixtures to the sugar mixture, alternately. Beat well after each addition until smooth. Fold in rhubarb and chopped walnuts. Pour into a buttered 8½″ x 4½″ x 2½″ loaf pan. Combine the ¼ cup sugar and melted butter and sprinkle over the top of batter. Bake for 1 hour.

Mrs. Donald Levans

Spice Cake with Mocha Icing

Serves: 12
Oven Setting: 350°

Spice cake like mother used to make.

¾ cup shortening
1½ cups sugar
3 eggs
1¾ cups flour
½ teaspoon baking powder
½ teaspoon baking soda
½ teaspoon salt
¾ teaspoon nutmeg
1 teaspoon cinnamon
2 tablespoon cocoa
¾ cup buttermilk
1 teaspoon vanilla
1 teaspoon lemon extract
½ cup chopped nuts, roasted

Cream shortening and sugar. Blend in well beaten eggs. Sift all dry ingredients together; add alternately with buttermilk. Blend in flavorings and nuts. Pour into greased and floured layer pans. Use 2 deep (8″) pans for high layers, or 2 (9″) pans for thinner layers.

Icing:
6 tablespoons butter
1 egg yolk
3 cups confectioner's sugar
1½ tablespoons cocoa
1 teaspoon cinnamon
1½ tablespoons hot strong coffee

Cream butter, blend in egg yolk. Sift sugar, cocoa and cinnamon and add to the creamed mixture alternately with hot coffee. Beat until smooth.

Mrs. Richard E. Richardson

Appelbeignets

Serves: 8-10

A traditional recipe from Holland. Serve with hot coffee or a dry white wine.

12 apples, peeled and cored
½ lb. bread flour
1½ cups beer
½ teaspoons salt
Crisco

Cut apples to form O's. Combine flour and beer to make a batter. Whisk until smooth. Add salt. Dip the apples in the batter and fry in Crisco at 370°. Drain and sprinkle with confectioner's sugar.

Mrs. Jon Carlsten

Butterscotch Delights

Makes: 8 dozen
Oven Setting: 325°

This is an old recipe of my mother's. One can whip it up in a matter of minutes and it always makes a hit!

1 stick butter (no substitute)
2 cups firmly-packed dark brown sugar
2 eggs
1¾ cups all purpose flour
2 teaspoons baking powder
1 teaspoon vanilla

In large saucepan, melt 1 stick butter. Stir in remaining ingredients in order listed above. Spread in lightly greased and floured 9″ x 13″ pan. Bake for 25 minutes. Insert knife in center of mixture. If it comes out clean, they are done. When cool, cut in 1½″ squares. A great accompaniment for after-dinner coffee.

Mrs. James L. Ewing, III

Dearmother's Hermits

Oven Setting: 300°

Marvelous winter cookie. This is my grandmother's recipe and I have been baking them for 25 years.

2 cups brown sugar
1 cup butter
2 eggs
2½ cups all purpose flour
1 teaspoon baking powder
1 teaspoon cinnamon
½ teaspoon allspice
1 teaspoon ground cloves, ginger and if possible, freshly ground nutmeg; otherwise, powdered nutmeg will do. After measuring teaspoons, shake a little more of each in.
1½ cups raisins; it's nice to mix black and golden in any proportion
1½ cups coarsely broken pecans

Cream sugar and butter; add eggs and mix. Sift flour and baking powder with spices; add to sugar, butter, egg mixture in thirds. Dredge raisins if hard and dry and add; then add nuts. Mix it all in electric mixer. Drop on greased tins (or ungreased foil) and bake for 20-25 minutes. Cookies will spread so allow room. Let cool on tins for several minutes. Remove from pan immediately to prevent sticking. Will keep for several months in tins!

Mrs. Hugh L. Sawyer

Syllabub

Serves: 4

A delicacy from the deep south.

1 lemon
1 orange
3 oz. sugar
¼ pint white wine
10 oz. (½ pint) double cream

Mix together the grated lemon rind and juice of 1 lemon, grated orange rind, sugar and wine; let stand for at least 1 hour. Strain into a mixing bowl and add cream whisking all the time. Continue whisking until mixture thickens. Spoon into tall glasses and leave in a cool place to set.

Mrs. Daniel O'Neil

Miss Margaret's Fudge Pudding

Serves: 6
Oven Setting: 325°

This recipe has been in my family for many years.

2 sticks margarine, melted
2 cups sugar
1 teaspoon vanilla
6 tablespoons cocoa
4 eggs
1 cup flour, sifted
pinch of salt
¼ cup pecan pieces

Cream together the margarine, sugar, vanilla and cocoa. Lightly beat the eggs and add to sugar mixture. Sift together the flour and salt and add to sugar mixture. Blend in the nuts. Pour the batter into an ungreased 8" x 8" pan. Place this pan inside another larger pan, the bottom of which is covered with water. As it bakes the top will form a crust, but the inside will remain pudding-like. Bake 45 minutes in a preheated oven. Spoon into bowls and serve hot with a scoop of vanilla ice cream on top.

Mrs. J.H. Lever

Sweet Noodle Pudding

Serves: 12
Oven Setting: 400°

A very old recipe with a wonderfully rich old-fashioned taste.

2 cups milk
1 cup sugar
1 cup sour cream
4 eggs, lightly beaten
¼ cup melted butter
2 tablespoons vanilla
1 teaspoon salt
4 oz. cream cheese, softened
1 cup small curd cottage cheese
½ cup golden raisins
½ lb. fine egg noodles
¼ cup melted butter

In a large bowl, combine milk, sugar, sour cream, eggs, first ¼ cup butter, vanilla and salt. Beat with mixer until well combined. Cut softened cream cheese into very small pieces and drop into mixture. Stir in cottage cheese and raisins. Cook the noodles in boiling water for 5 minutes. Drain well and mix noodles with the milk mixture. Pour into a greased 13" x 9" x 2" pan and drizzle ¼ cup melted butter over the top. Bake in a preheated oven for 1 hour. Chill and cut into squares and serve.

Mrs. J.M. Dangar

Mary Jane's Apple Cobbler

Serves: 6
Oven Setting: 400°

Mary Jane nursed me and both my girls. This is the only recipe she gave me. It is old fashioned but special.

1¼ cups sugar
3 tablespoons flour
¾ teaspoon cinnamon
¼ teaspoon salt
8 cups sliced apples
⅓ cup water
2 tablespoons butter
1 cup flour
1 tablespoon sugar
1½ teaspoons baking powder
½ teaspoon salt
3 tablespoons shortening
½ cup milk

Mix first 4 ingredients with apples, sprinkle with water and dot with 2 tablespoons butter. Cover with foil, bake 15 minutes.

Sift flour, mix with sugar, baking powder and salt. Cut in shortening, stir in milk. Drop by spoonfuls on hot apples. Bake uncovered 25-35 minutes.

Mrs. Richard A. Freeman

Claret Sherbet

Serves: 6

This has been passed down through three generations of Harts in Columbus, Georgia.

1 cup sugar
1 quart lukewarm water
juice of 3 lemons
1 lemon rind, grated
½ cup claret or other red wine
½ cup raspberry syrup
¼ teaspoon cinnamon
¼ cup white Karo syrup

Mix all together and freeze, stirring several times during freezing (this takes several hours).

Ms. Kent Hart

Blackberry Jam Cake with Buttermilk Icing

Makes: 1 large layer cake
Oven Setting: 325°

Worth the effort.

Cake:
1¾ cups flour
1 teaspoon baking powder
½ teaspoon salt
1 teaspoon baking soda
1 teaspoon cinnamon
½ teaspoon nutmeg
½ teaspoon allspice
¼ teaspoon ground cloves
1 cup sugar
1 cup oil
3 eggs, beaten
¾ cup buttermilk
1 teaspoon vanilla
1 cup blackberry jam
1 cup finely chopped pecans

Icing:
3 cups sugar
1 cup butter
1 cup buttermilk
2 tablespoons corn syrup
1 teaspoon baking soda
1 cup nuts
1 teaspoon vanilla

For cake: Sift and measure all dry ingredients except sugar, mix all together, sift 3 times, add sugar to oil, mix well, add eggs, mix well, add dry ingredients alternately with buttermilk. Stir in vanilla and blackberry jam, stir in nuts well. Bake in 2 greased and floured 9" pans about 30-35 minutes.

Buttermilk icing: In 4-quart pot over medium heat (be sure to use 4-quart pot, this icing will boil over) add all icing ingredients except nuts and vanilla. Boil, stirring constantly. Cook until small amount dropped into cold water forms ball. Pour in large bowl and beat with mixer at high speed for a few minutes. Beat with spoon until it cools; add nuts, vanilla, spread on layers.

Ms. Pansy Little

GALLERY VIII
Holiday Highlights

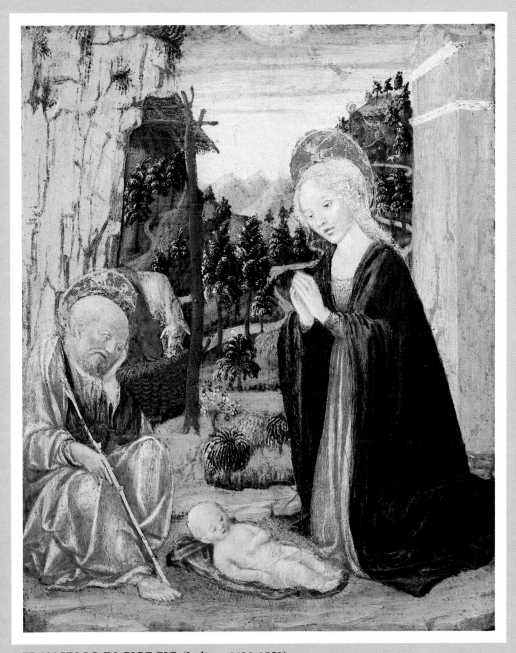

FRANCESCO DI GIORGIO (Italian, 1439-1502)
The Nativity, c. 1460, Tempera on panel, 9⅛ x 7½ inches. The Samuel Kress Collection, 1961. *Color reproduction in The High Museum of Art Recipe Collection sponsored by The Fräbel Gallery, Inc.*

Gallery VIII

Come-A-Caroling Wassail

Makes: 25 cups

Served at the Come-A-Caroling party hosted by the Junior Committee at the High Museum each year.

1 gallon apple cider
1 cup dark brown sugar
6-oz. can frozen lemonade
6-oz. can frozen orange juice
1 teaspoon ground nutmeg
6 cinnamon sticks
2 jiggers of sherry

Combine all of the above ingredients. Simmer 20-30 minutes in large container on stove. Looks beautiful served in a large punch bowl with whole oranges stuffed with cloves.

Mrs. Jim P. Letts, III

Hot Buttered Rum Mix

Favorite winter drink.

1 stick margarine (not butter)
1 lb. light brown sugar
1 heaping teaspoon cinnamon
1 heaping teaspoon nutmeg
$1/8$ teaspoon ground allspice
$1/2$ teaspoon angostura bitters
$1/4$ teaspoon ground ginger
dark rum

Mix all ingredients except rum thoroughly. Refrigerate until ready to use. For drink, combine 1 heaping teaspoon mix, 2 oz. dark rum and about 4 oz. boiling water. Mix will keep in refrigerator for several months.

Ms. Margaret Black

Mulled Red Wine

Serves: 6-8

Popular drink in Ireland and British Isles at parties following Fox Hunt. A pleasant drink in front of a warm, cozy fire in winter.

For each 1-liter bottle of red wine allow:
$1/2$ pint water
1 cup sugar
2-inch stick cinnamon
pinch grated nutmeg
dash of mace
1 orange
6-8 cloves
slices of lemon and orange for garnish

Put wine, water and sugar into a large pan. Place over gentle heat until sugar has dissolved. Add spices and the orange, stuck with cloves. Heat slowly to simmering point or until surface is covered with white foam. Remove from heat and strain into a pitcher. Pour into warmed glasses or goblets. Do not have wine too hot—it could break the glass. Put a lemon and orange slice into each glass.

Mrs. Daniel O'Neil

Hot Wine

Serves: 8

Wonderful on a cold winter's night with friends around a fire.

½ gallon Paisano wine
1 cup sugar
2 cups water
1 orange, cut in slices
3 cinnamon sticks
9 whole cloves

Heat all ingredients together to blend flavors. Do not boil.

Ms. Sherry Wren

Wassail

Makes: 25 cups
(6 oz. each)

The middle English words WAES, WAEIL mean "be thou well." (Our revision of English recipe from my father—Thomas Henry Stuart.)

1 gallon sweet or hard cider
10 (2-inch) sticks cinnamon
1 tablespoon allspice
½ cup fresh lemon juice
1 bottle (5th) apple jack or French apple brandy
 (Calvados)

Heat together all ingredients except apple jack or Calvados until mixture comes to a boil. Simmer 15 minutes. Add apple jack and serve hot. The bowl may be decorated with small, soft roasted or baked apples.

Mrs. Robert C. Garner

Cranberry Fruit Punch

Serves: 20-25

A favorite each time I have served it.

1 quart fresh cranberries
7 cups water
cheesecloth
2 cups sugar
1 cup orange juice
¼ cup lemon juice
1 quart ginger ale

Cook cranberries in 4 cups of water until tender. Crush and drain through cheesecloth. Combine sugar with remaining 3 cups of water and boil for five minutes. Add cranberry juice to this syrup and chill. Add orange juice and lemon juice. Just before serving, add ginger ale. Can be used as party, reception or bridal shower punch as well as aperitif for luncheon.

Mrs. William B. Astrop

Christmas Eggnog

Makes: 10-12 cups

Old family recipe, rich and delicious.

6 eggs, separated
1 cup sugar
1 pint heavy cream
1 cup rum
1 cup corn whiskey
nutmeg, freshly grated

Beat egg whites until stiff. Beat in sugar gradually. Beat yolks until thick. Whip cream in large bowl. Fold in beaten whites, yolks and liquor. Sprinkle with nutmeg before serving.

Mrs. Donald M. Stewart

London Fog

Serves: 10

Learned in Europe during the 1950's.

1 quart vanilla ice cream
1 quart strong coffee
2 cups bourbon
nutmeg

Mix all ingredients together in a punch bowl. Chill. Sprinkle nutmeg over punch before serving.

Mrs. Alton R. Taylor

Toffee Apples

Makes: approximately 1 quart

This is a quick and easy hors d'oeuvre recipe for a crowd. A favorite of the Junior Committee's Young Collector's Party.

½ cup butter
2 cups dark brown sugar
1 cup white corn syrup
2 tablespoons water
14-oz. can sweetened condensed milk
1 teaspoon vanilla
2 dozen apple slices

Melt butter. Add all other ingredients but vanilla. Stir until thick, in double boiler over moderate heat. Add vanilla. Serve toffee in a chafing dish over flame. Arrange bite-sized apple slices attractively on a tray for dipping. (Apple slices should be cut ahead of time and placed in grapefruit juice for a few minutes to prevent them from browning.)

Mrs. Jim P. Letts, III

Pâté Mock Venison

Makes: 1 loaf
Oven Setting: 350°

*A good hors d'oeuvre,
also a favorite in my home for
Sunday night supper!*

Marinade:
½ teaspoon salt
¼ teaspoon pepper
1 crushed bay leaf
½ teaspoon dried thyme
2 sprigs parsley
1 tablespoon onion, minced
1 garlic clove, crushed
1 tablespoon salad oil
1 cup red wine

Pâté:
1 lb. raw pork, cut into slices about ½" thick
¼ lb. ground pork
¾ lb. ground veal
½ teaspoon salt
¼ teaspoon pepper
1 egg, slightly beaten
1 tablespoon red wine
bacon, about ½ lb.

Combine ingredients to make marinade and soak sliced pork in it at room temperature for 6-8 hours, turning once. (Or marinate pork in refrigerator overnight.)

Mix remaining ingredients. Line a 9" x 5" loaf pan with bacon strips, letting them extend up the sides of the pan and over the edge. Put in a layer of one half the ground meat mixture, then a layer of half of the sliced pork (which you have lifted out of marinade but not wiped); press down. Add another layer of ground mixture and a last layer of sliced pork. Press down. Fold the overhanging bacon over the meat mixture and use more bacon strips to completely cover the surface of the pâté.

Cover pan with foil and set in shallow pan of water. Bake for 2 hours. Remove from oven and allow to cool thoroughly before removing foil. Refrigerate until serving time. After refrigeration you may wish to remove part or all of the solidified fat on the outside of the loaf. Unmold on serving platter and cut into crosswise slices. Serve with buttered pumpernickel or French bread.

Mrs. Spencer S. Sanders

Petite Mushroom Sandwiches

Makes: 40 squares
Oven Setting: 325°

Nice make-ahead hors d'oeuvre.

1 lb. fresh mushrooms, finely chopped
1 large onion, chopped
3 tablespoons butter
2 tablespoons flour
cream (half and half)
Worcestershire sauce
salt
pepper
1 loaf thin-sliced bread (20 thin slices)
melted butter

Sauté mushrooms and onion in butter. Add flour and enough cream to thicken. Flavor with Worcestershire sauce and salt and pepper to taste.

Make sandwiches with the sliced bread, trim crusts and cut into 4 squares. Brush with melted butter. Bake on cookie sheet for 20 minutes (until brown). These can be frozen before cooking. After spreading and cutting each into 4 squares, freeze. Brush with butter before baking.

Mrs. James Taylor

Cheese Wafers

Makes: 4 dozen
Oven Setting: 300°

We keep these in a tin lined with waxed paper and bring them out when guests drop by. Tasty with cocktails.

¼ lb. sharp cheddar cheese
¼ lb. (1 stick) butter
½ teaspoon salt
cayenne to taste
1 cup cake flour

Cream cheese and butter together with salt and cayenne. Sift in flour (do not sift beforehand). Make into a roll about the width of a silver dollar, wrap in waxed paper and chill in refrigerator. Slice thin, bake **light** brown (very important) in moderate oven for approximately 30 minutes. These are **very easy** to overcook. That light brown is very important.

Ms. Tippen Harvey

Soup au Pistou (Vegetable Soup with Herb Paste)

Serves: 6

Serve with hearty homemade bread.

Soup:
1½ tablespoons butter
1⅓ cups leeks, finely chopped
⅓ lb. each, finely chopped: peeled carrots; string beans and zucchini
2½ large tomatoes, peeled, seeded and chopped
⅓ lb. potatoes, peeled and finely chopped
bouquet garni: ¾ teaspoon basil, ¾ teaspoon thyme and 2 bay leaves
salt and pepper
water or chicken stock
3 oz. vermicelli, broken
½ can navy (or Great Northern) beans

Paste:
3-4 medium garlic cloves
1 tablespoon dried basil
½ cup freshly grated Parmesan or Sardo cheese
4 tablespoons olive oil

Sauté leeks, carrots, beans and zucchini in hot butter for 5 minutes. Add tomatoes, potatoes, bouquet garni, salt and pepper. Add enough boiling water or chicken stock to cover well. Simmer gently, partially covered, 20 minutes or until vegetables are tender. Add vermicelli and simmer 10 minutes. Add navy beans (which have been rinsed well) and simmer 5 minutes.

Make paste: crush garlic, basil and cheese to a paste using a pestle or blender. Drop-by-drop, beat in oil to form a thick paste. Just before serving soup, spoon some paste into soup (do not boil) and serve immediately.

Mrs. R.M. Smith, Jr.

Beef Soup-Stew

Serves: 10

Excellent for a bread and soup party.

⅓ cup oil
4 lbs. stew beef, cubed
2 large onions, sliced
3 cloves garlic, minced
1½ cups dry red wine
¼ cup chopped parsley
water to cover
2 cups fresh or 1 box frozen peas
4 large tomatoes, peeled and cut in eighths
10-12 small onions, peeled
6 medium carrots, scraped and sliced
1 lb. fresh mushrooms, sliced
1 cup dry red wine
salt
pepper
¾ cup wild rice, thoroughly washed

Heat oil in skillet and brown beef. Transfer meat to soup kettle. Add onion and garlic to skillet, cook and stir until tender and golden. Remove to soup pot. Add a little wine to skillet and boil, stirring until scrapings are free. Pour into soup. Add parsley, wine and water just to cover ingredients. Bring to a simmer, cover and cook about 1½ hours or until meat is very tender. Add fresh peas (frozen peas should be added with wild rice at end of recipe), tomatoes, onions, carrots, mushrooms and 1 cup red wine. Add a few grindings of black pepper and salt to taste. Stir the stew, bring to a boil and cook 15 minutes uncovered. Add wild rice and frozen peas, if used. Cover, bring back to simmer and cook 1 hour.

Mrs. Cecil D. Conlee

Holiday Quail

Serves: 6
Oven Setting: 350°

Festive holiday dish, yet very simple to prepare. Also makes an elegant brunch.

12 dressed quail
salt
freshly ground pepper
36 oysters
1 egg, beaten
cornmeal
butter, melted
flour
12 strips of bacon
12 pieces of toast

Wash quail thoroughly with cold water and salt and pepper to taste. Dip oysters in egg and then in cornmeal. Stuff each quail with approximately three oysters. Make a paste of flour and melted butter and coat each quail with this paste. Wrap each quail with a strip of bacon. Bake for 45 minutes or until golden brown. Serve on toast. Garnish with parsley and candied crabapples. Excellent with curried fruit and wild rice.

Mrs. Sal Henley

Imperial Chicken

Serves: 4
Oven Setting: 450°
then 350°

Delicious for an elegant sit-down dinner, or an excellent alternative to holiday turkey.

4 lbs. (or larger) chicken, rinsed, oiled and salted

Stuffing:
½ cup raisins
4 slices bacon
¼ cup chopped green onion
4 cups boiled rice
⅓ cup walnuts, chopped
1 teaspoon salt
½ teaspoon ground ginger (or more, to taste)

Sauce:
2 tablespoons bacon grease
12-oz. jar apricot preserves
2 teaspoons soy sauce
½ cup vinegar
2 tablespoons oil

Stuffing: Soak raisins in water to cover for 10 minutes. Slowly cook bacon until crisp. Crumble. Reserve 2 tablespoons bacon grease for sauce. Sauté green onions in remaining bacon grease. Add remaining stuffing ingredients, toss and remove from heat. Stuff chicken, placing any remaining rice mixture in casserole.

Put chicken, loosely covered with foil, in oven; immediately reduce heat to 350°. Baste often, cook until done (about 20 minutes per lb.). Uncover for last half hour.

Sauce: Heat ingredients in saucepan. Do not boil. Pour over chicken before serving. This sauce is sweet-tart and you may prefer to serve it in a gravy boat so that guests can help themselves.

Ms. Cynthia A. Joiner

Turkey Devonshire

Serves: 2
Oven Setting: 350°

A favorite use for leftover turkey!

4 slices buttered toast
sliced turkey
2 tablespoons butter
2 tablespoons flour
¼ teaspoon salt
¼ teaspoon dry mustard
dash cayenne
1 cup milk
1½ cups grated Cheddar cheese
paprika
¼ lb. bacon, cooked

Butter individual shallow baking dishes or oven-proof plates. In each, put buttered toast cut to fit. Arrange turkey on toast. In saucepan, make cheese sauce: melt butter, add flour and cook until bubbly. Add salt, mustard, and cayenne. Off heat, blend in milk. Stir in 1 cup cheese and return to low heat until cheese melts. Pour sauce over turkey. Sprinkle with remaining cheese, sprinkle with paprika, dot with butter, bake 15 minutes. Garnish with strips of bacon, put under broiler just long enough to brown lightly.

Ms. Pat Reeves

Veal and Ham Pie
with Mustard Sauce

Serves: 6 (as an entrée) *Special.*
12 (as a first course)
Oven Setting: 425°, 350°
then 325°

Pastry:
½ cup + 1 tablespoon boiling water
1 cup lard
3 cups flour
¾ teaspoon salt

Filling:
1 lb. boneless smoked ham, cubed
3 shallots, minced
2 tablespoons butter
1 tablespoon Madeira wine
1½ lbs. boneless veal, cubed
⅓ cup brandy
⅓ cup chicken broth
¼ cup fresh parsley, chopped
2 tablespoons lemon juice, 1 teaspoon grated lemon
 peel
salt to taste
½ teaspoon marjoram
¼ teaspoon tarragon
¼ teaspoon white pepper
pinch thyme
4 hardboiled eggs, shelled
1 tablespoon whipping cream
1 envelope unflavored gelatin
1 cup chicken broth

Pastry: pour boiling water over lard and refrigerate for 15 minutes. Mix the flour and salt together. Add to the lard mixture and stir with fork until all flour is added and mixture clings together. Shape into a ball and refrigerate at least 30 minutes.

Filling: sauté ham and shallots in butter and wine over high heat for 5 minutes. Remove from heat. Add veal, brandy, ⅓ cup broth, parsley, lemon juice and peel, salt and spices. Mix well.

Roll out ⅔ of the dough into a 13″ x 8″ rectangle. Ease into a 9″ x 5″ x 3″ greased loaf pan. Press down and into sides. Trim edges but leave ¼″ overhang. Spread half of veal-ham mixture over pastry. Place eggs in row down center. Top with rest of meat mixture. Heat oven. Roll out rest of dough and place over meat mixture. Pinch seams. Roll out scraps and brush dough with cream. Decorate with cutouts from scraps and brush all with cream. Place loaf pan on baking sheet. Bake 15 minutes at 425°. Reduce oven to 350° and bake 45 minutes. Reduce to 325° and bake 60 minutes. Cool for 15 minutes.

Soften gelatin in 1 cup chicken broth. Heat to dissolve. Place small funnel in hole in the pie; pour broth, 2 tablespoons at a time, into pie. Tilt gently around. Cool completely; then refrigerate 4 hours or overnight. Serve, sliced with mustard sauce.

Mustard sauce: mix 2 teaspoons dry mustard with 2 teaspoons warm water; stir in ¼ cup vinegar, whisk in 1 cup sour cream, 1 teaspoon Worcestershire, salt and pepper to taste. Refrigerate.

Mrs. C.R. Smathers

Christmas Goose

Serves: 4-8
Oven Setting: 350°

A smash hit for small dinner parties; festive family Christmas party.

8-10 lb. goose

Stuffing:
1 package stuffing mix
1 medium onion, chopped
thyme
sage
¼ cup (1 stick) margarine
½ pint oysters, optional
2 teaspoons salt
freshly ground peppercorns

Sauce:
2 tablespoons vinegar
2 teaspoons prepared mustard
2 teaspoons celery seed
1 tablespoon apple jelly

Rinse goose in cold water, pat dry. Combine ingredients for stuffing, toss with melted margarine; add oysters to stuffing for special parties. Stuff goose with mixture, truss with skewers. Pat dry with paper towels. Spread sauce mixture of vinegar, mustard, celery seed and apple jelly carefully over skin, until completely covered. Bake. Roast uncovered until skin is crisp. Use meat thermometer to ensure doneness (180°-185°). Do not overcook. Drain off excess fat. Garnish with spiced apple rings, parsley and fresh mint sprigs.

Mrs. Pamela Harris Myers

Christmas Eve Oyster Soufflé

Serves: 6-8
(can be doubled easily)
Oven Setting: 350°

Delicious—a family tradition on Christmas Eve.

1 pint oysters
1 teaspoon salt
black pepper
4 eggs, well beaten
½ pint sweet milk
1 stick butter
small box oyster crackers or about 20 saltines

Drain oysters. Reserve liquid. Mix strained liquid, salt, pepper, eggs and milk. Place layer of oysters in bottom of casserole, dot with part of butter (about ⅓ stick), add layer of crackers (crumbled). Cover with milk and egg mixture. Begin again and repeat until casserole is full. Bake until it begins to set, 30-40 minutes. Top with remaining crackers, butter and continue baking until lightly browned.

Mrs. J.D. Sands, Jr.

Cinnamon-Tomato Casserole

Serves: 8 *An unusual combination of flavors.*
Oven Setting: 350°

4 cups canned tomatoes, drained
3 cups seasoned croutons
¼ cup fresh parsley, chopped
1 tablespoon garlic, chopped
6 tablespoons melted butter
1 teaspoon ground cinnamon
½ teaspoon sugar
¼ teaspoon pepper
3 apples, peeled, cored and sliced
2 cups (8 oz.) grated mozzarella cheese

Place tomatoes on paper towel to absorb excess liquid. Sauté croutons, parsley and garlic in 4 tablespoons butter until all butter has been absorbed. Combine crouton mixture, tomatoes, cinnamon, sugar and pepper. Preheat oven. In a 2½-quart casserole, layer tomato mixture, apple slices and then cheese. Layer twice, ending with apple slices. Brush top with remaining 2 tablespoons butter. Bake for 30 minutes. Garnish with red apple peel and additional mozzarella cheese if desired.

Ms. Cheryl W. Abrams

Spinach and Strawberry Salad

Serves: 6-8 *This is a colorful salad with an unusual dressing—pretty at Christmas, or anytime.*

1 cup sugar
1 teaspoon paprika
½ teaspoon dry mustard
1 teaspoon Worcestershire sauce
1 cup oil
1 teaspoon onion, minced
½ cup vinegar
¼ cup poppy seeds
¼ cup sesame seeds
fresh spinach leaves
fresh strawberries, halved

Combine all ingredients except spinach and strawberries in blender or food processor and blend until well mixed. Serve over fresh spinach leaves and strawberries. (If dressing thickens too much in the refrigerator, shake well.)

Mrs. Peter Leff

Elegant Stuffed Sweet Potatoes

Serves: 12 *Great for Thanksgiving dinner.*
Oven Setting: 350°

6 medium sweet potatoes
½ cup butter
1 cup crushed pineapple, drained
4 tablespoons brown sugar
½ cup rum
sprinkling of grated nutmeg

Bake potatoes as usual. Cut potatoes in half lengthwise. Scoop out centers, being very careful not to break shells. Combine the scooped-out potato with butter, pineapple, brown sugar and rum. Beat to make fluffy. Fill potato shells with mixture and sprinkle tops with nutmeg. Bake about 20 minutes.

These potatoes freeze beautifully. Take from freezer as needed or when unexpected guests arrive.

Ms. Margaret Black

Portofino Mold

Serves: 12

Everyone wants this recipe. This is a favorite for Thanksgiving and Christmas dinner.

2 3-oz. packages raspberry gelatin
1¼ cup boiling water
1 lb. 4-oz. can crushed pineapple, undrained
1 lb. can whole cranberry sauce
¾ cup port wine
1 cup chopped pecans
8 oz. cream cheese (1 package)
1 cup sour cream
lettuce

Dissolve gelatin in boiling water. Stir in pineapple, cranberry sauce and wine. Chill until mixture thickens slightly. Fold in pecans and turn into a 2-quart rectangular dish. Chill until firm. Blend cream cheese and sour cream until smooth. Spread over gelatin. Chill until serving time. Cut into squares and place on crisp lettuce.

Ms. Betsy Bairstow

Stuffed Spinach Roll

Serves: 8
Oven Setting: 350°
then 375°

Garnish with spiced fruit or cherry tomatoes at Christmas

3 (10-oz.) packages chopped spinach
⅓ cup minced onion
¾ stick butter (6 tablespoons)
¼ cup cream
nutmeg, freshly grated
salt
pepper
5 eggs, separated
salt

Cook spinach according to package directions. Drain and squeeze out moisture. In a skillet, sauté onions in butter, add spinach and stir until onions and spinach are coated in the butter. Add cream, stir until absorbed. Season, transfer to large bowl, and beat in five egg yolks, one at a time. Line a buttered 15½″ x 10½″ jelly roll pan with waxed paper and butter paper well.

In a large bowl beat egg whites with a pinch of salt until stiff peaks form. Stir one fourth of whites into spinach. Fold in remaining egg whites. Spread in pan. Bake at 350° 20-25 minutes until firm.

Cover with tea towel and baking sheet when done and invert onto sheet. Remove waxed paper and roll jelly-roll fashion. Cool. Unroll. Spread with Duchesse Potatoes. (See below.) Reroll, wrap in foil. Chill at least one hour.

Slice roll into 1″ slices and arrange in a well buttered pan. Sprinkle well with melted butter and bread crumbs. Cover with foil. Bake at 375° for 20 minutes. Run under broiler 2-3 minutes to brown.

Duchesse Potatoes:
3 lbs. potatoes, peeled, quartered, boiled until tender
3 egg yolks
¾ stick butter (6 tablespoons)
nutmeg, freshly grated
salt

Put potatoes through sieve or mash. Stir in egg yolks and butter and seasonings. Cool. Spread on spinach when spinach is cool.

Mrs. Michael Gaddis

Julienne Vegetables with Tomato Sauce

Serves: 6

A very attractive but complex dish. Best served with a fairly simple main dish.

Sauce:
2½ cups canned plum tomatoes
½ medium onion
1 teaspoon basil
2 bay leaves
1 chicken bouillon cube
salt
2 teaspoons sugar
2 tablespoons olive oil
2 tablespoons flour
½ cup red wine

Simmer tomatoes, onion, basil, bay leaves, bouillon, salt and sugar for 25 minutes uncovered. Add a little water if mixture starts to cook down too much. Remove bay leaves. Pulse in food processor for about 4 seconds (steel blade) until fairly smooth. Warm olive oil in a small pan, add flour, stir to a smooth paste. Gradually add the tomato mixture, stirring to keep smooth. Add wine, stir with a whisk until smooth. Sauce will keep in the refrigerator for a few days.

Vegetables:
3 small zucchini
3 medium potatoes
3 large carrots
3 tablespoons butter
salt

Cut unpeeled zucchini into julienne pieces using a julienne slicer if you have one. Scrape carrots, peel potatoes and cut both into julienne slices. Toss carrots first into a pot of boiling water. Cook about 4 minutes or until just tender. Remove and drain. Cook the potatoes separately and then the zucchini in the same fashion. Do not overcook! Drain and refresh the vegetables in cold water after cooking. Right before serving, sauté the vegetables quickly (and separately) in butter to warm them. Add salt. Mound the potatoes, then zucchini, then carrots on a platter and pour warm tomato sauce on top. (This is very pretty on a blue Chinese platter.) Serve more sauce on the side.

Ms. Alison Taylor Bivens

Cranberry Sherbet

Serves: 8-10

Refreshing.

1 tablespoon unflavored gelatin
⅓ cup fresh lemon juice
1 pint cranberry juice
1 cup sugar
½ teaspoon grated lemon rind
¼ teaspoon salt
2 egg whites

Soften gelatin in ¼ cup cold water. Heat cranberry juice to which sugar has been added enough to dissolve gelatin. Add lemon rind and lemon juice. Freeze until mushy. Add salt to egg whites and beat until stiff. Fold into frozen cranberry mixture and freeze until firm. (You can freeze this in an ice cream freezer if you like but it is not necessary to do so. Delete gelatin and egg whites if you use an ice cream freezer.)

Mrs. F.C. Steinmann, Jr.

Cranberry Eggnog Cheesecake

Serves: 12
Oven Setting: 350°

Great holiday recipe found in Canadian countryside.

Crust:
3 tablespoons butter
3 tablespoons sugar
1 egg
1 cup flour
¼ teaspoon baking powder
⅛ teaspoon salt

Batter:
8-oz. package cream cheese
½ cup sugar
2 egg yolks
1½ cups eggnog
1 tablespoon flour
1 teaspoon vanilla
1 teaspoon lemon juice
2 egg whites

Topping:
1 cup chopped cranberries
½ cup sugar
⅓ cup water
1 teaspoon gelatin
¼ cup water

Crust: Cream butter and sugar; add egg, flour, baking powder and salt. Press into spring form pan.

Batter: Blend cream cheese and sugar and add egg yolks, eggnog, flour, vanilla and lemon juice. Fold in stiffly beaten egg whites. Pour mixture into crust. Bake for 45 minutes.

Topping: Combine cranberries, sugar and water in a small saucepan. Bring to boil, reduce heat and cook for 5 minutes; add 1 teaspoon gelatin softened in water. Chill until set. Spoon over chilled cake slices when you serve the cake.

Ms. Janis M. Basista

Norwegian Kringler

Makes: 2 coffee cakes
Oven Setting: 375°

Excellent for a coffee or brunch or for breakfast on Christmas morning.

1 cup flour
½ cup softened butter (not margarine)
1 tablespoon water
1 cup water
½ cup butter (not margarine)
1 cup flour
3 eggs
½ teaspoon almond extract

Frosting:
1 tablespoon heavy cream
1 cup powdered sugar
1 tablespoon butter
1 teaspoon (or less) almond extract
1 cup toasted, sliced almonds

Mix first 3 ingredients with mixer, pat on ungreased cookie sheet in two long strips 3″ wide. Heat water and butter to boiling. Take from stove and add flour. Stir until smooth. Beat in eggs, one at a time, beating until smooth after each. Add almond extract. Spread lightly over first mixture. Bake 45 minutes.

Frosting: Stir ingredients until smooth and spread on cakes when cool. Sprinkle almonds on top.

Probably best served cut into small squares and served on a tray. It is very delicate, so handle lovingly.

Mrs. James T. Roe, III

Snowball Refrigerator Dessert

Serves: 12

Simple, elegant, festive and light. It never fails to elicit praise.

1 large angel food cake
1 tablespoon unflavored gelatin
4 tablespoons cold water
1 cup boiling water
dash salt
1 cup orange juice
1 cup sugar
juice of 1 lemon
2 cups Cool Whip*

Frosting:
1 cup coconut
1 cup Cool Whip

Dissolve gelatin in cold water. Add other ingredients except Cool Whip. Let the mixture partially set (2½-3 hours). Fold in the 2 cups of Cool Whip. Line a deep round bowl with waxed paper. Cut all brown edges off large angel food cake and pull into 1″ pieces. Put a layer of mixture in bottom of bowl, then cake, etc., until the last layer is the gelatin mix. Cover and let stand overnight. Turn out on a large plate and frost with 1 cup of Cool Whip and coconut. Garnish with a sprig of holly and berries for Christmas or a few cherries for George Washington's birthday.

*Buy the 12-oz. size of Cool Whip.

Mrs. Edward Ramlow

Continental Bread

Makes: 2 long loaves
Oven Setting: 400°

Always good.

1½ packages active dry yeast
1 tablespoon granulated sugar
2 cups warm water (100°-115°)
1 tablespoon salt
5-6 cups bread flour
3 tablespoons yellow cornmeal
1 tablespoon egg white, mixed with 1 tablespoon cold water

Combine the yeast with sugar and warm water in a large bowl and allow to proof. Mix the salt with the flour and add to the yeast mixture, a cup at a time, until you have a stiff dough. Remove to a lightly floured board and knead until no longer sticky, about 10 minutes, adding flour, if necessary. Place in a buttered bowl and turn to coat the surface with butter. Cover and let rise in a warm place until doubled in bulk, 1½-2 hours. (Placing in oven with pan of boiling water on another rack a few inches below the bowl is a good method.) Punch down the dough. Turn out on a floured board and shape into two long, French bread-style loaves. Place on a baking sheet which you have sprinkled with the cornmeal but not buttered. Slash the tops of the loaves diagonally with a sharp razor blade in two or three places, brush with the egg white wash. Place in a cold oven, set the temperature at 400° and bake 35 minutes or until well browned and hollow sounding when the tops are rapped. Bread should be eaten the same day or well wrapped and frozen for later use.

Ms. Elizabeth Teeple

Holiday Eggnog Soufflé

Serves: 20 *Delicious after a holiday meal.*

8 eggs
2 packets unflavored gelatin
1½ cups sugar, split
1½ cups milk
scant ⅛ teaspoon salt
½ cup rum
2 teaspoons vanilla
⅛ teaspoon grated nutmeg
4 additional egg whites
2 cups whipping cream, whipped

Separate eggs and beat the yolks lightly. Mix gelatin and ½ cup sugar. Into top of double boiler put egg yolks, milk, salt and sugar and gelatin mixture. Beat mixture with whisk over simmering water until it thickens to coat a spoon (careful, eggs will curdle if overcooked). Add rum and continue to cook until mixture coats spoon again. Add vanilla and nutmeg. Chill, stirring often until mixture mounds (approximately 1 hour) from spoon. Beat egg whites until thick. Gradually beat in remaining sugar and beat to form stiff (but not dry) meringue. Fold into custard mixture then fold in whipped cream. Pour into 2-quart soufflé dish with lightly buttered foil (or waxed paper) collar extending 2″ above top of dish. Chill 4 hours (or overnight). Remove collar before serving.

Mrs. Robert M. Edney

English Plum Pudding

Makes: 2-lb. pudding *This is festive holiday fare; a custom in Anglican homes.*

1 cup beef suet
1 cup cooking molasses
1 cup seedless raisins
1 cup chopped dates
1 cup chopped apples
1 cup currants
1 egg
⅔ cup brown sugar
2 cups milk
1 teaspoon baking soda
1 teaspoon baking powder
½ teaspoon cinnamon
½ teaspoon ground cloves
½ teaspoon salt
flour, to make stiff batter
jigger of brandy
1 cup broken walnut meats

Purchase fresh suet from market, chop up fine. Combine with molasses, fruits, spices, sugar, milk, eggs. Add dry ingredients and enough flour to make stiff batter. Add nuts and brandy. Pour into conventional plum pudding mold (with cover) that has been oiled. Place mold on trivet in kettle of boiling water, at depth of half of mold. Steam in boiling water for three hours.

Garnish with holly leaves (with berries). Flame with brandy on serving tray next to table. Serve individual portions, topped with brandied hard sauce, while quite hot.

Mrs. Pamela Harris Myers

Ashly's Applesauce Fruit Cake

Yield: 1 cake
Oven Setting: 350°

A family recipe from West Virginia.

2 cups brown sugar
½ cup Crisco
2 cups lukewarm apple sauce
2½ cups flour
2 teaspoons baking soda
1 teaspoon baking powder
2 eggs
1 teaspoon cinnamon
1 teaspoon ground cloves
½ box dates, cut in quarters
½ cup mixed candied fruit
15 red candied cherries, cut
10 green candied cherries, cut
1 cup English walnuts
½ cup dark raisins
½ cup white raisins
bourbon

Cream sugar and Crisco. Add apple sauce and 2 cups flour. Mix soda with just enough warm water to dissolve it and add to flour. Add baking powder, eggs, cinnamon and cloves. Mix dates, fruit, nuts and raisins into remaining ½ cup of flour to keep them from sticking together then add to the cake mixture. Pour into greased and floured tube pan and bake 60 minutes. Keep wrapped in foil. From time to time pour a little bourbon over the top of the cake and rewrap securely.

Mrs. Joseph Wright Twinam

Blackberry Raisin Cake

Serves: 16-20
Oven Setting: 300°

A nice variation from the traditional fruit cake.

1 cup sugar
1 stick of butter
4 egg yolks
1½ teaspoons baking soda
1 teaspoon cinnamon
1½ cups flour
1½ teaspoons nutmeg
1 teaspoon ground cloves
1 cup seedless raisins
1½ cups buttermilk
1 cup blackberry jam

Cream sugar, butter and egg yolks; set aside. Mix dry ingredients together. Add raisins and sugar-butter-egg yolk mixture. Add buttermilk and jam. Pour into tube pan and bake for 1 hour and 25 minutes. Top with whipped cream or ice cream.

Ms. Margaret-Jennifer Carson

Christmas Nut Thins

Makes: 6 dozen *Tasty and easy.*
Oven Setting: 375°

1 cup butter or margarine, softened
1 cup sugar
2 eggs, well beaten
1½ cups all-purpose flour
½ teaspoon salt
1 cup chopped pecans
1 teaspoon vanilla extract
pecan halves

Combine butter and sugar, creaming until light and fluffy. Add eggs, beating well. Add flour and salt, and mix until smooth; stir in chopped pecans and vanilla, mixing well. Drop by ½ teaspoonsful about 2" apart on greased sheets. Press a pecan half in center of each cookie. Bake about 8 minutes or until lightly browned.

Mrs. E. Carl White

Date Nut Bars

Yield: 24 squares *Contains no shortening.*
Oven Setting: 300°-325°

1 cup flour
1 teaspoon baking powder
⅛ teaspoon salt
3 eggs
1 cup sugar
1 teaspoon vanilla
1 cup chopped dates
1 cup chopped pecans

Sift flour, baking soda and salt together. Beat eggs thoroughly, gradually adding sugar while beating, then add vanilla. Continue beating and add flour mixture a few tablespoons at a time. Beat well. Fold in dates and nuts. Pour into a greased 9" x 13" pan which has been lined with waxed paper; spread evenly. Bake in a slow oven for 30 minutes. Remove from pan to cool. Do not cut until ready to use.

Mrs. W.T. Turner

Almond Tarts

Makes: 4 dozen *Pretty at Christmas time.*
Oven Setting: 350° *Can also be decorated with a few almond slices just before baking.*

instant pastry mix (enough for 4 pie shells)
8 oz. almond paste
⅔ cup sugar
½ stick butter
4 eggs, beaten
2 teaspoons vanilla
2 teaspoons bourbon
2 teaspoons grated lemon rind
strawberries
2 kiwis
apricot jam

Make instant pastry mix according to directions on box. Refrigerate until cool. Place 4 dozen 1½" tart pans on a cookie sheet. Roll pastry into tiny balls and press into each tart pan. Combine almond paste and sugar and mix in food processor. Add butter, then eggs, vanilla, bourbon and lemon rind. Preheat oven. Fill each unbaked shell with a small amount of almond filling. Bake until light brown. Let cool and then turn out of tart pans. Slice strawberries and kiwi (kiwi should be peeled). Place kiwi and strawberries on tarts. Melt jam and brush over tarts. Baked shells will keep one day, but fruit should be added a few hours before serving.

Ms. Alison Taylor Bivens

Animal Cookies

Makes: 6 dozen
Oven Setting: 375°

This is the one cookie my mother has made every Christmas I can remember. Now it's a favorite with my own children.

1 cup butter
1 cup sugar
1 egg
½ cup sour cream
1 teaspoon vanilla
4 cups sifted all-purpose flour
½ teaspoon baking soda
1 teaspoon salt
1 teaspoon grated nutmeg

Cream butter and sugar, beat in egg, add sour cream and vanilla. Sift dry ingredients together and add to creamed mixture, blending well. Roll out thin on floured pastry cloth. Cut with cookie cutters. Place on greased cookie sheet. Bake for 8-10 minutes until just slightly brown around edges. These cookies can be decorated as desired before baking, or frosted afterward. They keep for several weeks if stored in well-sealed containers.

Mrs. William F. Evans

Good and Easy Cookie-Cutter Gingerbread Cookies

Oven Setting: 350°

Can be made in food processor, but do half a recipe at a time.

1 cup sugar
1 cup shortening
2 teaspoons baking soda
2 teaspoons salt
1 teaspoon baking powder
3 teaspoons ginger
2 teaspoons cinnamon
1 teaspoon allspice
¾ cup buttermilk (or whole milk with a little vinegar)
1 cup honey
6 cups flour

Mix all ingredients except flour well. Add flour a bit at a time. No need to cool. Flour board and roll out; cut with cookie cutters. Bake 8-10 minutes on greased cookie sheet.

Ms. Kathie Pierce

Pumpkin Cookies

Makes: 5-6 dozen
Oven Setting: 350°

Good and unusual.

Cookies:
2 cups all-purpose flour
½ teaspoon salt
1 teaspoon baking powder
1 teaspoon baking soda
1 teaspoon vanilla
1 teaspoon cinnamon
¼ cup butter, softened
¾ cup shortening
1 cup sugar
1 cup pumpkin
1 egg
½ cup pecans, chopped
½ cup dates, chopped

Icing:
3 tablespoons butter
¼ cup milk
½ cup light brown sugar
1 cup + 2 tablespoons confectioner's sugar
½ teaspoon vanilla

Combine all ingredients for cookies. Stir until well-blended. Spoon out onto lightly greased and floured cookie sheet. Flatten with a fork. Bake for 10-12 minutes. Prepare icing by boiling butter, milk and brown sugar in small saucepan for 2 minutes. Let cool. Stir in confectioner's sugar and vanilla and beat until smooth. Frost.

Mrs. Thomas C. Peacock

GALLERY IX
Just Plain Good

MATTIE LOU O'KELLEY (American, born 1908)
Spring — Vegetable Scene, 1968, oil on canvas, 17⅜ x 23 inches. Museum purchase, 1975.
*Color reproduction in The High Museum of Art Recipe Collection sponsored by a friend
of the museum.*

Gallery IX

Light and Healthy Mushroom Stew

Serves: 6 *Always good.*

5 tablespoons butter
1 tablespoon olive oil
2 bay leaves
4 cloves garlic, minced
1-2 large yellow onions, chopped
2 tablespoons flour
1 cup vegetable broth (dry-powdered kind found in
 health food stores works well)
1 cup tomato juice
2 cups peeled, quartered tomatoes
1 teaspoon thyme
1 ½ lbs. mushrooms, washed
1 lb. small boiling onions, peeled
4-6 tablespoons dry red wine
2 tablespoons chopped fresh parsley
1 cup pitted green olives

In a medium-sized saucepan, melt 2 tablespoons butter with olive oil and the bay leaves, garlic and chopped onions. Saute until the onions are golden. Stir in the flour and lower the heat. Cook this roux for several minutes, stirring constantly. Add the vegetable broth and tomato juice. Stir with a whisk to remove all lumps and add the tomatoes. In a larger pot, melt the remaining 3 tablespoons butter and add the thyme and mushrooms. Sauté the mushrooms over a high heat for several minutes, turning them over. Add the boiling onions and the tomato mixture. Turn the heat down and simmer the stew for 20 minutes. Add the wine, parsley and olives. Cook 10 minutes longer and serve hot with good bread and red wine.

Mrs. Bennett Wall

Silvergate Fish Stew

Serves: 8
(approximately
3½ quarts)

A New England background combined with a Southern atmosphere results in this marvelous fish dish.

2 lbs. halibut or cod (thawed, if bought frozen)
2 large potatoes, peeled and diced
¼ lb. salt pork, diced
2 large onions, chopped
½ teaspoon sugar
6½-oz. can minced clams
1 quart milk
salt and pepper to taste
minced fresh parsley
paprika

Simmer fish in 2½ quarts salted water until tender; remove bones, flake fish and set aside. Boil potatoes in fish broth until tender. Fry salt pork in frying pan until crisp. Remove pork from pan; add onions and cook until golden. Add sugar and stir. Add fish, potatoes with broth and minced clams. Add milk slowly. Bring to a simmer. Season. Garnish with parsley and paprika. Serve with hushpuppies.

Ms. Patricia J. McDaniel

Scallops Chateau

Serves: 4 as entrée
6 as appetizer
Oven Setting: Broil

From The Cross Roads restaurant.

3 medium-sized potatoes, peeled, cooked, riced
Add 1 tablespoon cream and 1 tablespoon butter,
 keep warm

½ cup sliced, fresh spring onion
2 tablespoons butter
1 lb. bag whole scallops
1 cup Chablis
1 bay leaf
1 turn milled black pepper
1 clove garlic
¼ lemon
2 tablespoons butter plus 2 tablespoons flour
2 tablespoons chopped parsley

Sauté sliced spring onion in 2 tablespoons butter, set aside. Poach scallops in Chablis spiced with bay leaf, pepper, garlic clove, and lemon. Remove scallops while still tender. Remove the spices and reserve the stock.

Make a roux from the 2 tablespoons butter and 2 tablespoons flour. Add to the reserved stock to make a medium-thick sauce. Add scallops, chopped parsley and spring onion. Check seasonings and add salt and more pepper if necessary.

Divide scallop mixture into oven-proof serving dishes. Fill pastry bag with potato mixture and squeeze potatoes around inner edges of serving dishes in a circular motion until the entire top is covered. Place the decorated serving dishes on a baking sheet for ease in handling. This can keep for 20 to 30 minutes prior to cooking.

Five minutes before serving, set scallops under broiler to brown the potatoes and until the scallop mixture is bubbling. Serve immediately.

Mr. Allan Ripans

Clam Sauce for Pasta

Serves: 2-3

Wonderful for Sunday night supper. A real favorite with my children.

4 tablespoons olive oil
4 tablespoons butter
1 large clove garlic
3 tablespoons shallots
2 (6½-oz.) cans minced clams
¼ cup fresh parsley
Parmesan cheese

Heat olive oil and butter in skillet, add minced garlic and finely chopped shallots and sauté over low heat until shallots are lightly colored. Drain clams and add ½ cup clam juice from the cans to the mixture. Simmer for 5 minutes. Add drained clams, and ¼ cup finely chopped parsley and bring to a light boil. Serve with ½ lb. linguine and top with fresh, grated Parmesan cheese.

Mrs. John C. Rieser

Chicken Breasts Stuffed with Cheese

Serves: 4

Everyone's favorite for 20 years!

Oven Setting: 350°

4 chicken breasts, halved, skinned and pounded thin
salt and pepper
½ cup soft butter
2 tablespoons finely chopped parsley
1 teaspoon marjoram
½ teaspoon thyme
¼ lb. Fontina or mozzarella cheese
½ cup flour
2 well-beaten eggs
1 cup bread crumbs (add a little paprika)
½-1 cup dry white wine

Sprinkle chicken with salt and pepper. Spread ¼ cup butter on chicken. Blend other ¼ cup with herbs; cut cheese in 8 sticks and put one in center of each piece of chicken. Roll up, tucking in ends to seal (use toothpicks to hold if necessary). Roll in flour, then eggs, then crumbs. Put in greased baking dish. You can refrigerate at this point. When ready to serve, melt butter/herb mixture and drizzle over chicken. Bake 20 minutes. Pour wine over all, bake 15 minutes more, basting often.

Ms. René Newcorn

Salmon Steak Supreme

Makes: 3-4 large servings *Light and easy.*
Oven Setting: 400°

¼ cup butter
juice of 1 lemon
1 teaspoon Worcestershire sauce
½ teaspoon salt
¼ teaspoon paprika
pepper, freshly ground
minced fresh parsley
about 2 lbs. salmon steaks

In a shallow pan melt the butter, add the lemon juice, Worcestershire sauce, salt, paprika and pepper. Baste salmon with this mixture and place steaks in pan. Bake 15 minutes or until fish flakes with fork and is no longer translucent in the center. Sprinkle with parsley.

Ms. Anna H. Newberry

Pineapple Chicken

Serves: 4
Oven Setting: 375°

Low in calories.

3 cups cooked chicken (about 2½ double breasts)
8-oz. can pineapple chunks
2 stalks diagonally-sliced celery
1 green pepper, cut in 1-inch pieces
¾ cup toasted almonds
1 small chopped tomato
2 tablespoons chopped onions
1 teaspoon ginger
⅔ cup sherry
¼ cup soy sauce
juice from pineapple
¼ cup cornstarch

Combine all ingredients except liquids, mix these together and thicken with ¼ cup cornstarch (or more) to give the sauce a good consistency. Pour over mixture. Bake 45 minutes.

Mrs. John M. Hoerner

Taco Casserole

Serves: 4-6
Oven Setting: 375°

Great crowd pleaser.

1 lb. ground beef
1 medium onion, chopped
¼ cup chopped green pepper
¼ cup chopped celery (optional)
1 envelope taco seasoning
15-oz. can tomato sauce
17-oz. can whole kernel corn, drained
½ lb. Monterey Jack cheese, sliced or grated

Cornbread Topping:
1 cup cornmeal
1 heaping tablespoon flour
½ teaspoon baking soda
1 teaspoon baking powder
1 egg
1 cup buttermilk or sour milk
1 tablespoon melted margarine
½ teaspoon salt

Brown meat. Drain fat. Add onions, peppers and celery and cook until tender. Add seasoning mix and mix well. Add tomato sauce and corn. Mix and simmer 20-25 minutes uncovered. (Mixture should not be runny. Simmer longer if necessary.) Pour into 13" x 13" casserole. Cover with cheese. Top with cornbread recipe, spreading evenly and bake 20-25 minutes or until cornbread is golden.

Cornbread topping: Sift dry ingredients together. Drop in egg and beat. Add milk gradually and beat until smooth. Add margarine and blend.

Mrs. Dal M. Covington

Sesame Chicken

Serves: 4
Oven Setting: 350°

Economy and taste.

1 egg slightly beaten
½ cup milk
½ cup flour
¼ cup sesame seeds
1 teaspoon salt
¼ teaspoon freshly ground pepper
¼ cup butter
1 broiler-fryer about 2½ lbs., cut in pieces

Combine the egg and milk. In another small bowl mix flour, sesame seeds, salt and pepper. Melt butter in a baking dish. Dip chicken in milk mixture, then in flour mixture. Put chicken in pan and turn so that butter coats all sides well. Bake, uncovered, about 1 hour or until tender and brown.

Ms. Anna H. Newberry

Stuffed Pork Chops

Serves: 4
Oven Setting: 350°

Adapted from a recipe from the old Purefoy Hotel in Talladega, Alabama.

3 slices rye bread
¼ cup chopped onion
Worcestershire sauce
4 (1-inch) pork chops, cut to stuff
1-2 tablespoons oil

Cut bread into ½-inch pieces. Add chopped onion. Add enough Worcestershire sauce to make very moist (it will be more than you think). Stuff into pockets of pork chops, skewer with toothpicks. Brown on both sides in skillet with a little oil. Bake 1 hour, turning once.

Mrs. Noel Wadsworth

Korean Broiled Pork

Serves: 4
Oven Setting: Broil

This is an easy dish because it can be eaten cold.

1 lb. lean pork
⅓ cup soy sauce
2 tablespoons sugar
1 teaspoon chopped candied ginger or ⅛ teaspoon ground ginger
2 tablespoons sesame seed
⅛ teaspoon pepper
1 green onion chopped
1 clove garlic, minced

Slice pork very thinly. Mix remaining ingredients. Add to pork and mix well. Cover and let stand at least 15 minutes—can be much longer if refrigerated. Broil under medium heat until brown.

Mrs. James Laney

Chinese Pepper Steak

Serves: 4

Can be made an hour before serving and slowly rewarmed.

1 lb. round steak, 1" thick
¼ cup butter
1 clove garlic, minced
½ teaspoon salt
¼ teaspoon freshly ground black pepper
4 tablespoons soy sauce
½ teaspoon granulated sugar
1 cup bean sprouts, fresh or canned
2 tomatoes, quartered or 1 cup drained canned tomatoes
2 green peppers, seeded and cut into 1" pieces
½ tablespoon cornstarch
2 tablespoons cold water
4 green onions, chopped

Slice the steak as thinly as possible in short crosswise pieces. (This is easier if steak is partially frozen.)

Heat the butter in a frying pan or wok and add the garlic, salt and pepper. Add the beef and cook until brown on both sides, stirring as needed.

Add the soy sauce and sugar, cover and cook over high heat for 5 minutes. Add the bean sprouts, tomatoes and green peppers. Cover and cook for five minutes, then stir in the cornstarch which you have dissolved in the cold water and cook, stirring, until the sauce is thickened. Sprinkle with the chopped green onions and serve with rice.

Note: If using canned bean sprouts, drain, rinse and drain again before using.

Shrimp Creole

Serves: 6-8

Makes a good omelet sauce if you substitute green peas and mushrooms for the shrimp.

4 slices bacon
4 stalks celery, chopped
1 large onion, chopped
1 bell pepper, chopped
1 large (28 oz.) can whole tomatoes
2-3 tablespoons flour
⅓ cup water
4 to 6 oz. tomato juice
2 lbs. cooked, peeled shrimp
4-oz. jar olives (green preferred but black may be substituted)
4 drops Tabasco
salt and pepper

Fry bacon and remove from pan. In bacon drippings cook and stir celery, onion and bell pepper. Add canned tomatoes (after cutting tomatoes up). Cover and simmer 5-10 minutes or until vegetables are tender-crisp. Blend flour with ⅓ cup water; stir into vegetable and tomato mixture. Heat to boiling, stirring constantly. Boil and stir for one minute. Reduce heat. Add tomato juice to obtain desired consistency. Just before serving, add cooked shrimp, olives, Tabasco sauce and salt and pepper. Sprinkle warm bacon bits over top of sauce and serve over rice.

Mrs. W. F. Brady

Spaghetti Sauce

Serves: 4-6 *Freezes well.*

Step 1:
¼ cup olive oil
1 stick butter
2 medium onions
1 large clove garlic
1 lb. lean ground meat

Chop medium size onions and sauté in butter and oil until golden, add chopped garlic, meat and stir.

Step 2:
2 beef bouillion cubes
1 cup water
6-oz. can tomato paste
14-oz. can tomatoes
¼ teaspoon thyme
¼ teaspoon basil
¼ teaspoon tarragon
¼ teaspoon celery seed
½ teaspoon parsley (4 fresh stalks)
1 palm sugar
salt and pepper, to taste—at end of cooking time

Mix all the ingredients in step two together and simmer. Then combine with ingredients in step one. Stir and simmer, covered, at least 4 hours. We usually quadruple the recipe and freeze in quart jars for quick dinners. Serve with 1 lb. thin spaghetti for every four people.

Dr. John Rieser

"Macon" Eggs

Serves: 1 (multiply as needed) *Serve in the baking dish.*
Oven Setting: Broil—350°
butter
3 slices tomato, with peel
dash of Worcestershire sauce
Tabasco sauce
basil
oregano
pepper
salt
eggs, 1 or 2 per person

Grease individual flat baking dishes (about 5 inches in diameter) with butter. Arrange tomato slices with equal spaces between them. Dash each slice with Worcestershire and Tabasco and sprinkle with basil, oregano and pepper. Pour ¼ cup water in each dish and broil until edges of tomatoes slightly curl. Remove from oven and carefully break eggs into spaces between tomatoes. Salt eggs and tomatoes. Bake at 350° until whites are firm, about 10 minutes.

Mrs. James A. Summers

Portuguese Pancake

Serves: 4
Broiler

Better than an omelet.

2 tablespoons olive oil
1 lb. zucchini, chopped
1 small onion, chopped
½ green pepper, chopped
1 clove garlic, minced
½ stalk celery, chopped
parsley
1 teaspoon each basil and oregano
1 chopped tomato or ½ cup tomato sauce
3 eggs
½ cup milk
salt, pepper, paprika
½ cup grated cheese

Toss vegetables into a heavy frying pan which has a lid. Brown in oil for about 5 minutes. Add seasonings and tomatoes or sauce. Simmer until barely moist. Beat eggs, milk, salt and pepper and pour over vegetable mixture. Cover, cook until eggs begin to set. Sprinkle with cheese and paprika and brown 10 minutes under broiler. Serve in pie shaped wedges with a good crusty bread.

Mrs. Harold Barrett

Wonderful Waffles

Makes: 6

My grandmother's recipe—loved by young and old.

4 tablespoons butter
2 eggs, separated
1 cup flour
½ cup milk
½ cup heavy cream
¼ teaspoon salt

Cream butter. Add well-beaten egg yolks and beat 2 minutes. Add flour, milk and cream slowly. Add salt to egg whites, beat until stiff and fold into yolk mixture gently with a rubber spatula. Bake on a hot waffle iron until golden. Batter will keep a day or two in refrigerator. Top with powdered sugar and serve with strawberries, bacon and maple syrup for a breakfast guests will remember.

Dr. John C. Rieser

Tomato Quiche

Serves: 4-6
Oven Setting: 350°

Informal and good.

1 pie crust
3 tomatoes, sliced
1 cup grated cheese
1 cup mayonnaise
½ teaspoon basil
3 tablespoons chopped green onions

Bake pie crust until just crisp. Peel and slice 3 tomatoes, place in cooled crust. Top with remaining ingredients. Bake for 25 minutes at 350°.

Mrs. F.C. Steinmann, Jr.

Lebanese Eggplant Casserole

Serves: 4-6
Oven Setting: 350°

Good with tossed salad or marinated vegetables.

1 medium eggplant
olive oil
1 large onion, chopped
1 lb. ground lean beef or lamb
¼ cup pignolia (pine nuts)
1 clove garlic, crushed or minced
½ teaspoon cinnamon
salt and pepper to taste
1 small (8-oz.) can tomato sauce and ¼ can water

Peel and slice eggplant. Place in ovenproof dish, drizzle olive oil over slices and bake 5-10 minutes. Brown onions in skillet in olive oil. Add meat, nuts and seasonings. Cook, stirring, to brown meat. Place a layer of eggplant in greased 2-quart casserole. Cover with meat mixture. Top with second layer of eggplant. Dilute tomato sauce with water and pour over top of meat and eggplant. Bake 35-40 minutes and serve piping hot.

Mrs. Spencer S. Sanders

Stewed Tomatoes

Serves: 4

A family favorite.

6 large fresh tomatoes, washed, skinned and quartered, or 2 #2 cans whole tomatoes
1 medium onion, sliced
3 bay leaves
1 teaspoon ground cloves
¾ cup brown sugar
¾ stick butter
1 slice brown bread

Cover and simmer one hour. For last 10 minutes add 1 slice brown bread, broken up. Let sit for one day. Top with ½ cup plain croutons. Heat and serve.

Mr. Comer Jennings

Sweet and Sour Cabbage

Makes: 4 cups

Wonderful with turkey or pork.

2 slices bacon
½ cup chopped onion
10½ oz. can chicken broth
⅓ cup wine vinegar
2 tablespoons sugar
⅛ teaspoon pepper
3 cups or 2 medium sliced tart apples
7 cups shredded red cabbage
1 tablespoon cornstarch
2 tablespoons water
1 bay leaf

Cook bacon, crumble and reserve. Cook onions in drippings until tender. Stir in broth, vinegar, sugar and pepper. Add apples and bay leaf. Bring to boil. Add cabbage. Cover and cook over medium heat 45 minutes until tender. Combine cornstarch and water, stir into cabbage. Cook until slightly thickened. Remove bay leaf. Sprinkle reserved bacon on top. Garnish with green-skin sliced apples that have been rinsed in lemon juice and water.

Ms. Janis M. Basista

Norwegian Sauerkraut

Serves: 6

Letting it sit for a day or so adds character—marvelous with pork roasts or chops.

1 large red cabbage
water
½ cup sugar
2 teaspoons caraway seeds
salt and pepper
2 tablespoons bacon fat
½ cup vinegar

Slice the cabbage a little more coarsely than you would for cole slaw. Barely cover the bottom of a good-sized pot with cold water; put the cabbage in layers. Between each layer of cabbage sprinkle the sugar and the caraway seeds. Let this cook very slowly until the cabbage is tender, stirring from time to time.

Add salt and pepper to taste and the bacon fat. Just before serving, add half a cup of vinegar and stir. Sauerkraut may be served hot or cold.

Mr. Gudmund Vigtel

California Rice

Serves: 6
Oven Setting: 350°

Hardly tastes like a rice dish.

¾ cup uncooked rice
2 cups sour cream
salt
½ lb. Monterey Jack Cheese (grated)
4-oz. can chopped green chilis
butter

Cook rice. Combine with sour cream. Add salt to taste. Arrange ½ mixture in small casserole. Place ½ grated cheese on rice. Sprinkle green chilis on top. Add remaining rice and dot with butter. Cover with remaining cheese. Cook 30 minutes.

Mrs. Joel Engel

Carrot Delight

Serves: 4-6
Oven Setting: 350°

This will make a carrot lover out of anyone.

4 tablespoons butter or margarine
1 medium onion, finely chopped
1 green pepper, finely chopped
2 lbs. carrots, cooked and mashed
8 oz. sharp cheddar cheese, grated
½ teaspoon salt
⅛ teaspoon pepper
2 tablespoons butter or margarine
1 cup herb stuffing mix, crumbled

Preheat oven. Melt 4 tablespoons butter in skillet and sauté the onion and green pepper until tender. Combine onion and green peppers with carrots, cheese, salt and pepper. Place in a 1-quart, buttered casserole. Melt 2 tablespoons butter and add stuffing crumbs. Mix well and cover carrot mixture. Bake uncovered for 20-30 minutes or until bubbly. Garnish with sliced carrot flowers with green pepper stems.

Ms. Pat Scott

Rice Orientale

Serves: 8-10

Talk about more helpings. This is a dish that just keeps disappearing.

1 cup cooking oil
1 bunch (large) scallions, chopped
½ lb. fresh mushrooms, sliced
3 eggs
2 cups raw white rice, cooked
soy sauce
salt

Add the cup of oil to a large frying pan. Heat at medium-high and drop in scallions and mushrooms. When lightly sautéd, add eggs and scramble. Add cooked rice and mix thoroughly. Add soy sauce until rice is covered or to taste. Add salt if needed and more oil, while cooking, if necessary to prevent sticking. Serve dish hot, but it is also delicious cold. It gets better the next day.

Ms. Gale F. Barnett

Stir Fry Vegetables

Serves: 4

Adds exotic touch to dinner.

½ cup carrots, julienned
½ cup celery, cut in thin diagonal slices
1 medium zucchini, cut in thin diagonal slices
1 tablespoon peanut oil
2 tablespoons chicken broth
¼ lb. snow peas (or ½ package frozen snow peas, defrosted)
salt and pepper to taste

Chop vegetables. In wok or frying pan, bring oil to high heat. Add carrots; stir fry 1 minute, add celery; stir fry 1 minute, add zucchini; stir fry 1 minute. Add the chicken broth, cover and steam for 30 seconds. Add the snow peas, cover and cook an additional 30 seconds. Season with salt and pepper and serve immediately.

Baked Stuffed Squash

Serves: 8
Oven Setting: 350°

Effortless.

8 whole yellow squash (medium)
salted water
salt and pepper to taste
6 tablespoons grated onion
4 tablespoons butter
6 tablespoons buttered toast crumbs
additional buttered toast crumbs for topping

Parboil whole squash in lightly salted water until tender, about 15 minutes. Remove from water and cool slightly. Cut an oblong piece out of each squash. Scoop out squash pulp. Mix this with salt, pepper, grated onion, butter and 6 tablespoons buttered crumbs. Fill squash shells with mixture. Sprinkle additional crumbs on top. Bake for 20 minutes.

Mrs. Austin P. Kelly

French Dressing and Marinade

Yield: 1½ cups *Great marinade for shish-kabobs!*

1 cup salad oil
¼ cup vinegar
1 teaspoon salt
1 teaspoon sugar
1 teaspoon paprika
1 teaspoon dry mustard
1 clove garlic
¼ teaspoon pepper
1 teaspoon lemon juice

Mix together in cruet. Shake well. Chill. It's best to make this a day ahead.

Ms. Tippin Harvey

Cheese Bread

Makes: 2 loaves
Oven Setting: 400°

6 cups bread flour
2 teaspoons salt
1 package yeast
1¾ cups warm water
1 tablespoon margarine
¾ cup shredded sharp cheddar cheese
1 tablespoon coarsely ground black pepper

Sift flour and salt in a bowl. Dissolve yeast in ¾ cup warm water. Make "well" in flour mixture and add yeast and remainder of water. Mix thoroughly. Turn onto lightly floured surface. Knead for 10 minutes. Shape into ball and place in generously greased large bowl. Cover with towel and let rise in warm place until doubled in bulk. Mix cheese and pepper. Turn risen dough into cheese and pepper. Knead cheese and pepper into dough for 5 minutes. Form into 2 loaves. Put in greased loaf pans, cover, let rise. Bake 30-40 minutes. Bread should sound hollow when turned out. Cool on rack.

Ms. Virginia B. Tuttle

Quick Whole Wheat Beer Bread

Makes: 1 loaf *Hard to believe anything*
Oven Setting: 350° *this easy can be so good!*

2 cups self-rising flour
1 cup whole wheat flour
1 teaspoon baking powder
4 tablespoons honey
12-oz. can beer at room temperature (not opened previously)

Sift together dry ingredients. Stir in honey and beer. Pour into greased and floured loaf pan. Bake for 40-45 minutes. (When done, bread should come away from sides of pan and a straw inserted into center should come out clean.) Slice and serve warm or at room temperature.

Ms. Diana Darr

Onion-Yogurt Cornbread

Serves: 4 *Confirmed cornbread haters*
Oven Setting: 425° *love this!*

1 tablespoon sweet butter
1 tablespoon oil
¾ cup cornmeal
1 egg
½ teaspoon baking soda
1 teaspoon salt
½ cup chopped onion
freshly ground pepper
1½ cups plain yogurt

Melt butter and oil in a 9" baking dish or 1-quart casserole in preheated oven. Mix together remaining ingredients and pour into hot baking dish. Bake 30 minutes, until just set. Serve warm or at room temperature with fresh sweet butter.

Ms. Ingrid Barker

Mother's Biscuits

Makes: 12
Oven Setting: 450°

This is one of the recipes I asked my mother for when I first left home. It's always good.

Sift together:
2 cups flour (all-purpose)
½ teaspoon salt
4 teaspoons baking powder
¼-⅓ cup sugar (depending on sweetness desired)

Pour in a cup together and
add to the flour mixture:
⅔ cup milk
½ cup oil

Stir above together until the side of the bowl is clean. (You may need to add a little more flour.) Lightly knead the dough 10 to 12 times on a floured board. Roll to one-half inch thickness. Cut with a biscuit cutter and place on cookie sheet or baking pan so that biscuits are touching. Bake for 12 to 15 minutes. Serve warm.

Ms. Denise Bassett

Gingerbread

Serves: 8-10
Oven Setting: 350°

A favorite winter snack or dessert.

¼ lb. (1 stick) butter or margarine
1 cup sugar
2 eggs, beaten
½ teaspoon salt
3 cups flour, sifted
2 teaspoons ginger
1 teaspoon cinnamon
1 teaspoon baking soda
2 tablespoons boiling water
1 cup strong coffee
1 cup molasses

Cream butter, sugar, eggs and salt. Sift flour with spices and soda in a separate bowl. Combine with other mixture. Blend in coffee and the molasses. Put in greased 8" x 8" pan. Bake for 20-30 minutes or until knife blade comes out clean.

Editor's note: Delicious topped with warm lemon sauce: Combine and stir in a double boiler over hot water until thickened—¼ cup sugar, 1 tablespoon cornstarch, 1 cup warm water. Remove from heat and stir in 2 tablespoons butter, ½ teaspoon grated lemon rind, 1½ tablespoons lemon juice and ⅛ teaspoon salt.

Mrs. Frank H. Maier, Jr.

Sour Cream Pound Cake

Makes: 1 large cake
(18 or more servings)
Oven Setting: 325°

Excellent with fruit, cheese and wine.

½ lb. butter or margarine
3 level cups sugar
1 teaspoon vanilla extract
½ teaspoon salt
6 eggs, separated
3 cups plain flour
¼ teaspoon baking soda
½ pint sour cream

Cream butter and sugar thoroughly. Add vanilla and salt. Blend in egg yolks, one at a time, beating well after each addition. Sift together the flour and the baking soda; add alternately with the sour cream. Fold in stiffly-beaten egg whites. Place in a well-greased, lightly floured tube or bundt pan and place in oven. Bake for 1¼ hours, or until cake tests done. Cool in pan 30 minutes before turning out on rack.

Editor's note: Kaki Thurber makes a similar sour cream pound cake to which she adds 1 tablespoon lemon extract and glazes with a mixture of lemon juice and powdered sugar.

Ms. Carol Burch Tooke

Cream Cheese Pound Cake

Serves: 20-25
Oven Setting: 325°

Great for college students' care packages.

3 sticks butter
8-oz. package cream cheese
3 cups sugar
6 eggs
1 teaspoon vanilla flavoring
½ teaspoon coconut flavoring
¼ teaspoon almond flavoring
3 cups plain flour
½ teaspoon baking powder

Cream butter and cream cheese. Add sugar and eggs, beating well after each addition. Add flavorings and flour with baking powder. Bake in 9-inch tube pan in preheated oven for 1½ hours. Test for doneness.

Mrs. Theodore Hecht

"I Can Remember the Recipe" Cookies

Oven Setting: 325°

Teach children to bake with this recipe.

1 stick butter
1 cup sugar
1 egg
1 cup flour
½ teaspoon vanilla

Preheat oven. Cream butter and sugar; add egg. Stir in flour and vanilla. Drop small amount onto cookie sheet as they will spread. Makes very thin cookies. Cook 10 minutes or until edges are brown. Remove at once.

Ms. Elizabeth Adams

Buckeye Candy

Makes: 70-80 pieces

Luscious.

1 stick butter, melted
1 box confectioner's sugar (1 lb.)
3 cups Rice Krispies
2 cups crunchy peanut butter
12 oz. chocolate chips
⅓ bar parafin

Mix butter, sugar, Rice Krispies and peanut butter. Roll into 1-inch balls. Melt chocolate and parafin together. Dip each ball in the chocolate and allow to dry on wax paper.

Editor's note: Cathy Temple makes a similar candy with 4 sticks butter, 1½ cups peanut butter, 1 teaspoon vanilla and 2½ boxes confectioners' sugar. Roll and dip as above.

Mrs. Newton T. Clark

Peanut Butter Pie

Makes: 1 pie

So weird I almost didn't try it, but it's now one of our family's favorite desserts.

9-inch pie shell
2 (8-oz.) containers of Cool Whip
3-oz. cream cheese, softened
4 tablespoons extra crunchy peanut butter
1 cup powdered sugar
⅓ cup chopped salted peanuts or grated bittersweet chocolate for garnish

Cook pie shell and cool. Mix one of the containers of Cool Whip and 3 oz. of softened cream cheese in mixer. Add 4 tablespoons extra crunchy peanut butter and one cup powdered sugar (10X). Pour mixture in pie shell and top with the other container of Cool Whip. Sprinkle nuts on top.

Mrs. Walter Sprunt

Buttermilk Coconut Pie

Makes: 1 pie
Oven Setting: 350°

Rich but wonderful!

3 eggs
1 cup sugar
¾ stick margarine, melted
¼ cup buttermilk
1 teaspoon vanilla (or lemon extract)
1 cup flaked coconut
1 unbaked 9-inch pie crust

Beat eggs, add sugar, melted margarine, buttermilk, flavoring and coconut. Mix well. Pour in unbaked pie shell. Bake 1 hour.

Mrs. Henry A. Mann

Georgia Apple Pie

Serves: 6-8
Oven Setting: 350°

Perfect ending for a casserole and salad dinner.

4-5 large apples, peeled and sliced very thin
½ cup sugar
1 cup brown sugar, packed
1 cup all-purpose flour
1 cup pecans, coarsely chopped
½ cup margarine, melted

Arrange apples in oiled 3-quart oblong baking dish. Sprinkle granulated sugar over apples. Mix brown sugar, flour, pecans and melted margarine and spoon over entire surface. Bake for 45 minutes. Serve warm with ice cream or whipped cream.

Editor's note: If planning to freeze, cook 15 minutes less and reheat in oven or microwave.

Mrs. Clifford N. Bullard

Easy Fruit Cobbler

Serves: 8-10
Oven Setting: 350°

Old family favorite from Michigan.

3 cups cut up fruit (apples, peaches or any drained, canned fruits) in dish or 9″ x 9″ pan

Sprinkle fruit with mixture:
⅔ cup sugar
2 tablespoons flour
½ teaspoon cinnamon
dot with 2 tablespoons butter

Sift together in bowl:
1 cup plain flour
2 tablespoons sugar
½ teaspoon double-action baking powder
¼ teaspoon salt
½ cup soft shortening, oleo or oil
3 tablespoons milk
1 egg

Stir pastry mixture in bowl with fork until well blended. Drop by spoonful over fruit, or if desired may be spread over fruit with spatula. Bake 25-30 minutes. Can add whipped topping and serve warm, or "as is" cold.

Ms. Arlene Harris

Homemade Vanilla Ice Cream

Makes: 2 quarts

This ice cream may be varied by adding almost any good, ripe fruit—peaches, strawberries or bananas.

2 cups milk
1 cup sugar
¼ teaspoon salt
4 cups light cream
4 tablespoons vanilla

Scald milk and remove from heat. Add sugar and salt to milk, stirring until both are thoroughly dissolved. Then add cream and vanilla. Cool completely. Pour into ice cream freezer and freeze as directed.

Lemon Sugar Cookies

Yield: 60
Oven Setting: 400°

Pack in small, colored shopping bags for holiday giving.

½ cup shortening
1 teaspoon grated lemon rind
1 cup sugar
1 egg, unbeaten
2 tablespoons milk
2 cups flour, sifted
1 teaspoon baking powder
½ teaspoon baking soda
extra sugar

Mix ingredients together well in the order given. Make small balls of dough and place on a lightly greased cookie sheet. Flatten each cookie with the bottom of a small glass that has been greased and dipped in sugar. Bake 6 to 8 minutes. Sprinkle tops of cookies with extra sugar and remove from cookie sheet while warm.

Mrs. Raymond M. Warren, Jr.

GALLERY X
Menus

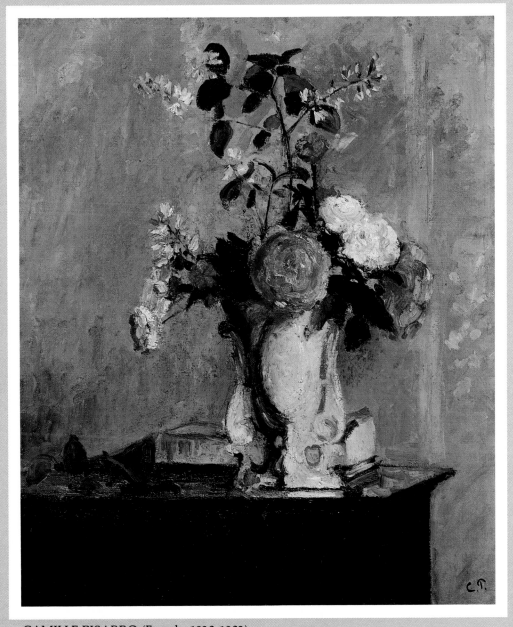

CAMILLE PISARRO (French, 1830-1903)
Bouquet of Flowers, c. 1873, oil on canvas, 21⅝ x 18¼ inches. Gift of The Forward Arts Foundation in honor of Mrs. Robert W. Chambers, first president of the foundation, 1974.

Breakfast for Weekend House Guests
(for 6)

Assorted Juices
Canadian Bacon
*Eggs Baked in Cheese Sauce
English Muffins
Café au Lait

Al Fresco Brunch When the Dogwoods Bloom
(for 6)

Strawberries in Orange Juice
*Seafood Shells
*Baked Fresh Asparagus
Croissants with Apricot Jam
*Iced Spiced Coffee

Before the Game Brunch
(for 8)

Sliced Oranges and Grapefruit
*Sautéd Chicken Livers
*Stuffed Spinach Roll
*Cheese Date Treats

OR

*Mushroom, Shrimp, Egg Casserole
*Fresh Broccoli Salad
Toasted French Bread
*Brandied Peaches

The Sunday Before Christmas Champagne Brunch
(for 16)

Chilled Champagne
*Curried Pecans
Sliced Virginia Ham
*Oysters Rockefeller Casserole
*Cream Biscuits
*Apricot Ring Mold
*Ashley's Applesauce Fruitcake

*Check recipe yield—in some instances recipe will need to
be doubled for the proper number of servings.*

Luncheon after Mixed Doubles
(for 4)

*Salad Niçoise
Sesame Bread Sticks
*Cassis Cream
*Lemon Sugar Cookies

Ladies Luncheon
(for 8)

*Curried Grape-Shrimp Salad
Warm Melba Toast
*Key Lime Pie Extraordinaire

End of Summer Kids' Splash Party

Carrot and Celery Sticks
*Best Pizza
*Orange Banana Sherbet
*Chocolate Delight

Tailgate Picnic in Athens
(for 10)

*California Artichoke and Shrimp Dip
Assorted Crackers
*Beef Soup Stew
*Layered Coleslaw
*Continental Bread
Apples and Cheddar Cheese
*Lemon Pecan Squares

After the Peachtree Road Race
(for 8)

*Shrimp Gazpacho
*Pesto Genovese
Hard Rolls
*Minted Cantaloupe Mold

Celebration Luncheon
(for 8)

*Stuffed Mushrooms
*Fillets de Poisson Florentine
Bibb Lettuce and Sliced Tomatoes
*Strawberry Grand Marnier Sorbet

Picnic Before the Concert in Chastain Park
(for 6)

*Cold Plum Soup
*Veal and Ham Pie with Mustard Sauce
*Summer Stuffed Tomatoes
*Almond Cheesecake Brownies

OR

*Shrimp Gazpacho
*Beef Vinaigrette
Crusty French Bread
*Fresh Fruit Grand Marnier

Apéritifs Before the Show
(for 8)

*Asparagus Tart
*Gurkas Dilisas
Radishes
Warm Salted Almonds
Suggested Aperitifs:
Dubonnet, Lillet, Kir
Compari, Sherry

Cocktails Before the Dance
(for 16)

*Sausage-Cheese Stuffed Mushrooms
*Hot Crabmeat Dip
Cherry Tomatoes Stuffed with
*Guacamole—Fort Sam Houston
Assorted Crackers
Salted Nuts

Holiday Cocktail Buffet
(for 50)

*Caviar and Avocado Mold
*Hors d'Oeuvre Salmon Loaf
*Crispy Cheese Rounds
*Mushroom Croustades
*Marinated Roast Tenderloin
Hot Rolls
Assorted Mustards
*Turkey in Lettuce Leaves
Crudities with Curried Mayonnaise
*Almond Brandy Mold
Assorted Cheeses
Crisp Crackers
Fresh Fruit
*Raspberry Walnut Shortbread Bars

After the Game
(for 10-12)

*Hot Bacon and Cheese Hors d'Oeuvres
*Moussaka with Artichokes
*Macedonian Salad
*Georgia Apple Pie

Hearty Winter Dinner
(for 8)

*Hot Cheese Balls
*Roast Pork Stuffed with Prunes
Oven Roasted Potatoes
*Braised Endive with Carrots
*Tomato Aspic with Artichoke Hearts
*Applesauce Brulée

VIP Dinner
(for 6)

*Coquilles St. Jacques
*Rare Roast Beef with Horseradish Sauce
*Julienne Vegetables
with
Tomato Sauce
*Bleu Cheese and Walnut Salad
French Rolls
*Frozen Orange Soufflé Grand Marnier

Hunting Season Dinner
(for 6)

*Vegetable Soup Nivernaise
*Holiday Quail
Wild Rice
*Mandarin Orange Salad
with
Tarragon Dressing
*Dacquoise au Café

Informal Buffet
(for 20)

*Shrimp Butter
Crisp Crackers
*My Very Own Pâté
*Party Pasta
*Avocado Grapefruit Salad
Hot Garlic Bread
*Coffee Tortoni

In Celebration of Spring Dinner
(for 6)

Cherry Tomatoes stuffed with *Boursin at Home
*Artichoke Soup
*Georgia Mountain Trout in Wine
Brown Rice with Pine Nuts
*Asparagus Polonaise
*Horse Race Pie

Birthday Dinner for a Special Friend
(for 8)

*Cream of Carrot Soup
*Roast Leg of Lamb with Artichokes
Rice Pilaf
*Caesar Salad
French Rolls
*White Chocolate Cake with
White Chocolate Frosting

Cookout for a Crowd

*Mushroom Pâté
*Hot Asparagus Dip
*Grilled London Broil with Herb Butter
or
Grilled *Herbed Leg of Lamb
*Ratatouille
Mixed Green Salad
Toasted Pita Bread
*Mixed Fruits with Walnuts and Liqueurs

Dinner on the Terrace
(for 6)

*Cheese Straws
*Vichysquash
*Stuffed Flank Steak
*Green Beans with Walnuts
Boston Lettuce with Cucumber and Tomatoes
*Cointreau Soufflé

Working Wife Supper
(for 4)

*Chicken Mediterranean
Rice or Egg Noodles
Green Salad
*Banana Pudding

Dinner for the Dieters
(for 6)

*Mulligatawny
*Cucumber and Red Onion Salad
*Sorbet aux Pamplemousse

Sit Down Buffet
(for 12)

*Mushroom Puffs
*Chicken Bolognese
*Broccoli Rice Casserole
*Orange and Olive Salad
*Kahlua Chocolate Mousse

A Country French Dinner
(for 4)

*Cream of Sorrel Soup
*Garrou de Veau
Toasted Sliced French Bread
Green Salad Vinaigrette
*Almond Tarts

Dining Vegetarian
(for 6)

*Chilled Spinach and Cucumber Soup
*Fresh Vegetable and Cheese Pie
*Quick Whole Wheat Beer Bread
*Apricot Squares

Quick Supper for the Hurried Cook
(for 6)

Pan Broiled Italian Sausages
*Portuguese Pancake
*Aunt Annie's Coleslaw
Vanilla Ice Cream with Crushed *Pecan Pralines

Sunday Supper in the Kitchen
(for 10)

*Mushroom Bleu Cheese Appetizer
*Delta Gumbo
Brown Rice
Green Salad
Hard Rolls
*Easy Lemon Ice Cream

Make Ahead Dinner with Style
(for 6)

*Hot Cheese Balls
*Chicken Breasts Wellington
Fresh Peas with Tiny Onions
*Molded Avocado Ring with Sassenage Dressing
*Chocolate Fantasy

Buffet Supper for Teenagers

*Guacamole with Tortilla Chips and Crudities
*Taco Casserole
Tossed Salad
*Sour Cream Pound Cake
Fresh Fruit

After a Museum Opening
(for 6)

*Veal Stew with Olives
Egg Noodles
Spinach, Tomato and Mushroom Salad
*Lemon Cream Puffs

Supper After the Opera
(for 4)

*Cold Tomato and Basil Soup
*Fettuccine alla Romana
Romaine and Ripe Olive Salad
Grissini
*Amaretti Torte

Caroling Party

*Come-a-Caroling Wassail
or
*English Wassail
*Toffee Apples
*Cheese Wafers
*Christmas Nut Thins

Come at Eight for Just Desserts
(for 30)

*Almond Tarts
*Dacquoise au Café
*Walnut Roll
*Lemon Cream Puffs
*Blackberry Jam Cake with Buttermilk Frosting
*Raspberry Walnut Shortbread Bars
*Cheesecake Eagle's Nest
*Chocolate Fantasy
*Grand Marnier Pie
Serve with Dessert Wines and Coffee or Espresso

Index

ORDER FORMS

Please send me ___ copies of THE HIGH MUSEUM OF ART RECIPE COLLECTION at $12.95 per copy, plus $2.00 per copy postage and handling. Georgia residents add $.65 sales tax per book.

Enclosed is my check or money order for $ _____ .

Name: _____

Street: _____

City: _____ State _____ Zip _____

Make checks payable to Cookbook-The High Museum of Art.

Price is subject to change.

Mail to: **COOKBOOK**
 High Museum of Art
 1280 Peachtree Street, N.E.
 Altanta, GA 30309

- -

Please send me ___ copies of THE HIGH MUSEUM OF ART RECIPE COLLECTION at $12.95 per copy, plus $2.00 per copy postage and handling. Georgia residents add $.65 sales tax per book.

Enclosed is my check or money order for $ _____ .

Name: _____

Street: _____

City: _____ State _____ Zip _____

Make checks payable to Cookbook-The High Museum of Art.

Price is subject to change.

Mail to: **COOKBOOK**
 High Museum of Art
 1280 Peachtree Street, N.E.
 Altanta, GA 30309

- -

Please send me ___ copies of THE HIGH MUSEUM OF ART RECIPE COLLECTION at $12.95 per copy, plus $2.00 per copy postage and handling. Georgia residents add $.65 sales tax per book.

Enclosed is my check or money order for $ _____ .

Name: _____

Street: _____

City: _____ State _____ Zip _____

Make checks payable to Cookbook-The High Museum of Art.

Price is subject to change.

Mail to: **COOKBOOK**
 High Museum of Art
 1280 Peachtree Street, N.E.
 Altanta, GA 30309

ORDER FORMS

Please send me ___ copies of THE HIGH MUSEUM OF ART RECIPE COLLECTION at $12.95 per copy, plus $2.00 per copy postage and handling. Georgia residents add $.65 sales tax per book.

Enclosed is my check or money order for $ _____ .

Name: _____

Street: _____

City: _____ State_____ Zip _____

Make checks payable to Cookbook-The High Museum of Art.

Price is subject to change.

Mail to: **COOKBOOK**
 High Museum of Art
 1280 Peachtree Street, N.E.
 Altanta, GA 30309

--

Please send me ___ copies of THE HIGH MUSEUM OF ART RECIPE COLLECTION at $12.95 per copy, plus $2.00 per copy postage and handling. Georgia residents add $.65 sales tax per book.

Enclosed is my check or money order for $ _____ .

Name: _____

Street: _____

City: _____ State_____ Zip _____

Make checks payable to Cookbook-The High Museum of Art.

Price is subject to change.

Mail to: **COOKBOOK**
 High Museum of Art
 1280 Peachtree Street, N.E.
 Altanta, GA 30309

--

Please send me ___ copies of THE HIGH MUSEUM OF ART RECIPE COLLECTION at $12.95 per copy, plus $2.00 per copy postage and handling. Georgia residents add $.65 sales tax per book.

Enclosed is my check or money order for $ _____ .

Name: _____

Street: _____

City: _____ State_____ Zip _____

Make checks payable to Cookbook-The High Museum of Art.

Price is subject to change.

Mail to: **COOKBOOK**
 High Museum of Art
 1280 Peachtree Street, N.E.
 Altanta, GA 30309